AVIATION ART

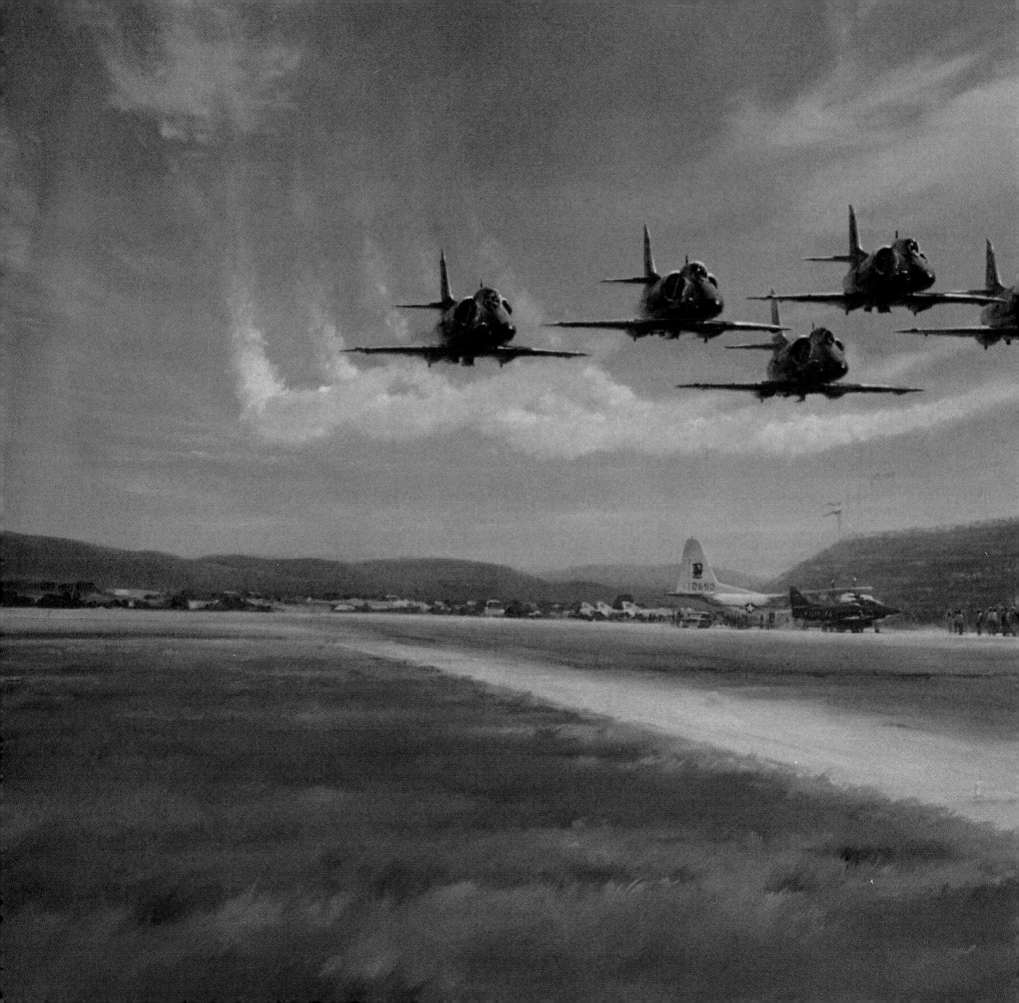

AVIATION ART

Michael Sharpe

Thunder Bay
P·R·E·S·S

This edition published in 1998 by
Thunder Bay Press
5880 Oberlin Drive, Suite 400
San Diego, California 92121
1-800-284-3580

http://www.admsweb.com

Produced by
PRC Publishing Ltd,
Kiln House, 210 New Kings Road,
London SW6 4NZ

ISBN 1 57145 163 3
(or Library of Congress CIP data if available)

1 2 3 4 5 98 99 00 01 02

Printed and bound in China

Previous Page:
The Blue Angels

R. G. Smith

In close formation, the U.S. Navy flying
display team the "Blue Angels" demon-
strate the capabilities of the McDonnell

Right:
**Ernst Scheufele's Messerschmitt
Bf109G-14AS**

Jerry Crandall

Ernst Scheufele achieved 18 victories
including three bombers and two P-51s
in this Bf109G-14AS.

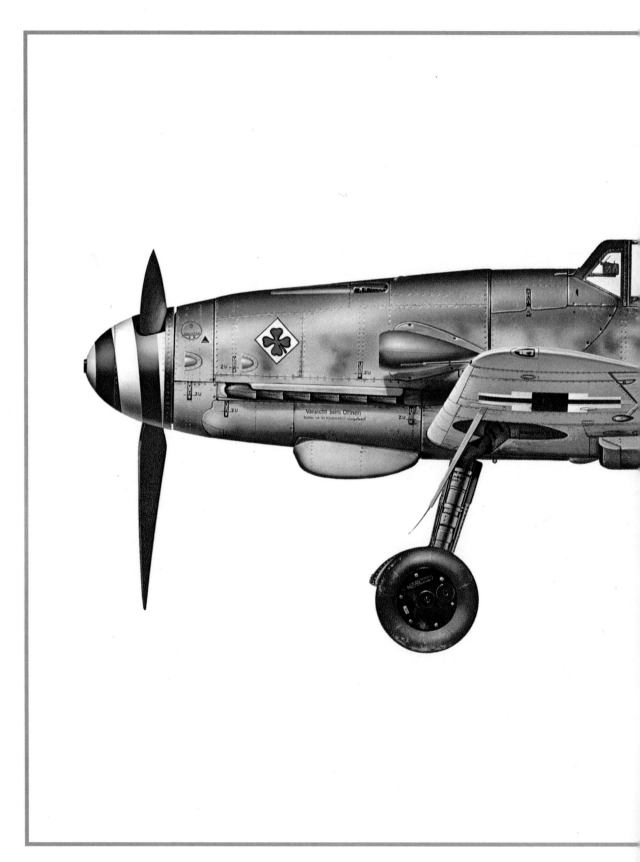

CONTENTS

INTRODUCTION

Aviation art occupies a unique creative niche. A graphic representation of momentous events in aviation history can provide us with a valuable record where no other visual archive is available. Aside from this value, however, the art has an evocative appeal of its own. Aviation artists can convey some of the power, the movement, and the chaos of aerial combat, and some of the terror of an aerial strike. They can also create visual panoramas that evoke the thundering noise of a bomber formation, the raw smell of aviation fuel, the tranquillity and the isolation at 35,000 ft. These are places, emotions, or experiences that will be unfamiliar to many of us. There is a consummate skill in capturing these moments, and one that is convincingly demonstrated by the selection of works in this book.

The history of the two world wars continues to provide aviation artists with a plethora of subjects. The periods 1914-1918 and 1939-1945 witnessed the most dramatic changes in the aircraft industry and its products, and is rich with stories of heroism and sacrifice. When those tiny, fragile aircraft made their tentative first flights over the Western Front in 1915, it would have been scarcely believable that, not three decades later, the same skies would be darkened by awesome bomber fleets hundreds strong. The sheer volume and breadth of topics for study have ensured the lasting appeal of these most dramatic times.

Many, however, prefer to remember more peaceful times — the golden age of aviation in the 1930s when thousands would flock to the spectacle of the flying display and the barnstorming shows, the age of flying boats and the start of regular commercial aviation routes, when the R.A.F was innocently regarded as the "best flying club in the world" by its officers. That innocence was lost forever in World War II, but in the years following, both commercial and military aviation capitalized on the breathtaking advances made during that conflict. The 1950s saw the ascendancy of the jet, both as a weapon of war and as the herald of a revolution in international travel. The throb and hum of the piston-engine was rapidly replaced by the whine and roar of the jet engine. There are wonderful post war paintings included here, by artists of such renown as Robert Taylor and John Young, as well as the excellent and highly regarded American artist, William Yenne. In this selection,I have tried to

Above right:
An NS starting for a Patrol over the North Sea from East Fortune

Alfred Egerton Cooper

Balloons and airships were a popular subject for Great War artists.This scene, which Cooper executed in watercolour, is one of the more
unusual.

Below right:
British Maurice Farman attacked by a German Fokker while dropping sacks of corn on Kut-el-Amara during the siege of 1916

Sidney W. Carline

Carline, a contemporary of Cooper, preferred oils. His depiction of the ancient Mesopotamian town of Kut-el-Amara is richly detailed, showing the warren of houses that stands to this day in modern Iraq.

choose pieces which represent the enormous changes in society, the aviation industry, and changing artistic values. The book finishes with contemporary depictions of the Space Shuttle, a summation of almost a century of technological and artistic endeavour.

Of course, there are the familiar topics — the Zeppelin raids on London that ushered in the new dark age of total war; the balmy summer days of 1940 when, in the skies above southern England, the desperate Battle of Britain was waged by Hitler's Luftwaffe and won by the R.A.F., and the daylight raids by the U.S. air forces that pounded the Reich when the tide had turned in the Allies' favor. Refreshingly though, many artists have chosen to depict lesser known aspects of the wars in the air, and in so doing have, perhaps, helped to bring knowledge of these equally vital theaters to the attention of a wider audience. Fortunately, much of this work is either on public display in museums or galleries, or is regularly reproduced in aviation literature. In Britain one of the highlights of the year for any aviation enthusiast is the annual Guild of Aviation Artists exhibition and in the U.S an equally talented pool of artists is kept busy by a growing band of aviation enthusiasts. As we approach the end of the century many new and interesting works are on display. It is clear that interest in this field is flourishing, with more artists emerging all the time: sadly, it is impossible to include them all.

In this review of aviation art, I have tried to steer away from assessing only what is termed "photo-realistic" art, a style which is so much in vogue today. The galleries of many major museums hold pictures that are executed in less familiar styles but are just as rewarding and often hold an impact that is lacking in the more obvious technique. It is also important to remember that the technique utilized by the artist will reflect values which help to place a work in its social context and thus lend a depth of meaning absent in a purely representational piece. For example, both of the works on this page are delineated in a characteristic impressionist manner. This artistic movement developed a seemingly casual technique which, with its extraordinary use of light and color, attempted to create works which were spontaneous and conveyed a sense of immediacy. This is particularly apparent in Cooper's work at the top of the page where dark browns and blacks are sharply contrasted with the white snow in the background — this provides an impression of the despair and monotony of the war and juxtaposes the unsullied natural landscape with the gloomy, menacing machine which intrudes upon the scene and totally dominates it. The piece thus speaks of peace and beauty as being obscured almost to the point of obliteration by the darkness of the unnatural and manufactured conflict.

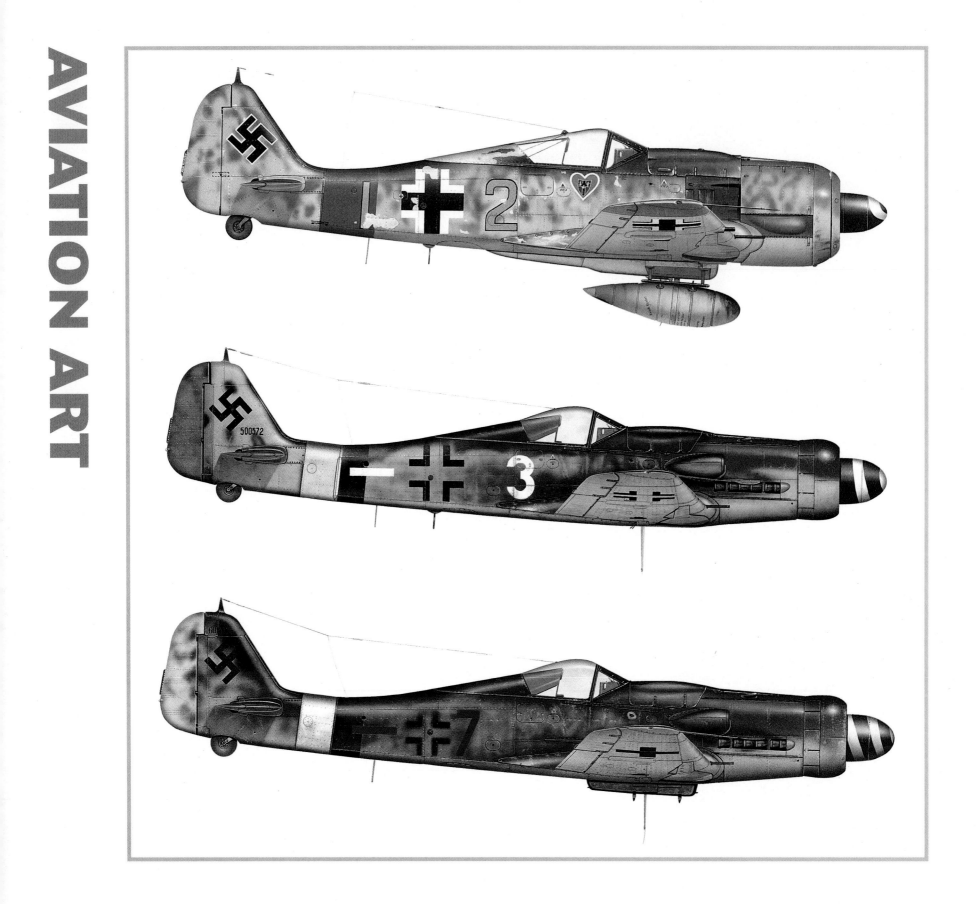

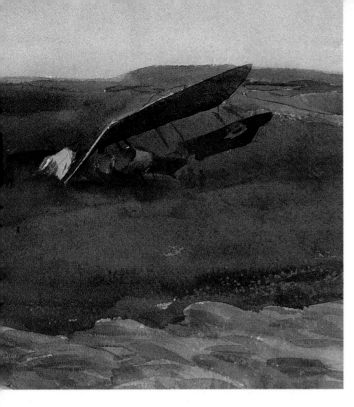

Above:
A Crashed Aeroplane (Detail)

John Singer Sargent

There is a wonderful poignancy about the body of work Sargent undertook for the British War Memorials Committee, that extends to this view of a fallen aircraft. Sargent is recognized as one of the most important of all war artists.

Left:
Focke-Wulf FW190s

Jerry Crandall

Examples of the ultimate in realism — Jerry Crandall's wonderful side views of important fighters include these remarkably accurate FW190s.

With such considerations in mind I have tried to include a spectrum of works by lesser known artists as well as their more famous colleagues and have given space to pictures which accurately render the machines and their environment as well as more emotive pieces. Hopefully this will provide a balance of styles and perspectives will give the viewer a deeper insight into the genre of aviation art. It is also important to note that some of the work in the following chapters has been produced to commission, and this book provides an opportunity to see artworks that are not on public display.

World War I

World War I was the crucible in which military aviation was forged. In the few years since the Wright brothers' first flight in 1903, the military had not been slow to see the possibilities that manned flight could realize, particularly when the shape of the World War I became apparent. With mile upon mile of trenches, barbed war, and machine guns, and a landscape that soon resembled a moonscape, even the most hidebound staff officer could see the benefits of aerial reconnaissance. Once the Kaiser's Zeppelin fleet began to terrorize London and the coastal towns of eastern England, the wider implications were obvious — and the form of military aviation as we know it today was laid down. The fact that a country's civilian population and workforce could be threatened and pressured far behind the front line brought the first concepts of total war, that would become a full reality only in the last years of World War II.

It is unsurprising, too, that artists — official war artists and others — quickly took to aviation as a source of inspiration. There is a certain reverence in many of the works of the time that reflects the awe and terror in which aircraft were once held. Many famous artists were to make bold and charismatic attempts to capture this terrible new facet to the most terrible of wars. Even today, the urge to paint the images of early air combat is strong and is reflected in the selection of material chosen to illustrate World War I in this book.

Of the many important contemporary artists to paint military wartime scenes, American John Singer Sargent (1856-1925), received a letter of invitation from the British prime minister, Lloyd George, to paint "the fusion of British and American forces." He was commissioned later in the war by the British War Memorials Committee and joined their body of official war artists. Sargent's style was unique among Great War artists. Influenced by the Impressionists and their use of light, but also by the

style of the old masters such as Franz Hals and Velasquez, his work covered the whole gamut of warfare. While there is the mark of a draftsman, it is one who combines subtlety and exceptional technique to convey his mood. His epic "Gassed" was "a harrowing sight, a field full of gassed and bindfolded men" witnessed at Le Bac du Sud and was completed in 1919 after his return to England. His work is represented in this book by "A Crashed Aeroplane," which was completed in 1918, the final year of the conflict. It shows a wrecked R.F.C. aircraft languishing in the August sun. In the foreground, two farmers stoop to rick hay. The contrast between the simplicity and peacefulness of their world, which has survived despite the horrors of the conflict represented by the war machine behind them, is powerful indeed. The use of watercolor adds to the mood of tranquillity. The wrecked aircraft has the air of a stricken bird. Its grace, poise, and dignity lie shattered on the sunburnt earth.

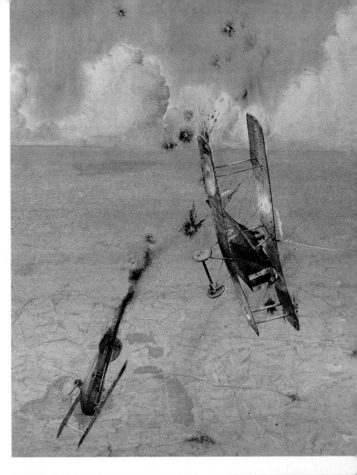

Other contemporary artists, such as Royal Academician Sir John Lavery, R.A., R.S.A., painted images of war without the pathos or the military action. He used the size of the British airships in their sheds, like great animals at rest, to impress. His work provides interesting comparison with that of Alfred Egerton Cooper. Both men were established artists of some renown before hostilities began, something that is perhaps reflected in the skill of their composition and use of color.

A more heroic pose is struck by Captain Albert Ball in Norman G. Arnold's "The last flight of Captain Ball" (1919). Ball is one of the most famous of aviators. Awarded the Victoria Cross, the Distinguished Service Order, and the Military Cross while serving with the Royal Flying Corps, the humble and modest Ball is the very epitome of the dashing aerial ace eulogized by the press. In the picture Ball is shown wheeling his SE5 to starboard in a desperate attempt to elude a pursuer. Flak bursts puncture the air around him — one feels a sense of drama, movement, and vulnerability. Little is known of Ball's fate, and so Arnold's work is pure supposition. The heroic nature of the work is a theme that proved popular with Arnold. His output was prodigious, and he possessed a newsman's eye for the dramatic.

One of the most enjoyable aspects of aviation art is this ability to tell a story. Stuart Reid had a wonderful feel for the unusual and a great skill in figure drawing. His work is usually event based with wonderful stories attached to each painting. Take for example the story behind "The Seward Exploit" — a painting that captures a moment of great bravery in one of the lesser theaters of the war. While on a photographic mission over Syria, 2-Lt. W. E. L. Seward, M.C. was forced to ditch in the sea, and was fired on from the land. To evade his Turkish adversaries he had to

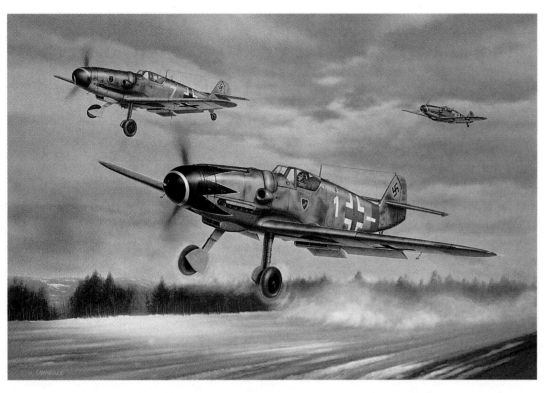

perform a great feat of physical endurance, swimming out to sea and then for some hours along the coast. The painting shows his Martinsyde Scout sinking as he swims out to sea.

Like many of his fellow artists, Reid's contemporary, Sidney Carline, also has a flair for capturing unusual moments in aviation history. The work showing a "British Maurice Farman attacked by a German Fokker while dropping sacks of corn on Kut-el-Amara during the siege of 1916" is a good example. The detail is finely executed, showing the Fokker climbing to attack the hapless "Farmer."

The United States joined the conflict in 1917, but in the eighty years since, her native artists have produced many notable works on aviation. Troy White, a modern painter, specializes in capturing the airmen of legend, and among them none is more legendary than Manfred, Freiherr von Richthofen. Richthofen, the pupil of Oswald Boelcke, epitomizes the gallantry of the early scout pilots. The "Red Baron," with his distinctively painted aircraft and famous "Flying Circus," was the deadliest of foes but inspired a feeling of professionalism, even courtesy, making him a very suitable subject for a current artist.

Between the Wars

In the years after the Armistice, aviation became commonplace. The war

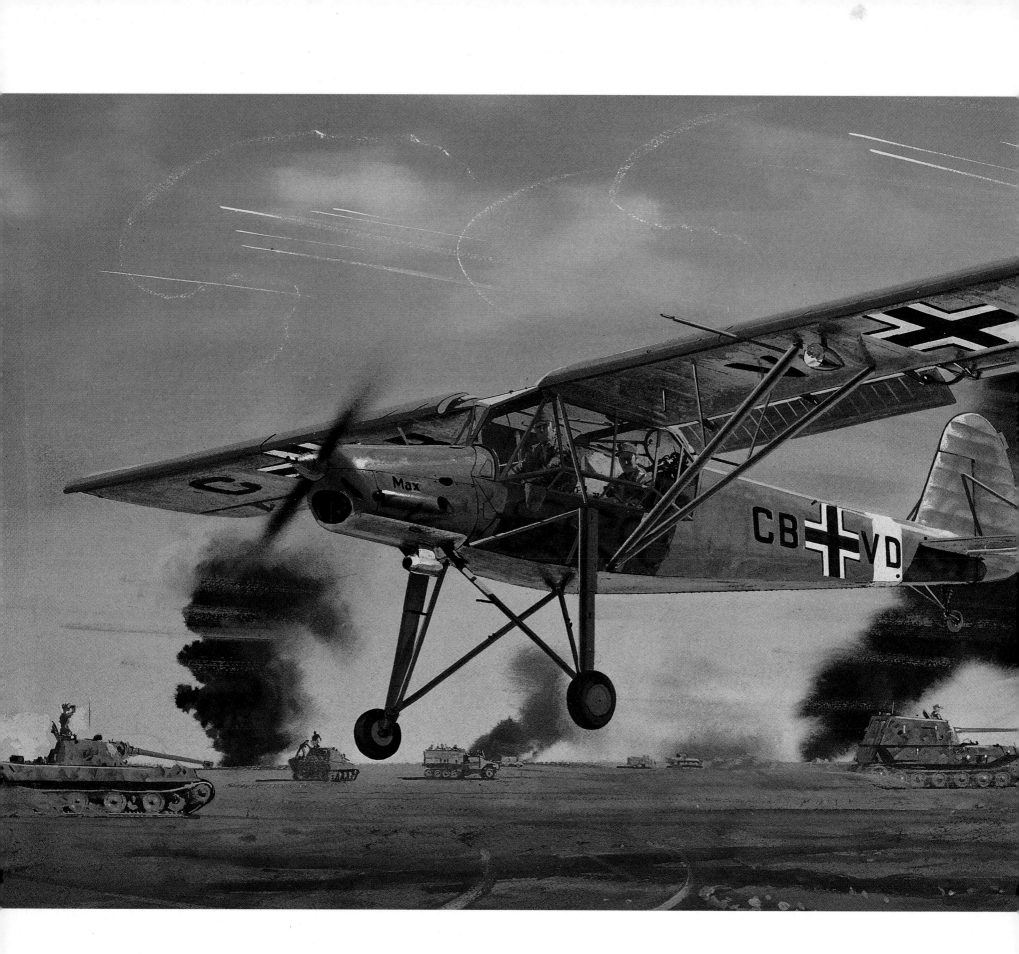

had left a burgeoning aviation industry, a large number of pilots for whom the thrill of flying would not allow them to return to land-based occupations, and unwanted military aircraft. The commercial opportunities did not escape them. From passenger-carrying to barnstorming, from exploration and adventure to invention and the quest for speed, the 1920s and 1930s saw a huge expansion in the types aircraft and their sophistication, which I have tried to capture in such images as "Avro Baby," which shows an endurance flight from Britain to India and Charles Thompson's "Supermarine"s Speed Machine," which shows one of the Schneider Trophy winners.

Charles Thompson, President of the British Guild of Aeronautical Artists, has a particular skill in capturing the spirit of inter-war aviation, and the fact that he is heavily represented in this section bears this out. One of my favorite aspects of his work is his ability to capture an aircraft in its environment so well, and to use buildings, people and familiar landscapes to lend authenticity to his work. His "Luxury to Luxor" or "De Havilland Tiger Moth and Railton" show how unusual composition and subject matter can evoke powerful images of bygone days. "Is it a bird? Is it a plane?" looks at a one of Cierva's strange autogiros, typical of many blind alleys of inter-war aviation research.

Today's aircraft restoration and preservation scene has seen many inter-war aircraft restored to flying condition, allowing artists to capture real images of aircraft from this period. Many works of aviation art are obviously commissioned by proud owners and pilots who wish to preserve their machines. Rick Ruhman's "David's Staggerwing" is very much a personal work, but we can have no doubt of the immense pride of this beautiful little aircraft's owner, and the skill of its restorers.

The more modern penchant for photo-realism is provided in "The Professionals" by Jim Dietz. Dietz is among the foremost of contemporary American artists, and enjoys as well-deserved reputation for his technical skill and composition. His study of U.S naval aviation during the 1930s captures the bustle and activity that characterizes the flight-deck of a carrier during flying operations.

Less technically proficient, Stan Osborn came to aviation art by a

Left:
Fieseler Storch

The Fieseler Storch was commonly used by Germany as an observation aircraft. This representation shows off its color scheme in a reference for modelers.

more unusual path — while incarcerated in Stalag Luft 1. Osborn had one of the more dangerous occupations of the war — he was a tail gunner in a Lancaster bomber — and was fortunate to survive being shot down over Hannover in March 1945. Many of his paintings show the R.A.F in more peaceful times, when graceful Gamecocks were the cutting edge of progress.

World War II

In May 1940, Britain stood at the brink of defeat. Her armies had been overrun in a matter of weeks and stood with their backs to the English Channel at the small French port of Dunkirk. These were dark days, indeed, and the next five years of war saw the role of aviation dominate the great land and sea battles. It is unsurprising, therefore, that such events should generate so much contemporary art and, post-war, so much retrospective work. Even today, the aviation art scene is dominated by paintings of World War II.

When war broke out in 1939, Paul Nash was forty-seven and had cemented his reputation as one of the greatest British painters of his generation. Perhaps the most famous of all British war artists, Paul Nash (1889-1946) included few aviation works in the body of works he produced during the Great War. Nash felt rooted in the trenches with the common soldier. To these men, the strange machines scudding and wheeling through the skies above their own stinking mud-holes must have seemed strangely distant. It is perhaps regrettable that Nash did not lend his prodigious talents to the field of aviation art prior to World War II. Despite this, two of the greatest works of war art came from Nash's palette. "Battle of Britain," in the collection of the Imperial War Museum, was completed under commission in 1941. White contrails snake through the stratosphere above the Thames Estuary in a heavenly melée. It is an observer's view, not that of a participant, and that is why it was greeted with such enthusiasm when it was first displayed. It is the battle in the eyes of the civilian. Nash chose a lofty position for his perspective of the combat, which seems distant — almost removed. In 1945, Nash was commissioned as Artist to the Royal Air Force, and later became attached to the War Artist's Advisory Committee. He died in 1946.

The tense days of the Battle of Britain have been a popular topic for many artists, and it is interesting to compare their styles. "The Rochford Boys" by Charles Thompson is very much a personal account of the Battle, from the perspective of the civilian population. The Spitfire was an

Above:
The Battle of Britain (Detail)

Paul Nash

Commissioned in 1941 to commemorate Britain's victory, the painting, executed in oil on canvas, is a vivid portrayal of the battle as seen by millions of ordinary people. Nash lived through both wars, although his work from the WW2 is considered less significant.

Right:
Limited edition collector's prints

Jerry Crandall

Top — General Günther Rall's Bf109G-2, "Black 13"; Rall achieved 275 kills.

Center — "Black 10" was an FW190A-8 flown by Knight's Cross holder Hauptmann Robert Weiss.

Bottom — "Brown 31" was an FW190D-9 flown by Pilot Unteroffizier Walter Stumpf.

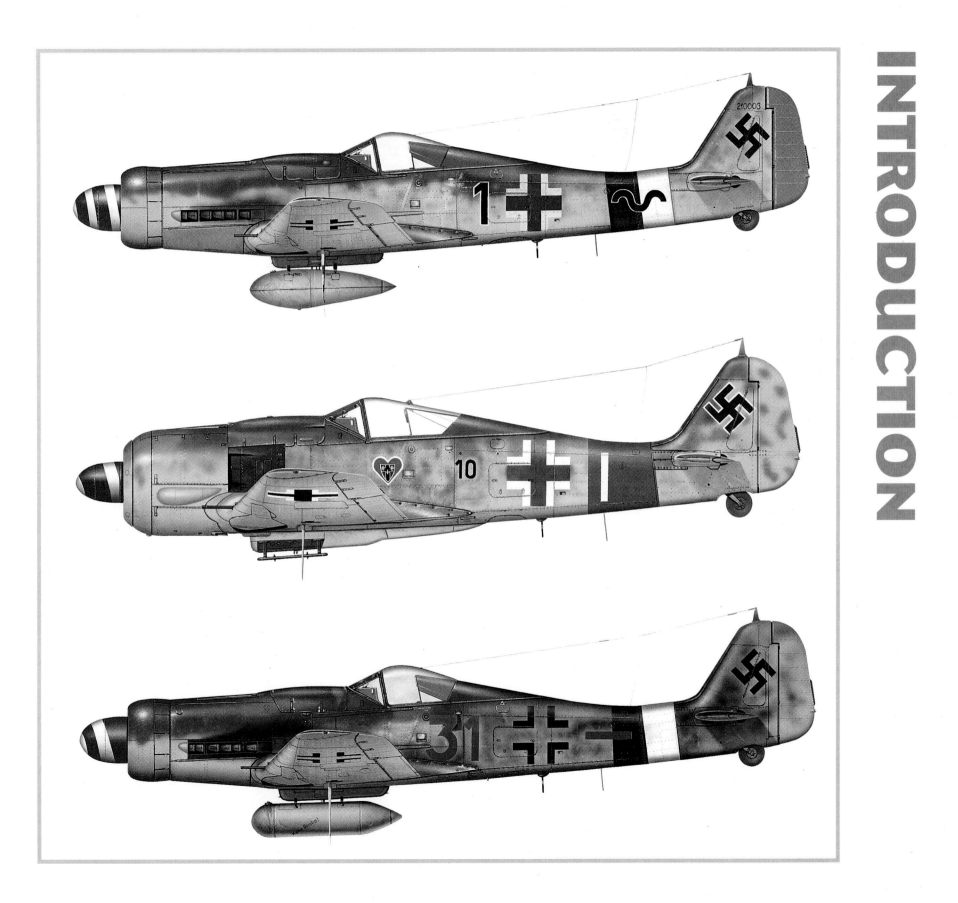

15

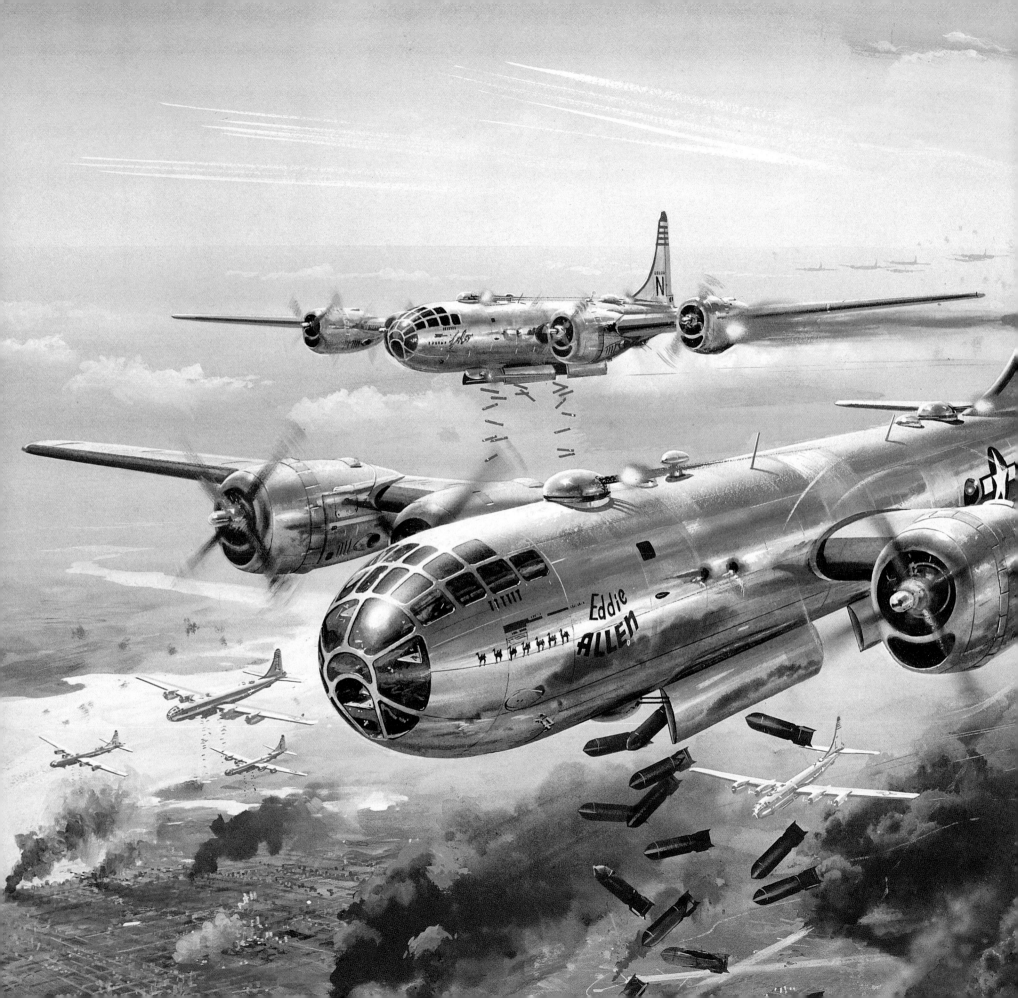

aircraft of legend for small boys and men alike during the war. Its pilots were heralded as latter day knights. The sight and sound of one of these legendary aircraft is one of the most stirring experiences to a generation of people who lived through the Battle. With "The Wing's Return" Thompson has managed to capture the great sense of foreboding felt in Britain as Hitler's armies stood poised to strike across the Channel in the summer of 1940. It is interesting to note the way he has used scale in this picture. The aircraft are dwarfed by the towering thunderclouds, yet are still very much the focus. One can almost sense the anxious ground crew peering into the darkening skies to count the aircraft back.

The largest section in this book, there are many images here that show the different styles of aviation art — including the meticulous detail of Jerry Crandall's work. This hyperrealism studies famous aces and famous battle encounters. His work always exudes drama and action and is executed with a fine draftsman's eye. Crandall's research is very thorough, often involving interviews with the pilots and witnesses. Hugh Polder has a style similar to Crandall, and captures one of the greatest combat pilots of all time in his portrait of Hans Ulrich Rudel. Opposing him was the leading Soviet and Allied ace of the war, Ivan N. Kozhedub, who is commemorated in another featured Crandall painting.

In December 1941, the surprise Japanese attack on Pearl Harbor dragged the United States into the war — although Americans had been fighting for some time. The "Flying Tigers," led by Claire Chennault had been fighting in China and are shown in Nicolas Trudjian's "Tiger Fire,, but nothing could have prepared the American people for the shock the attack on Pearl Harbor. "This is No Drill," painted by former American Airlines pilot Craig Kodera, captures the drama and destruction. In a matter of months U.S. forces were fighting around the world, from the hot jungles of the central Pacific islands to the chill skies above Central Europe. Understandably a large part of the work by American artists focuses on their great airmen and battles. Of these, I have selected what I feel to be a good representation of material. Both Jerry Crandall and Troy White pay homage to the legendary aviators, their units, aircraft,

Left:
B-29 Superfortress

Another modelers' reference, this painting shows the heaviest of the World War II bombers — the Boeing B-29 Superfortress, a strategic bomber and reconnaissance aircraft which was widely used for high altitude, long distance missions. Following World War II, B-29s served with the R.A.F. as Washingtons.

and battles. Both of these artists are careful to provide useful background information to their art which has a thoroughness and accuracy that speaks for their skills as aviation historians. Rick Ruhman has also made some fine studies of heroic actions in the air, perhaps none finer than "Point of no Return (The Miracle Mission)." A more anonymous scene, but one of my personal favorites, is Jim Dietz's beautiful portrayal of a Consolidated PBY Catalina and its tender. The detail is wonderfully crisp, matched by the intelligent selection of color and a natural feel for light and shadow.

A number of paintings by British wartime artists are included, such as Charles Cundall, Raymond McGrath, Julius Stafford Barker and the highly regarded Royal Academician Eric Ravilious. It is interesting to see how many of these artists, for whom aviation was the main focus of their work, approached the subject. "Spitfires at Sawbridgeworth" has the sense of an artist without time on his hands. It is worthy to note that Eric Ravilious was one of the few war artists to die on active service. Likewise Leslie Cole's depiction of "Royal Marine A.A. Gunners" as they "bring down a Flying-bomb." Dame Laura Knight captures the crew of a Lancaster as they make their pre-flight checks before setting off for a target somewhere in Germany. The tension in the face of the navigator in the foreground is plain to see.

Nicholas Trudgian is held in high regard by afficionados of aviation art. His depiction of B-17 Flying Fortresses of the 100th Bomb Group en route for their "First Strike on Berlin" captures the desperate vulnerability of those daylight raids, despite the fighter escort. Even the cover of night was insufficient, as the men of R.A.F. Bomber Command found when stalked by the Heinkel He219 Uhu, as shown in Rick Ruhman's artwork. An earlier and less capable night hunter, the radar-less Boulton Paul Defiant, forms the subject of Charles Thompson's evocative "Night Fighter," setting out for a mission in the evening sun.

Peace again

As the dust clouds settled over Nagasaki and Hiroshima it was clear to all that a new age had been unveiled. The fact that the most destructive weapon ever devised was dropped by an aircraft was no coincidence, and underlined the pre-eminence of the aircraft in warfare. In 1948, men with clear memories of bombing the German capital of Berlin by night were flying mercy missions to rescue the population from another enemy — starvation. Charles Thompson's homage to the airmen and women who took part in the Berlin Airlift shows an R.A.F. Avro York on

Right:
The Blue Angels

R. G. Smith

In close formation, the U.S. Navy flying display team the "Blue Angels" demonstrate the capabilities of the McDonnell Douglas A-4 Skyhawk. This single-seater jet has a top speed of 670 m.p.h. and was common during the Vietnam conflict where it was used for close support and interdiction missions.

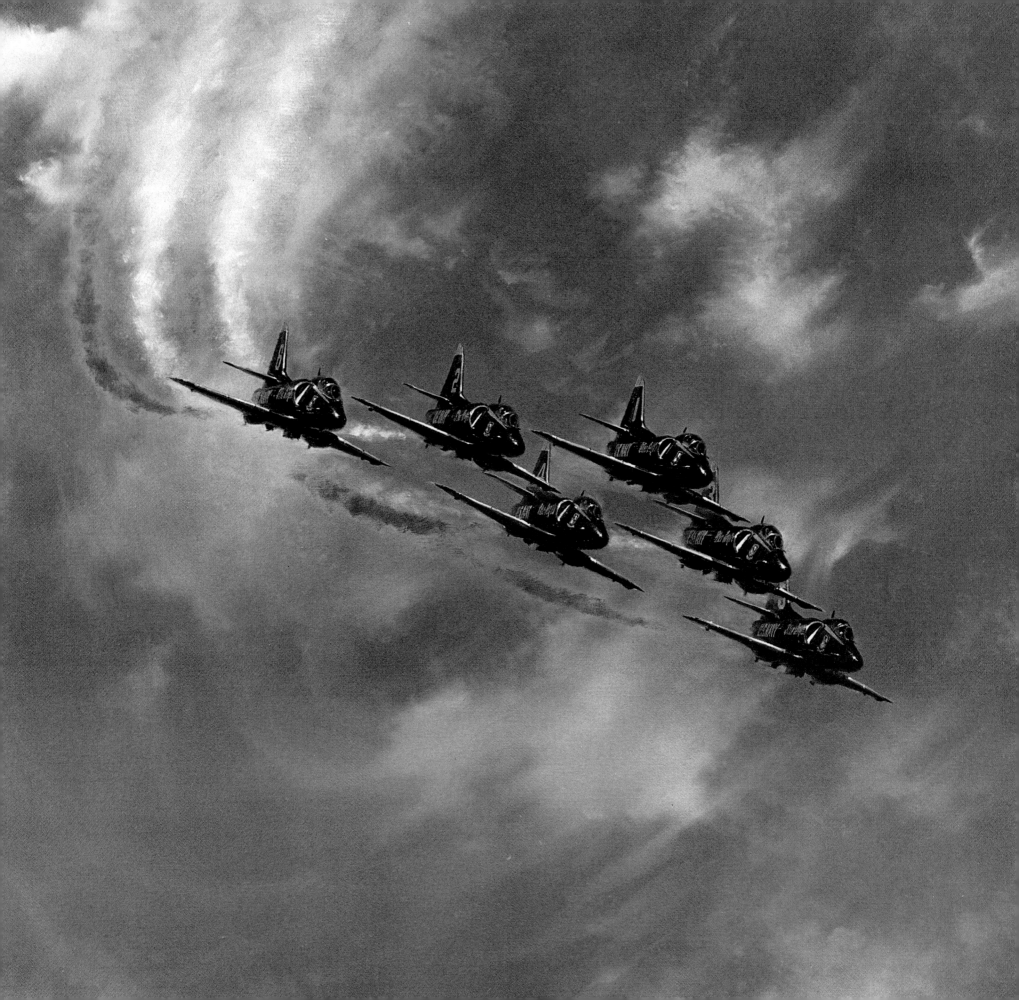

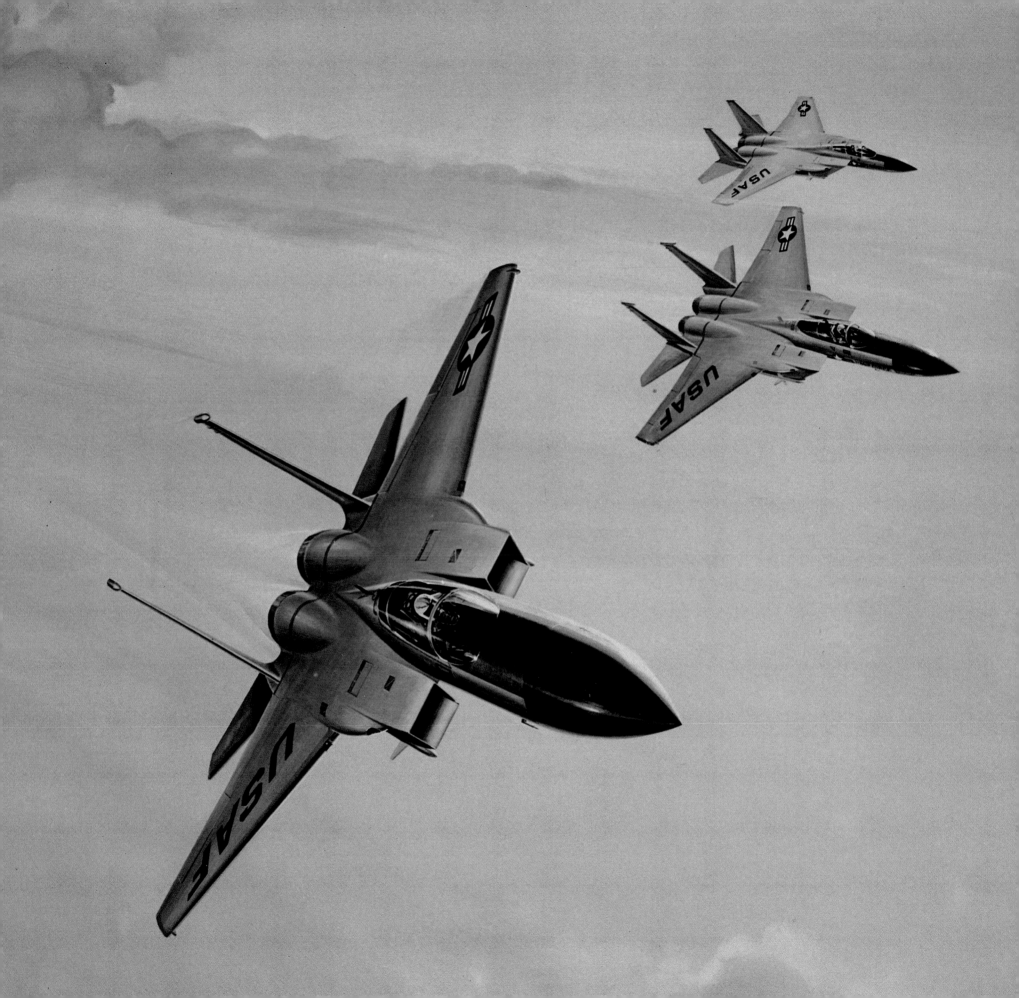

Left:
F-14 Tomcat

With a top speed of Mach 2.34 and an AWG-9 weapons control system, the Grumman F-14 Tomcat is an effective multi-mission fighter aircraft. A deadly machine, it carries a 20mm. M61-A1 multi-barrel cannon, four AIM-7 Sparrow, up to eight AIM-9 Sidewinder air-to-air missiles, and six AIM-54 Phoenix.

its final approach to Gatow airfield in Berlin. Another veteran of that operation, the C-47 Skytrain, is shown in Troy White's "Outbound Skytrain." The cessation in hostilities led to a minor boom in the airline industry. One of its most faithful servants was the beautiful Lockheed Constellation, shown in Charles Thompson's painting in the colors of Australian carrier Qantas. The elegant lines of the Constellation, with its unmistakable dolphin back, are shown to good effect in another featured Thompson painting "A Real Honey."

The Korean War defined a new age in air combat. Both Troy White and Hugh Polder have taken the classic battle of the war, between Soviet-built MiG-15s and American F-86 Sabres, as their theme. "Looking for Casey Jones" and "Jabby's big day" are the continuation of a familiar motif for White. The Cold War is represented by John Young, William Yenne, and Charles Thompson. It is particularly pleasing to include John Young's work in this collection. He is widely respected throughout the aviation community and one of the most in-demand artists. Young's depiction of B-47s represents one of the more obvious faces of the Cold War. In comparison, Charles Thompson's personal view of a Lockheed U-2 represents a less publicized aspect of the postwar arms race. Bill Yenne's work, part of the U.S. Air Force's Art Collection.

After World War II, air operations — from Vietnam through the Middle East to the Falklands — have been fundamental to all conflicts. Without air forces, land and carrier-based, the prosecution of the Vietnam War would have been impossible. Without their air superiority, the Israelis would have succumbed to their Arab neighbours. Without the Harriers, Britain would never have recovered the Falkland Islands. These wars are covered by artists of such renown as Robert Taylor — widely regarded as the best of the modern school of aviation artists — and William S. Phillips. Taylor's impressive research and eye for detail is exemplified well by "Phantom Strike" and "Air Strike over West Falkland."

Fittingly, however, we close with images that show aircraft in a less warlike guise: the beauty of Concorde, still the only supersonic commercial aircraft, and what is, perhaps, the ultimate flying machine, the Space Shuttle.

Michael Sharpe

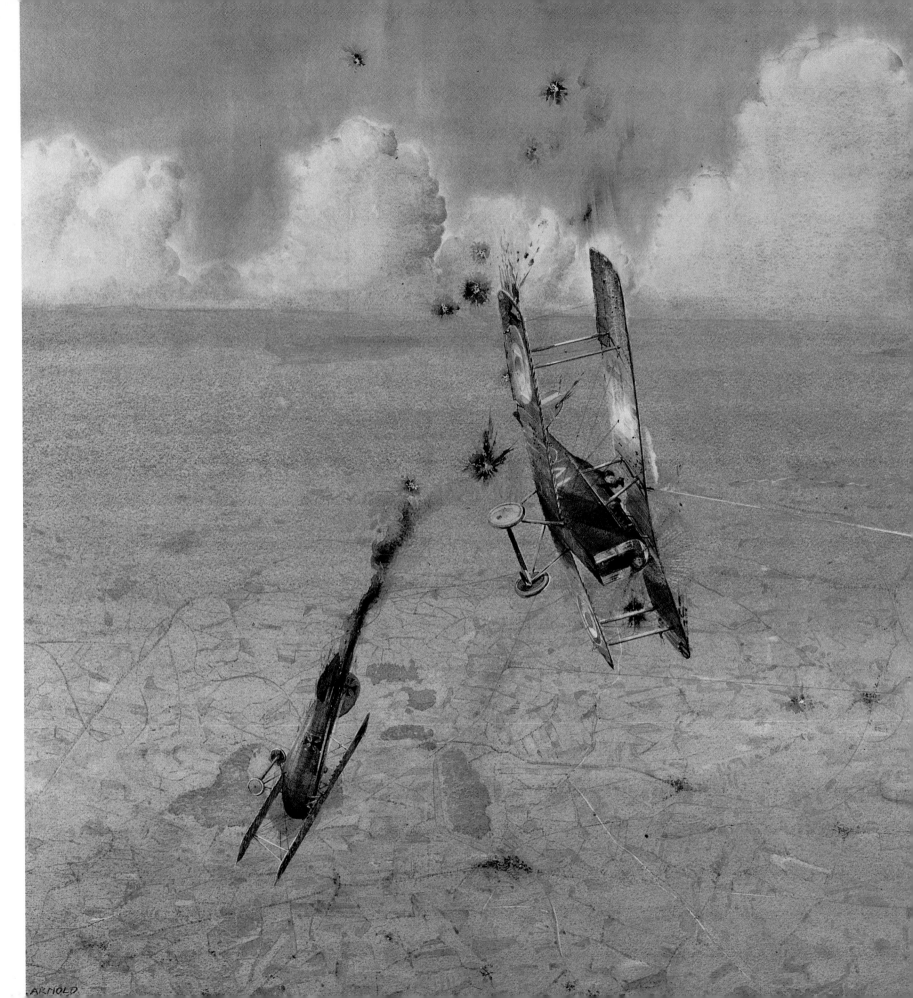

ARNOLD

WORLD WAR I

The last flight of Captain Ball, V.C., D.S.O., M.C.

Norman G. Arnold

When Arnold painted this picture in 1919, no one had been able to explain fully the fate of Captain Albert Ball, the R.A.F.'s first air hero and recipient of his country's highest award for gallantry — the Victoria Cross — as well as the Distinguished service Order and two bars, and the Military Cross. On May 7, 1917, Ball's No. 56 Squadron intercepted the famous Jagdstaffel II, commanded by Luther von Richthofen, over Douai in France. The squadron was badly split up and suffered heavy casualties. Undaunted, Ball continued to pursue the German aircraft. In fading light they flew through some cloud, and when they emerged one of Ball's flight commanders, Captain Billy Crowe, saw the daring young ace chasing an enemy machine. The German aircraft disappeared into cloud, closely followed by Ball. He was never seen alive again. When Arnold executed this painting, Ball's fate remained a mystery. Later it was found that he was brought down by a machine gun mounted on the tower of a church.

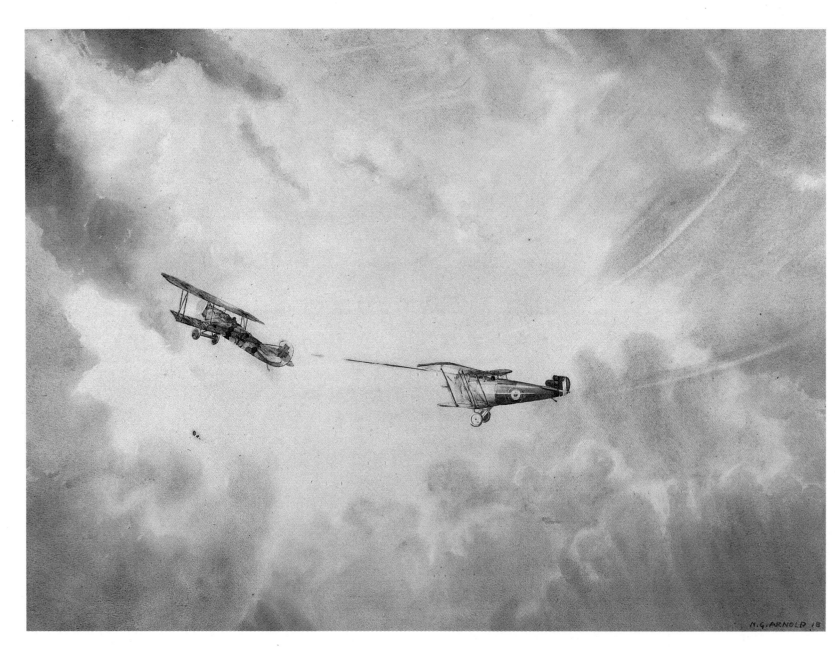

Over-shooting

Norman G. Arnold

Most of the maneuvers in early air combat were designed to place the enemy in front of the attacker's guns and give him a target. One of the main ways of achieving this was to dive from a high altitude on an unsuspecting foe. Here, a German pilot has dived too fast on a British Scout, over-shot, and has found himself on the receiving end. For pilots fresh from a few brief weeks of flying training, the skies over the Western Front could be a hard classroom. The average survival rate for R.F.C. recruits over France in early 1917 was a mere twenty-three days.

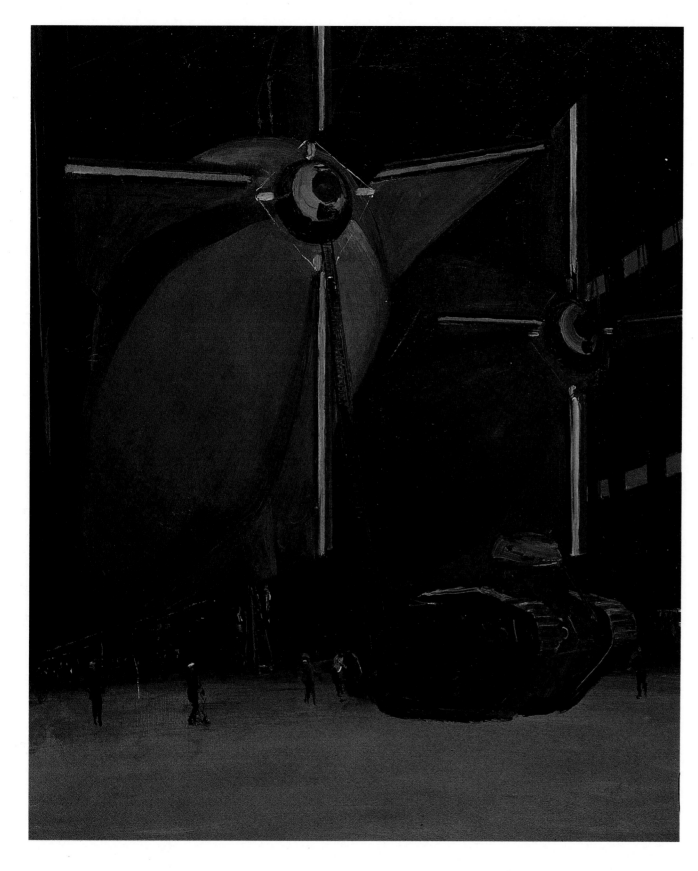

Rigids at Pulham, 1918

Sir John Lavery

Unlike Germany, Britain only adopted rigid construction airships towards the end of the war and, even then, only in very limited numbers. In 1914, the Royal Naval Air Service took control of all service airships and numbered them from '1' with the prefix 'R' for rigid. These R23 machines are pictured in their hangars at Pulham St. Mary in Norfolk, during their very limited operational careers. The machine in the foreground is used for maneuvering the airships on the ground.

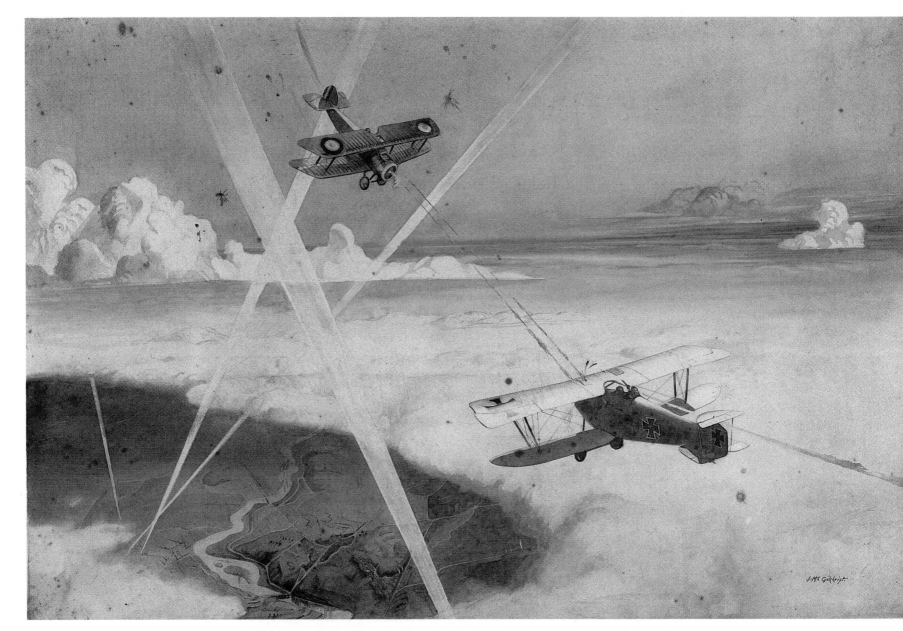

**Above the cloudfields of the sky —
Sopwith Camel attacking a Hannoveranger biplane**

J. M. McGilchrist

The Sopwith Camel was the most successful fighter of World War I, and its pilots claimed over 3,000 victories. It first flew in 1916 and first saw combat in June 1917. No. 70 Squadron was the first R.F.C. unit to receive the Camel, and it proved an immediate success. Maneuverable and agile, it was armed with two fixed 0.303 in. forward-firing machine guns and by the end of the war the Camel equipped nineteen squadrons on the Western Front. This painting is a good example of how artists were fascinated by the new medium of combat above the clouds, high above the landscape.

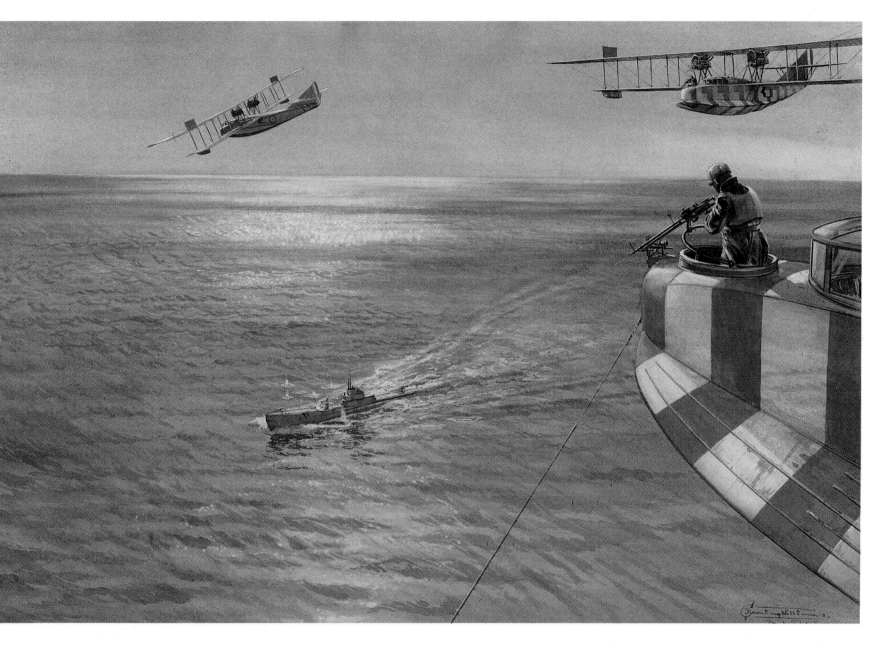

Flying boats machine gunning a crippled German submarine

C. R. Fleming-Williams

This painting shows Royal Navy Air Service Felixstowe F2A flying boats attacking a German U-boat. Credit for the extremely successful series of Felixstowe aircraft can be attributed to Commander John C. Porte, one of the pioneer pilots of the R.N.A.S. Porte improved upon an earlier American design and the F2A became the standard British flying boat of the war. The aircraft are seen in the disruptive camouflage scheme adopted by the R.N.A.S. later in the war.

An Aerial Fight

Louis Weirter

This stunning, stylized image of a dogfight over the Western Front was painted by Louis Werter (1871-1932) in 1918.

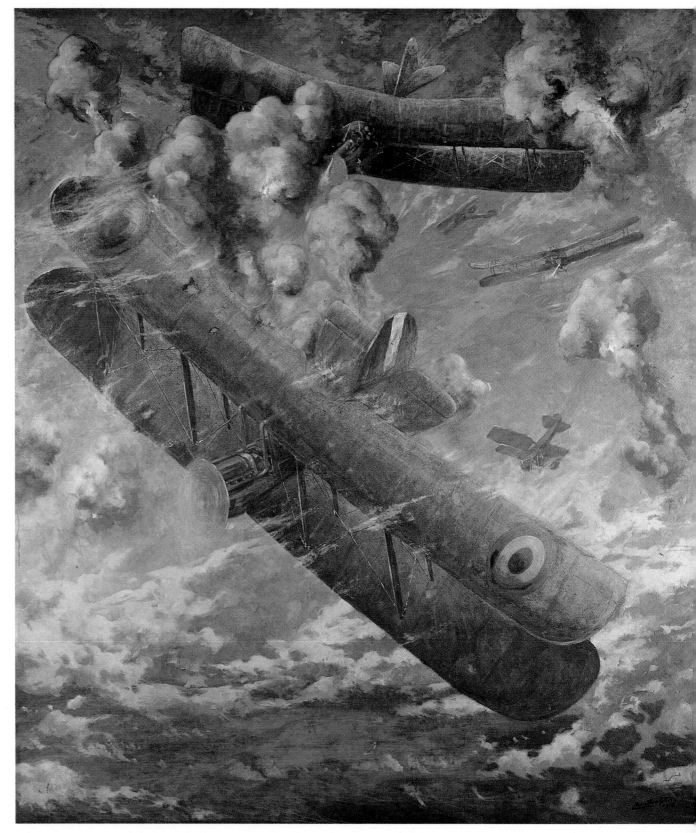

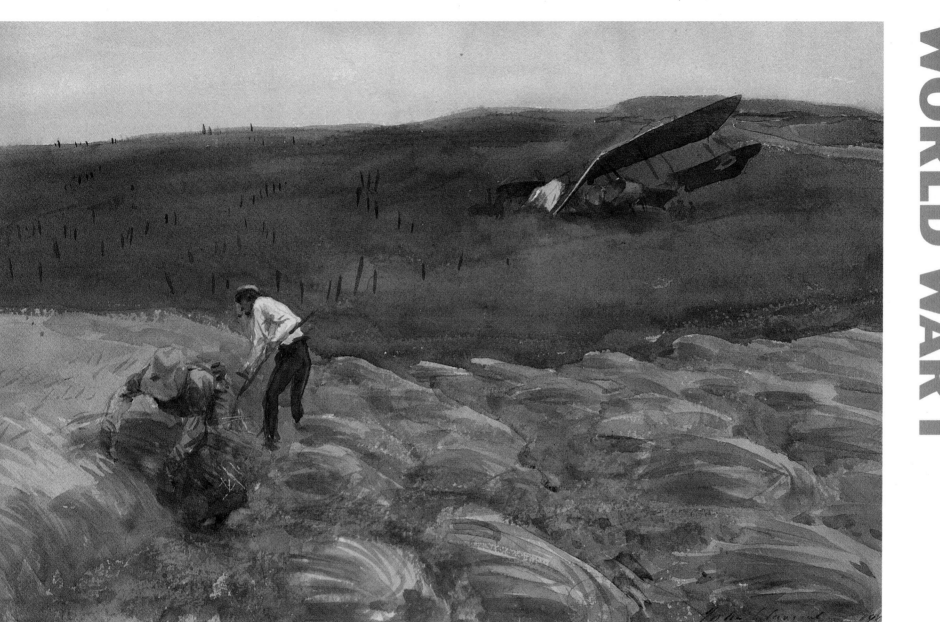

A Crashed Aeroplane

John Singer Sargent

Best known for his portrait paintings, Sargent seems a strange choice for a war artist — but the gallery dedicated to his work in the Imperial War Museum in London shows his great skill. This is exemplified by his monumental "Gassed," showing a line of soldiers on the Western Front, blinded after a gas attack, and in the more subtle painting shown here. The carnage of war is brought home in this work, which contrasts the peaceful rural idyll of the harvest laborer with the wreckage of a British aircraft. John Singer Sargent (1856-1925) painted the scene in 1918. An American citizen by birth, he was persuaded to record the conflict for posterity by the British War Memorials Committee.

Right:
An Attack on a German Troop Train

Bertram Sandy

Bertram Sandy's 1918 watercolor shows a scene more associated with World War II than World War I. However, ground-attack missions became increasingly popular in the latter stages of the Great War. The aircraft pictured appear to be Sopwith Camel.

Far right:
The Sea of Galilee: Aeroplanes attacking Turkish boats, 1919

Sidney Carline

In August 1915, the Royal Naval Air Servcice made the first successful torpedo attack on a ship from the air when Flight Commander C. H. K Edmunds, R.N., dropped a 14 in. torpedo to sink a 5,000 ton Turkish military transport in the Sea of Marmara. Arnold's post-war painting shows three aircraft diving into the attack, with the Jordan river lower left, and snow-capped Mt. Hermon rising above the clouds at upper right.

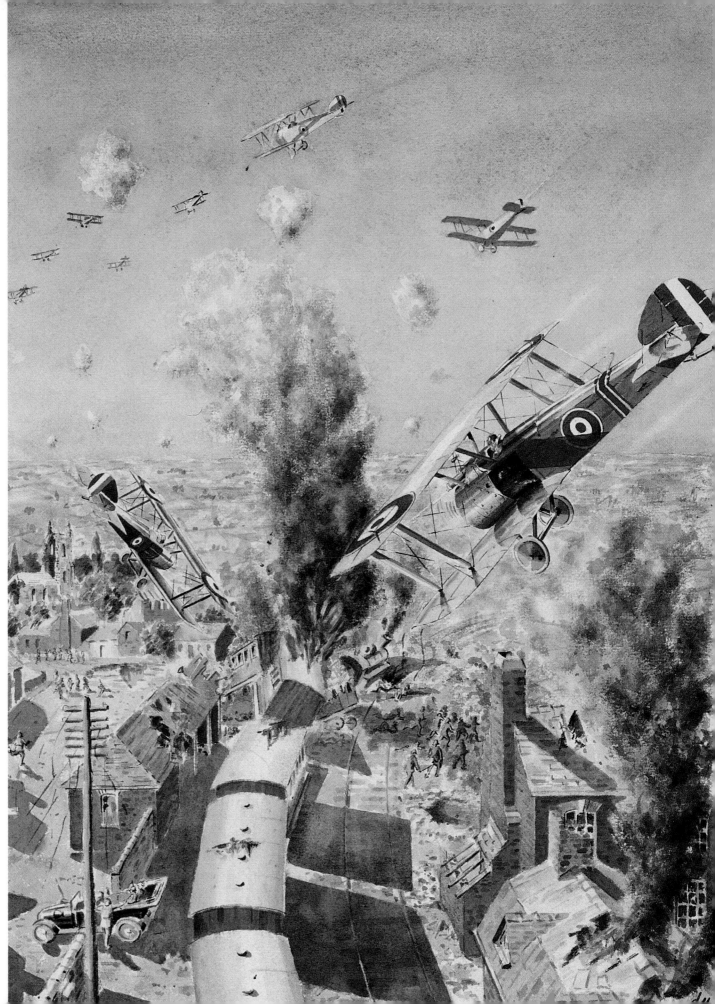

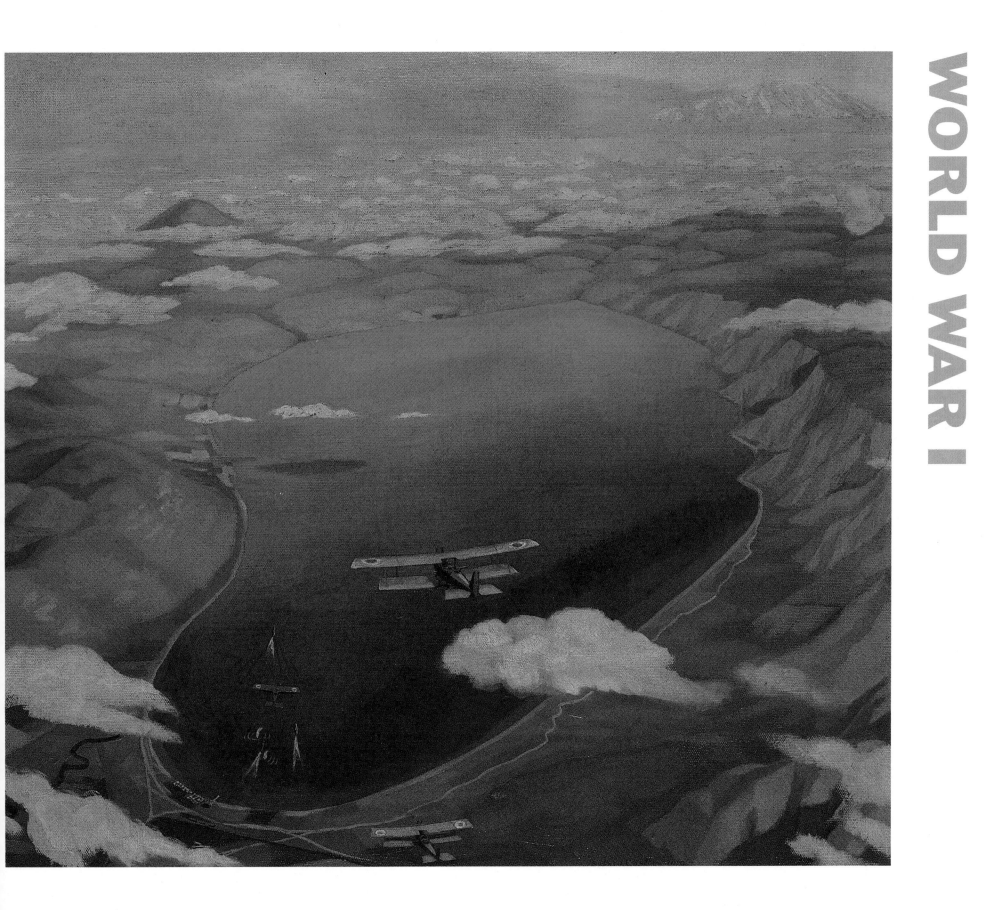

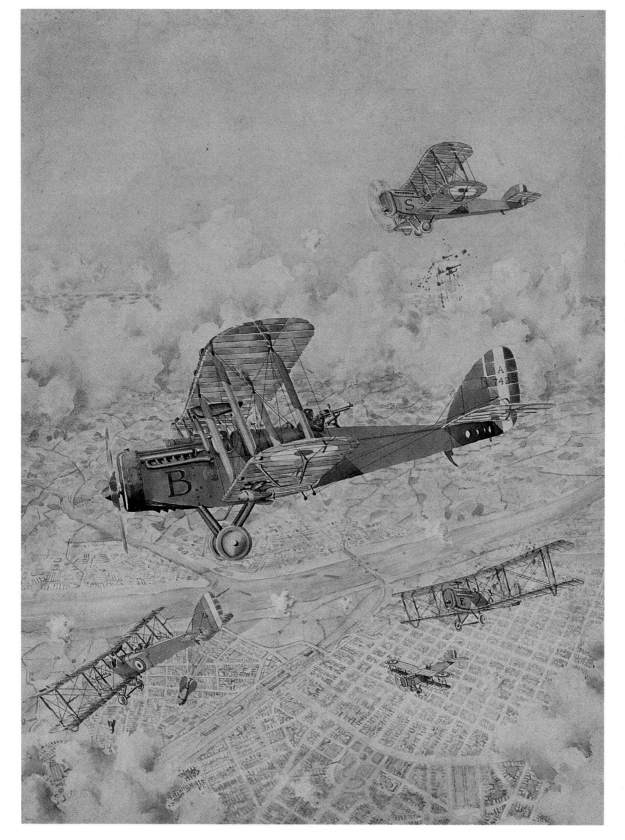

The first British raid over Mannheim, December 24, 1917

Bertram Sandy

Christmas Eve, 1917, and a flight of Airco DH4s arrive over Mannheim to deliver their deadly load. The Air Board decided to increase the strength of the Royal Flying Corps in mid-1917 in response to daylight raids by German aircraft on London. Large numbers of the excellent DH4 were ordered to equip new squadrons. The aircraft is widely considered to be the finest day bomber of World War I.

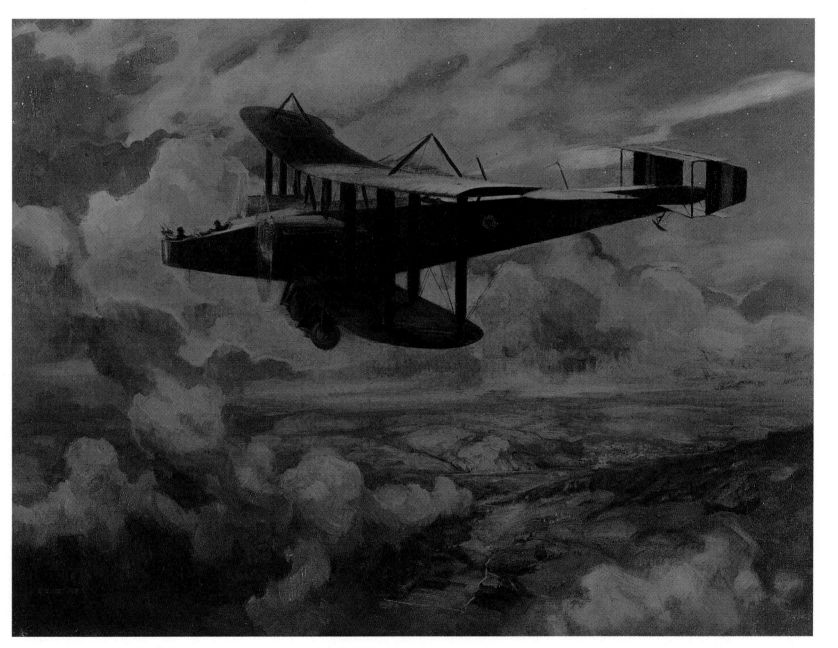

Bombing Nabulus by Night

Stuart Reid

Britain's failure to construct an effective heavy bomber in the years prior to the war was remedied in 1916 with the introduction of the Handley Page 0/100. This aircraft had been ordered, designed, and constructed with the precise aim of reaching and bombing Germany. The 0/100 and the improved Handley 0/400 were used for the remainder of the war for systematic bombing of military targets. The giant 0/1500 was developed too late to see wartime service, but can be regarded as the first truly strategic bomber. Here, one of the giant Handley Page bombers flies over the darkened desert having bombed Nabulus, some thirty miles north of Jerusalem.

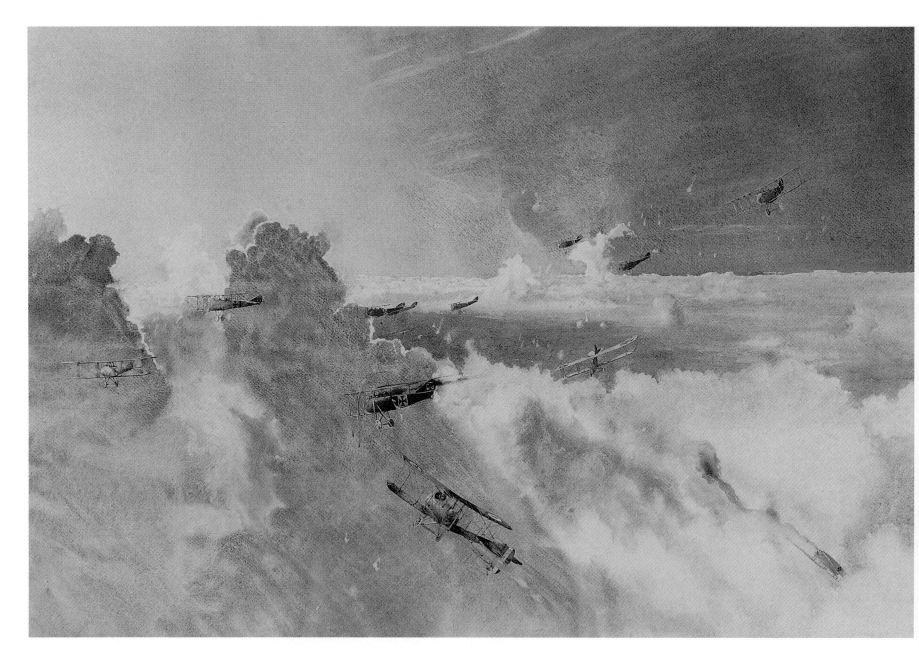

Colonel L. W. Brabazon Rees Winning the V.C.

Norman G. Arnold

On July 1, 1916, Major (later Colonel) L. W. Brabazon Rees, commanding No. 32 Squadron, R.A.F., attacked ten German bombers in a single-seat Airco DH2 scout. Although wounded, he continued to attack until the Germans abandoned their mission. This was a not inconsiderable act of bravery considering the tricky handling characteristics of the DH2, with its Gnome Monosoupape pusher engine. Airco built 400 of the high-performance fighter which first flew in July 1915. Brabazon Rees received his country's highest award for gallantry, the Victoria Cross, for this action.

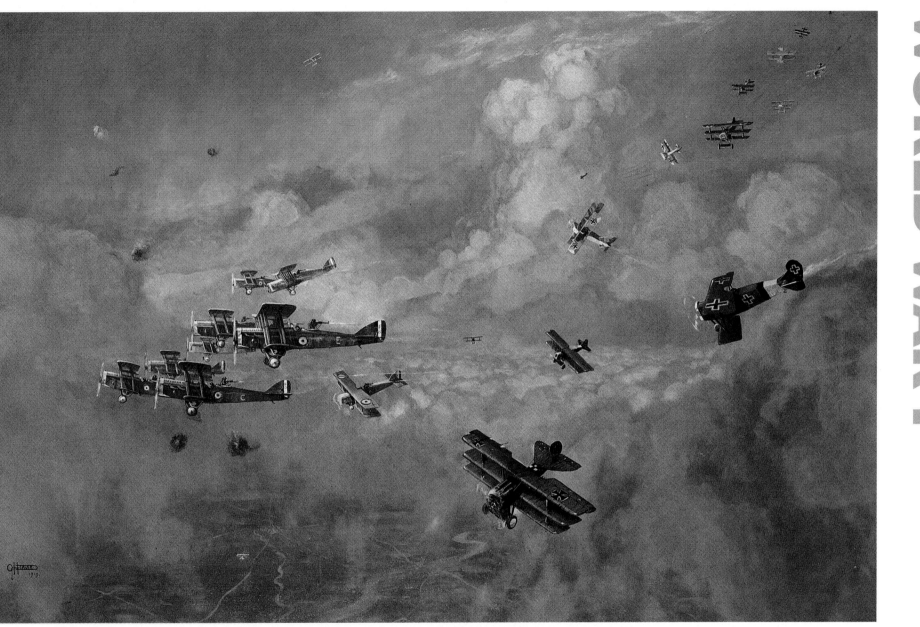

Closing Up

George Horace Davis

The Airco DH4 was designed by Geoffrey de Havilland around an Air Ministry request for a new day bomber and was the first British aircraft to be designed for such purpose. Almost 6,300 DH4s would be built — 1,449 for the British and most of the others built as DH4As in the United States under licence — 1,885 served with the U.S. Army Air Service and U.S. Navy. The most controversial feature of the bomber version was the wide separation between the pilot and observer, which made it difficult for the two to communicate. This formation of DH4s is closing up so that the aircraft can better protect themselves with overlapping fields of fire, a tactic also used to effect during World War II. The attacking aircraft are Fokker Triplanes.

.British Maurice Farman attacked by a German Fokker while dropping sacks of corn on Kut-el-Amara during the siege of 1916

Sydney W. Carline

Seen over the brown waters of the Tigris river with two large sacks of corn falling towards the flat roofs of Kut-el-Amara below, this Farman F-40 is being engaged by a Fokker Eindecker. The F-40 two-seater, powered by a 160 h.p. pusher propeller, was designed in 1915 by the French Farman Brothers. The Royal Naval Air Service took a few of a reconnaissance/light bomber aircraft that lacked rear armament. It would be easy prey for the Eindecker. The Fokker aircraft had been rejected by the British in 1913, the experts considering it "badly made." Fokker, a Dutchman, threw his lot in with the Central Powers, who put his M5 monoplane into production. Fitted with machine gun interrupter (synchronisation) gear and with a number of revisions, the Eindecker became the scourge of the Royal Flying Corps during 1915.

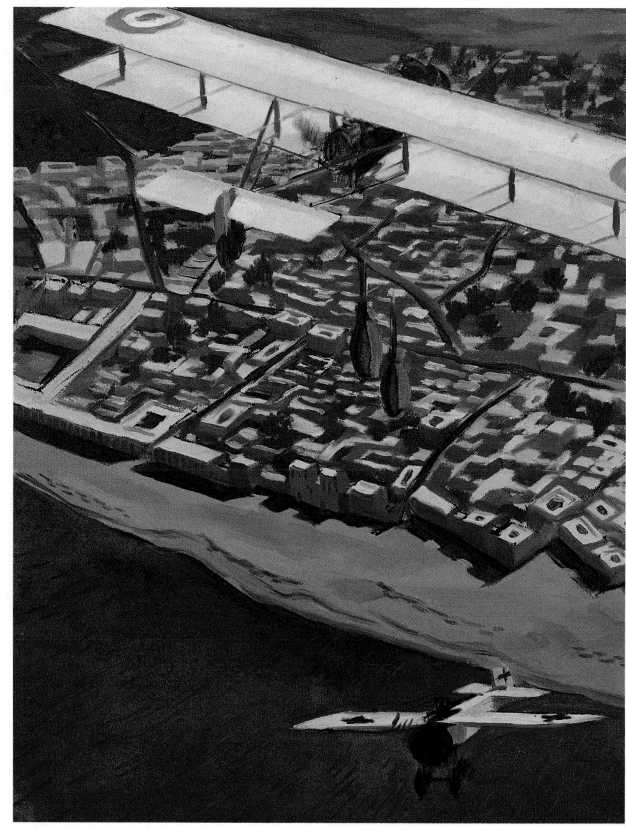

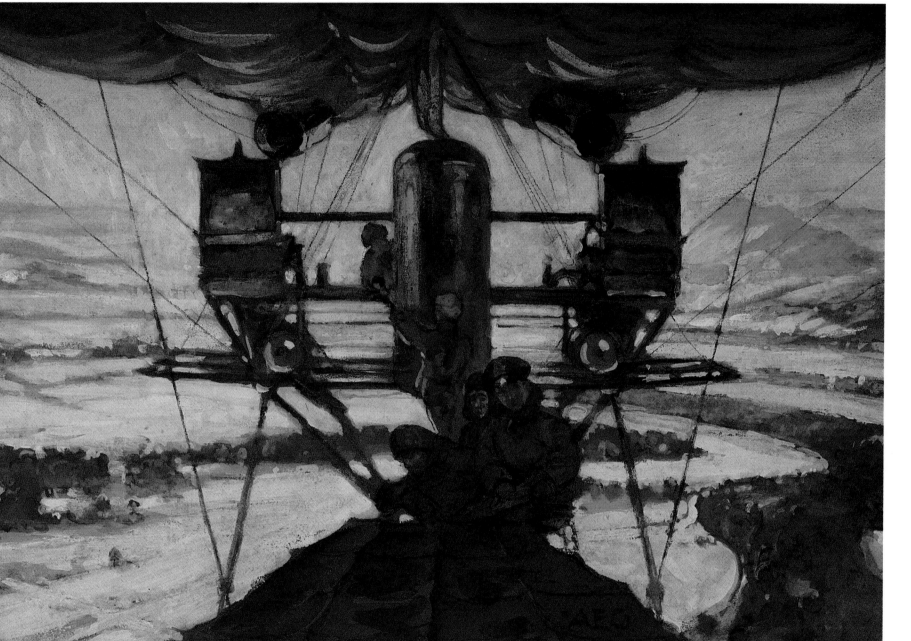

An NS Starting for a Patrol over the North Sea from East Fortune

Alfred Egerton Cooper

This unusual view from the observation car of an NS (North Sea type) airship, demonstrates the hardiness of the early aviators, who sat in a BE2C aircraft fuselage attached as a cockpit for anything up to fifty hours. Proceeding at a stately fifty m.p.h., these blimps — probably the finest airships produced by Britain during the war — searched the North Sea for enemy shipping and submarines, escorted convoys, and liaised with naval vessels.

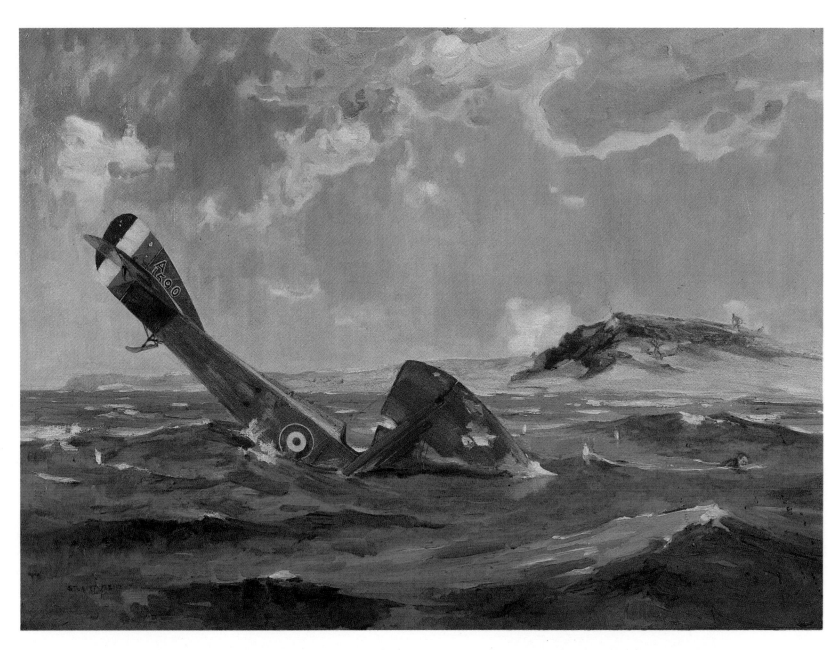

The Seward Exploit

Stuart Reid

Rigid 29 and NS7 at East Fortune

Sir John Lavery

On March 24, 1917, 2-Lt. W. E. L. Seward, M.C. was on a photographic mission over Ramleh, near Jaffa, in Palestine when his Martinsyde Scout was brought down by anti-aircraft fire. He flew the Scout into the sea and, under heavy fire, he swam further out from shore. The Turks believed him drowned, but after over four hours swimming and a walk of 25 miles, Seward — an Olympic swimmer — eventually reached Allied lines.

A fellow of the Royal Academy, Lavery focused his attention on the airship. Here he pictures both rigid and semi-rigid types in one of the giant sheds at East Fortune.

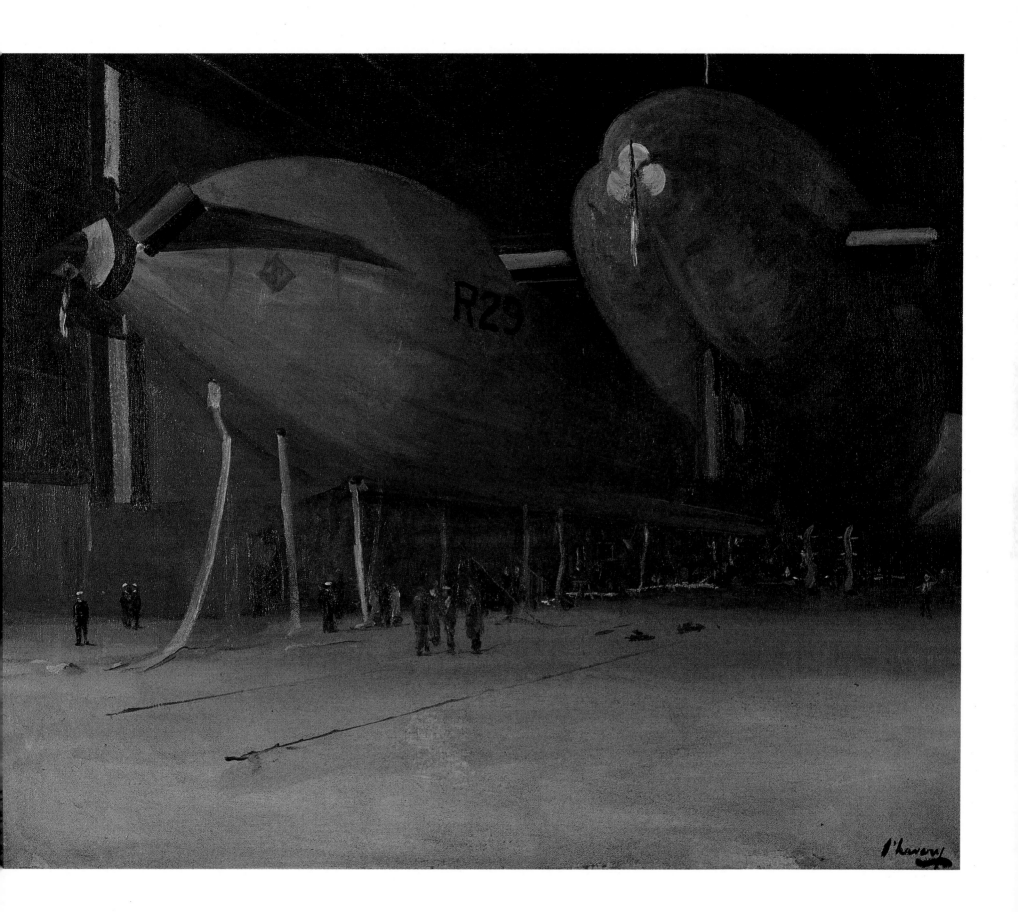

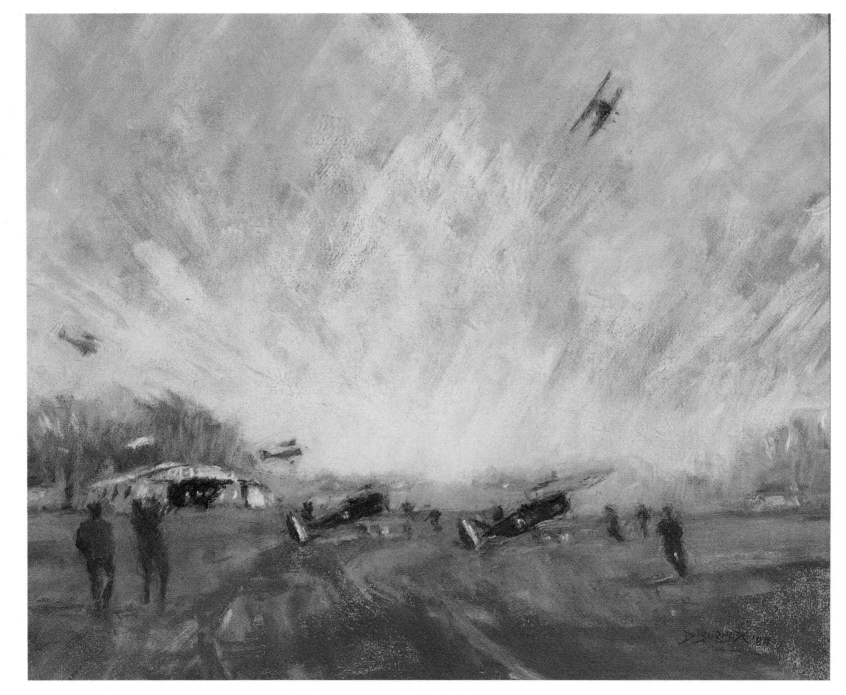

Summer 1917

Dudley Burnside

Matched, but not bettered, by the Fokker DVIIs which arrived at the front in the summer of 1918, the SE5 and SE5A proved to be just the aircraft that the Royal Flying Corps needed to improve its fighting record in 1917. This scene, painted by World War II pilot Dudley Burnside, D.S.O., O.B.E., D.F.C.s, shows a squadron doing circuits, training new pilots.

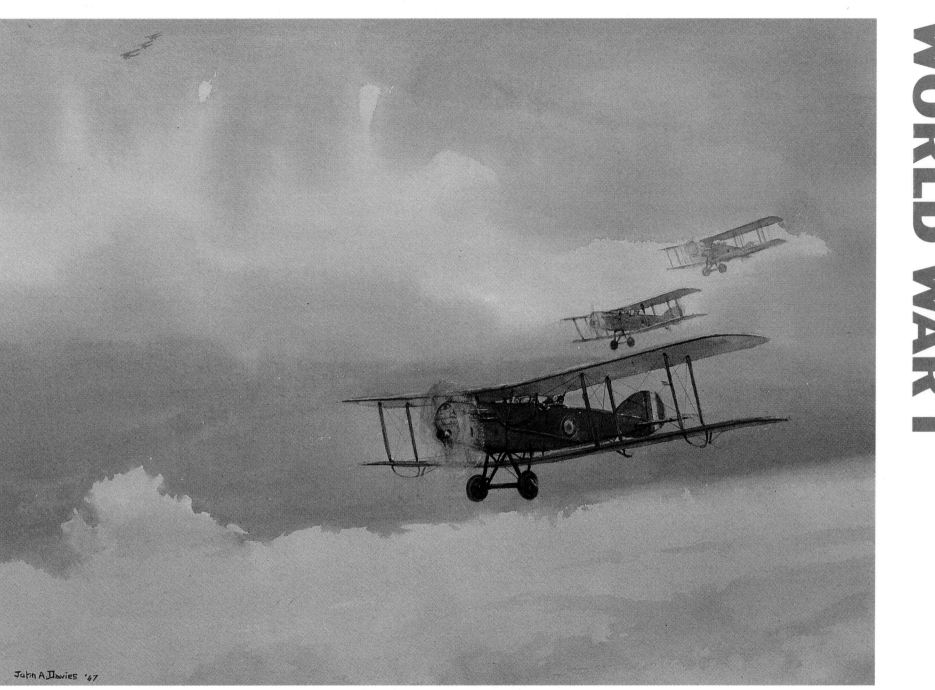

John A. Davies '47

Bristol Fighters, Western Front, 1918

John A. Davies

The Bristol F2 Fighter was a two-seat biplane introduced into action at Arras in 1917. That day it would have been hard to believe that it would go on to become the most successful of its type on the Western Front, as four of of the first six were shot down by von Richthofen's pilots. Over 3,000 were built, and from July 1917 it was the mainstay of all British reconnaissance units.

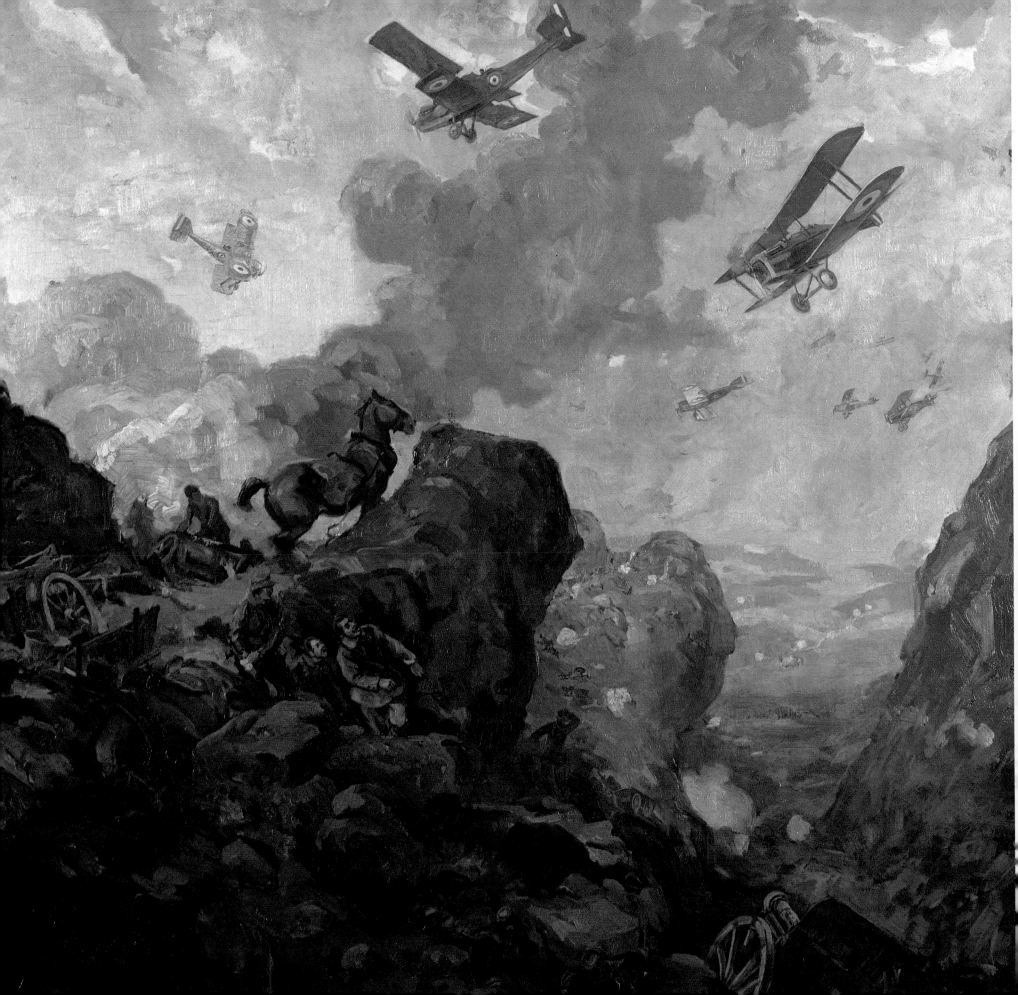

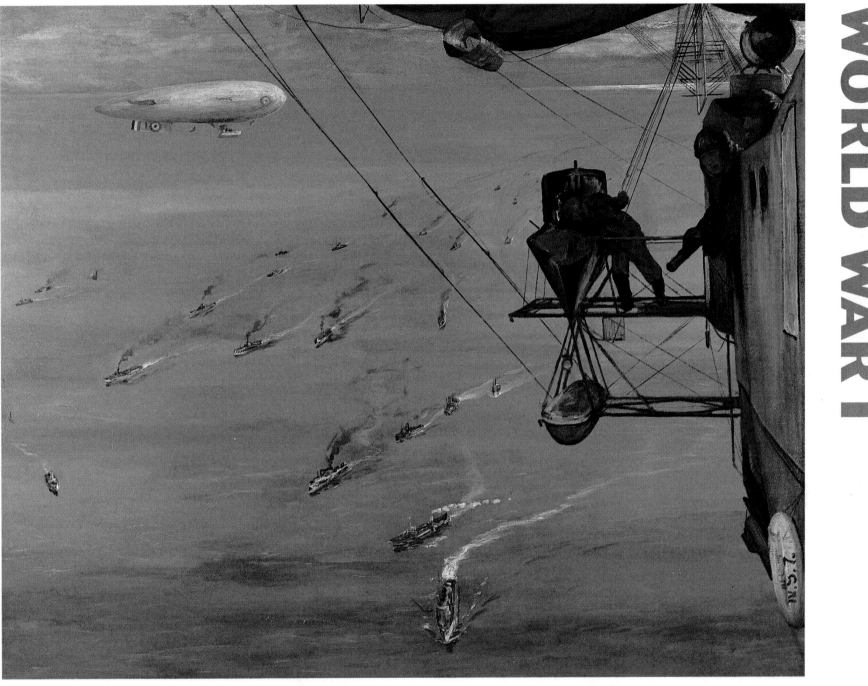

The Bombing of the Wadi Fara, September 20, 1918

Stuart Reid.

Reid's delightful use of color comes to the fore in this depiction of British aircraft bombing a narrow gulley (wadi) in Palestine.

A Convoy, North Sea, 1918

Sir John Lavery

This was painted from NS7 off the coast of Norway, one of sixteen NS class airships constructed 1917-18. They provided invaluable service escorting convoys.

43

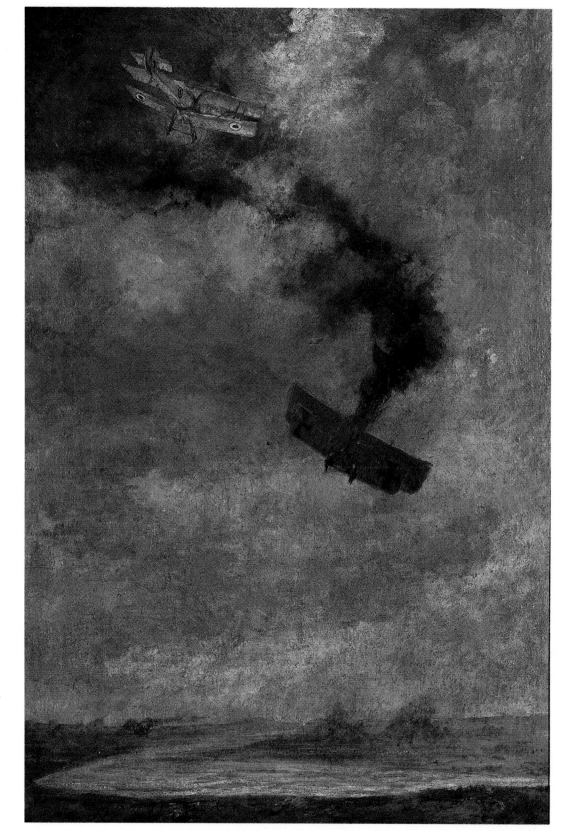

British Nieuport Scout destroying an Enemy Biplane in Italy

Mario Barberis

When Italy joined the war on the side of the Entente Powers, it presented British and French squadrons with the ability to base aircraft in a key strategic position in Southern Europe. Much combat was seen over the Adriatic and northern regions of the country. Mario Barberis, a contemporary painter, captured this scene in oil. Many hundreds of Gustave Delage's Nieuport scouting aircraft served with the Entente Powers, and the Type 17 was the chosen mount of famous aces such as Nungesser, Gunmeyer, Ball, and Bishop.

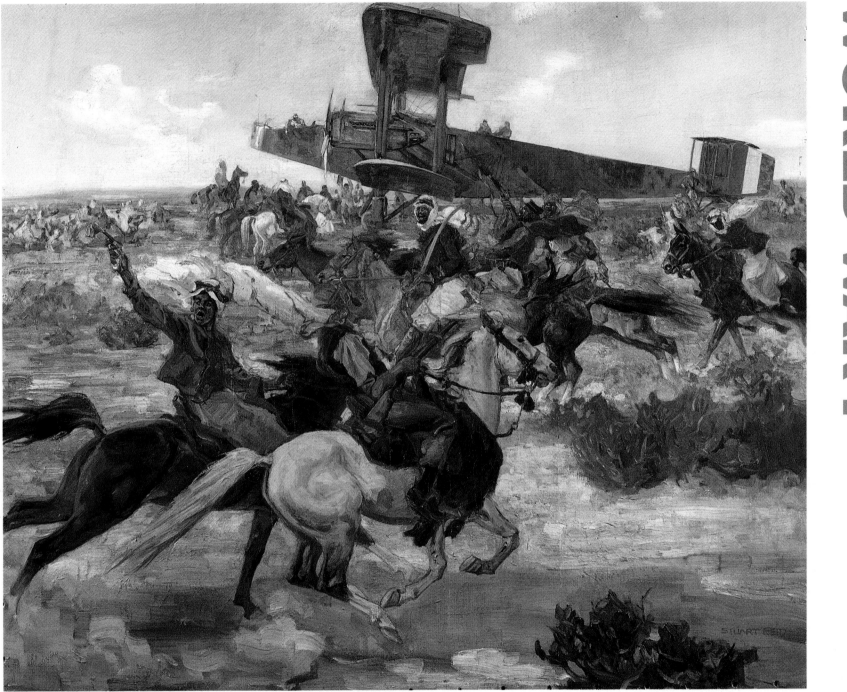

Deraa. The Arab welcome to the first Handley Page machine to arrive in Palestine, September 22, 1918

Stuart Reid

The Handley Page 0/400 caused a sensation when it was deployed in Palestine. As it landed — bringing stores of petrol and munitions for two Bristol Fighters based with the Sherifan forces — it was surrounded by mounted troops.

Left:
Lieutenant Warneford's Great Exploit

F. Gordon Crosby

Over Ostend in Belgium, Flight Sub-Lt. Reginald Warneford scored the first victory for the R.N.A.S. over the Zeppelins. Patrolling in his Short biplane, he spotted LZ37. He raked the German craft with machine-gun fire, sending it plummeting to the ground. Miraculously, the helmsman survived after falling through a convent roof onto a bed! For this action Warneford was awarded the Victoria Cross.

Far left:
The Bott Incident

Stuart Reid

Reid had a particular fondness for unusual events, and for depicting air operations in the Middle East. His favorite medium was oil on canvas. Many of his works are held and displayed in rotation by the Imperial War Museum in London.

Captain Alan Bott was a well known and popular author of books on flying. While on a reconnaissance mission over Palestine he crashed his Nieuport Scout. Local Arabs arrived on the scene and started looting the machine, threatening the pilot. They are seen hurriedly escaping as Turkish troops arrive to investigate.

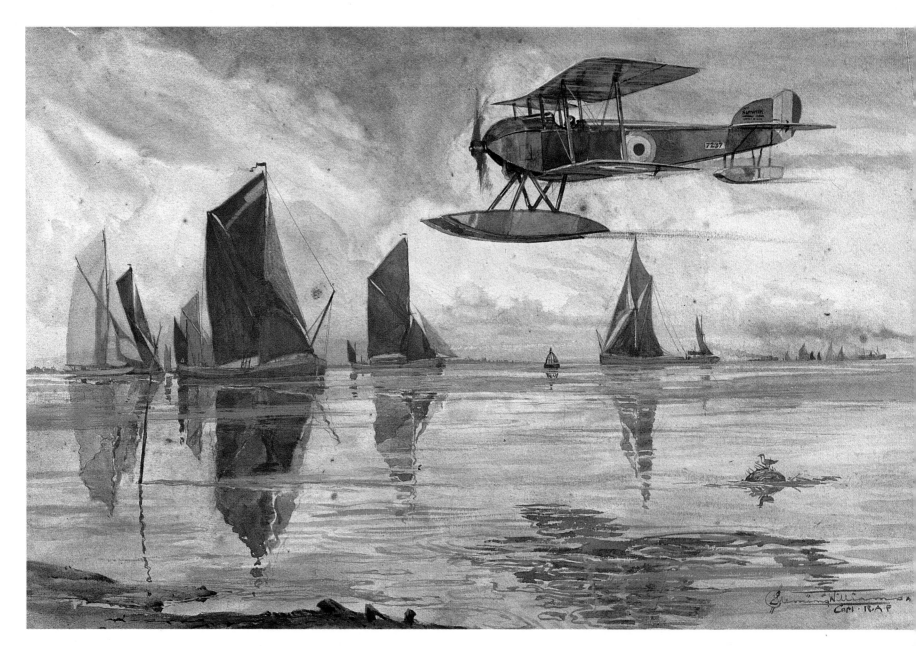

Sopwith Scout

C. R. Fleming-Williams

Before terms such as "fighter" or "reconnaissance" were used, there were "scouts" and this scout is, in fact, a Sopwith Tabloid, the first single-seat scout to go into production, in early 1914. It was used by both R.F.C. and R.N.A.S. One Tabloid — 3734 — was fitted with floats and won the Schneider Trophy in April 1914, in the process becoming the first in a line of Sopwith naval scouting aircraft. Of artistic interest is Fleming-Williams's bold use of watercolors, juxtaposing the ship of the air with the Thames barges. The scene was almost certainly painted on the Thames Estuary, common ground for both types of machine.

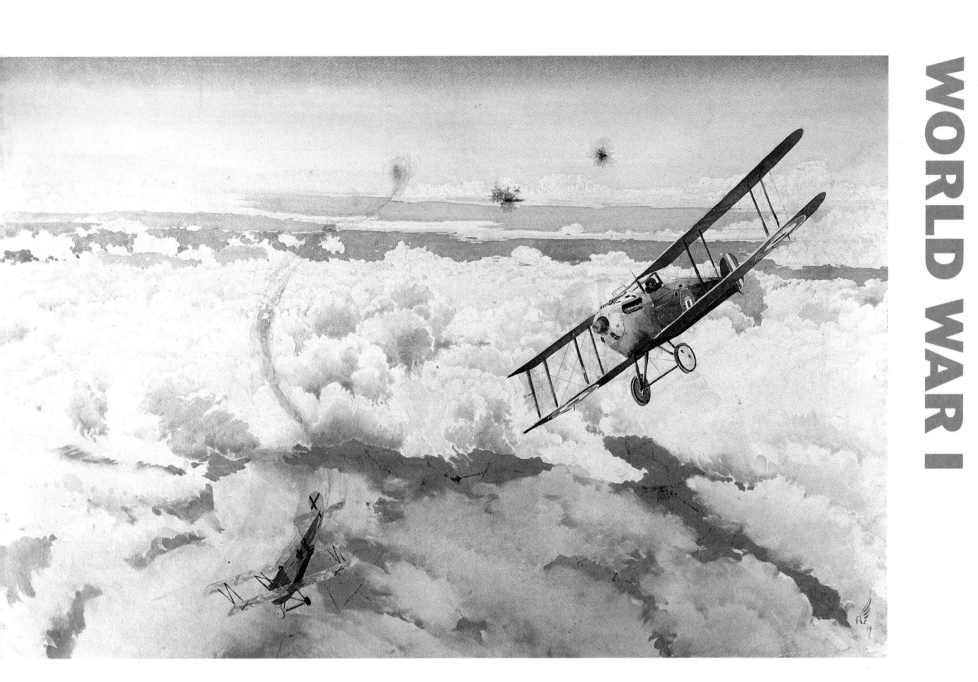

A Fokker Biplane attacked by a Sopwith Dolphin

Norman G. Arnold

The Dolphin was designed to give its pilot the best possible field of view and he was, indeed, afforded great upward and all-round vision by merit of having a low-mounted upper wing. However, this was not enough to endear it to the pilots who flew it. The back-staggered wing produced unusual stall characteristics, and the pilot's exposed position could prove fatal if the aircraft nosed over onto its back after a heavy landing. Nevertheless, despite its problems, over 1,500 were built during the war and a Mark II was under development when the Armistice came.

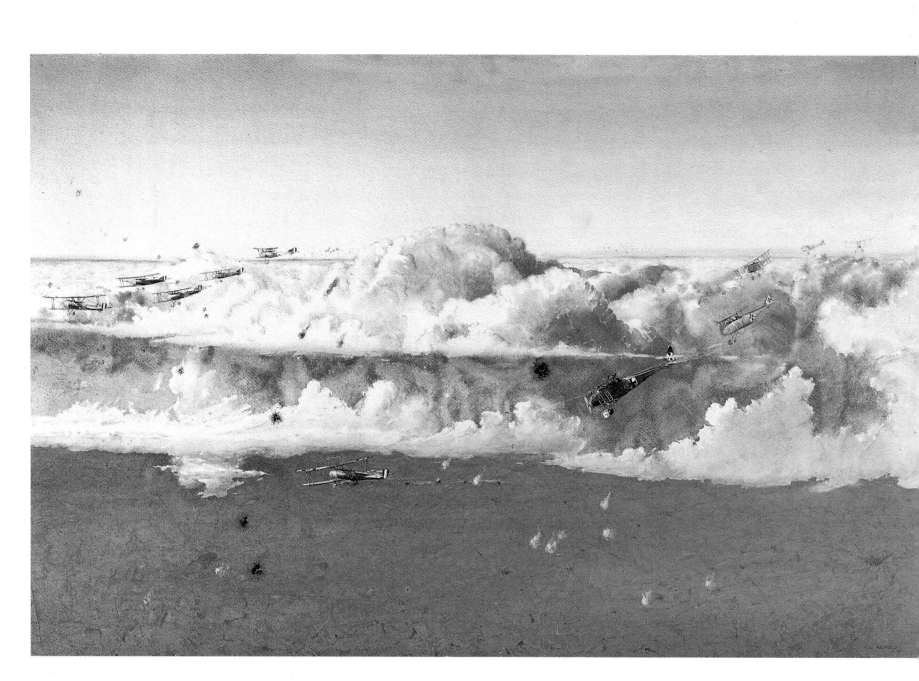

The Straggler

Norman G. Arnold

The aircraft in this painting are Sopwith 1½ Strutters of the R.F.C. and German Halberstadts. The 1½ Strutter was the first aircraft to be designed from the outset with a synchronized machine gun, and also the first to equip a strategic bombing force. Two types were constructed during the war, the two-seat 9400 and the single-seat 9700. The Halberstadt concern was a subsidiary of Bristol before the war started and its family of D Types had a top speeds similar to the British aircraft.

Norman Arnold's painting shows a German aircraft, possibly a DIV, making an opportunist attack on a straggling British aircraft, which is probably returning from a bombing attack with engine trouble.

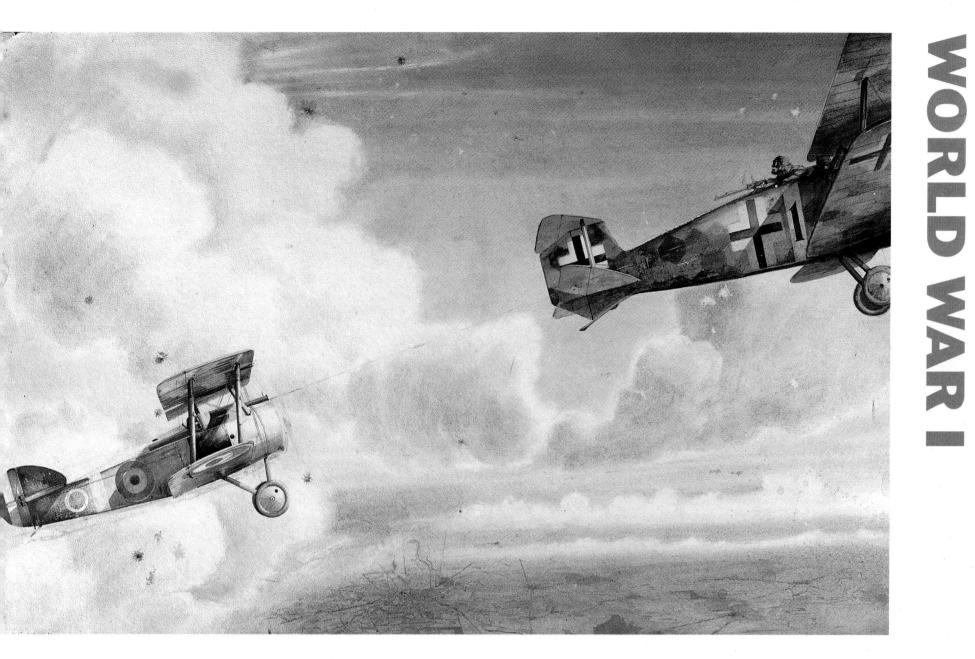

The Blind Spot: British Sopwith Camel and a German Hannover

Norman G. Arnold

By attacking from below and behind the Hannover, the British pilot in Arnold's painting has successfully obscured his Sopwith Camel from the German pilot's field of vision and made it more difficult for the rear gunner to acquire a target. He also has the advantage of having a lighter, faster aircraft. Although the Hannover (the aircraft pictured appears to be a CLIIIa) was a fine, agile, aircraft, designed for reconnaissance and ground-attack duties, the Camel was undoubtedly its superior. Indeed, it was one of the very best aircraft of the war.

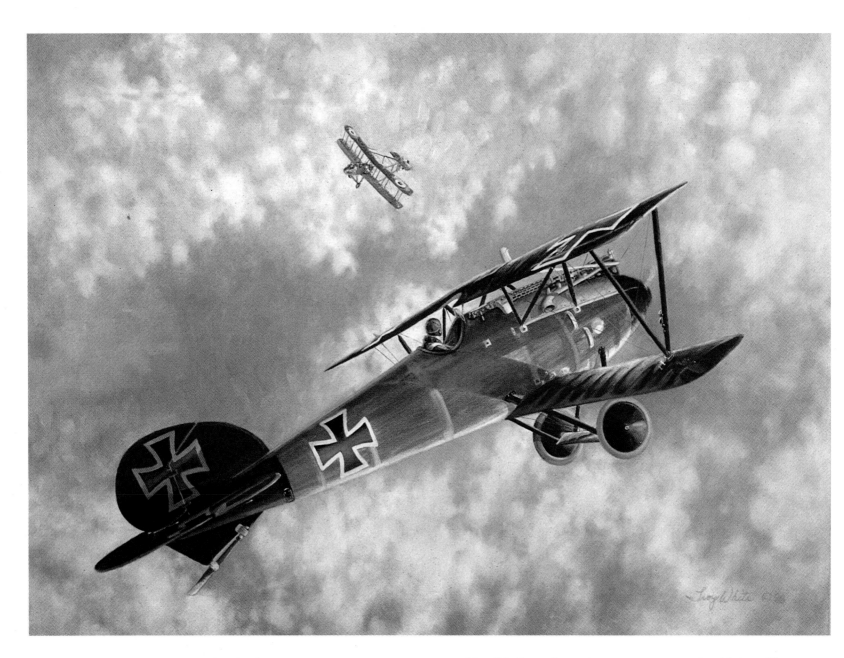

Von Richthofen

Troy White

The Red Baron needs no introduction. He was commander of the legendary Jagdstaffel II, the Flying Circus. Here, he banks his Albatros DV as his opponent from No. 20 Squadron, R.F.C., turns his FE2D towards him. Moments later, Von Richthofen was knocked out by a single round fired by observer/gunner A. E. Woodbridge. He came to in a near vertical dive and was able to make an emergency landing behind his own lines.

No. 56 Squadron Aces encounter the Flying Circus,

Hugh Polder

Following the desperate losses of "Bloody April" — Richthofen alone had scored twenty victories that month — while the R.F.C. supported the offensive at Arras, the arrival of the SE5 gave the British some parity in aircraft capabilities. White's painting shows one of the numerous encounters between the elite units during winter 1917.

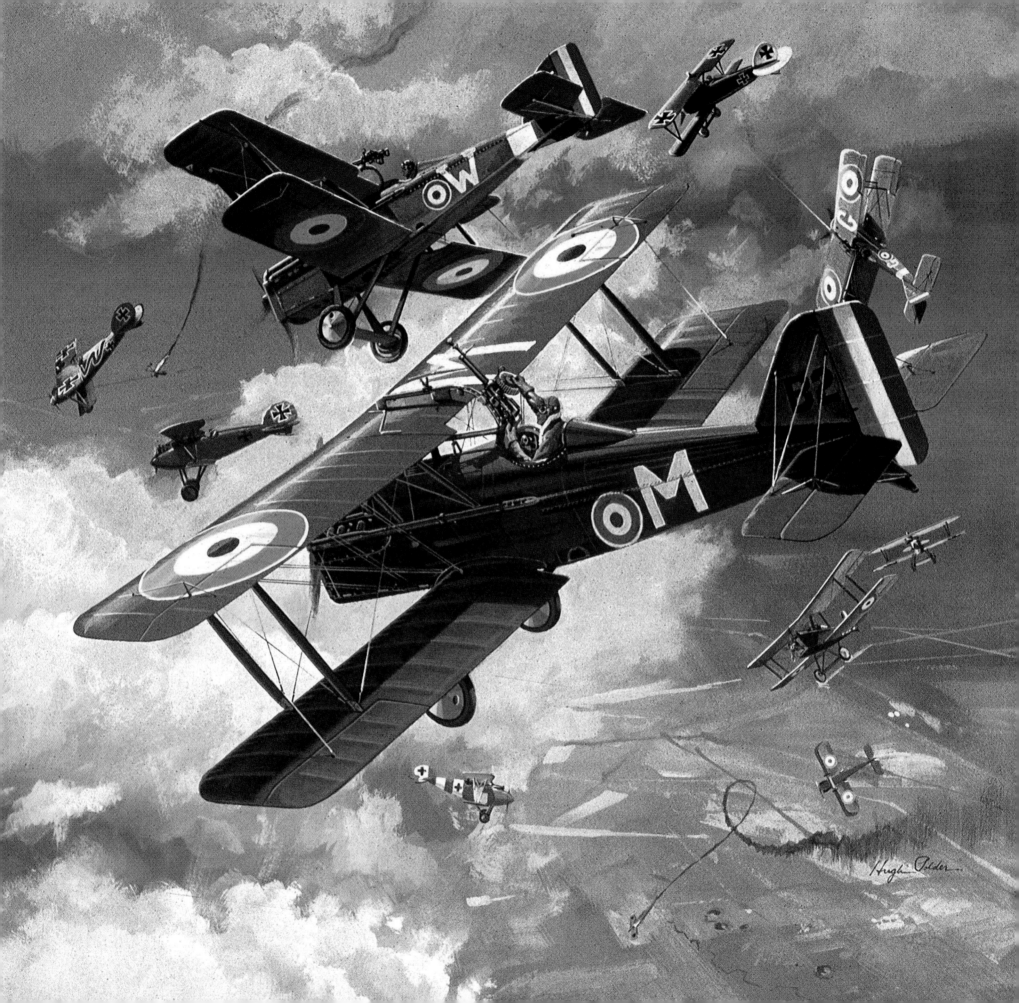

BETWEEN THE WARS

Number 2 Loses Station

A. Achard

The Hawker Demon was a development of the Hawker Hart and the first R.A.F. fighter since World War I to feature a second crew member — a rear gunner armed with a Lewis gun. Introduced in 1931, Demon manufacture moved to Boulton Paul's factory in Wolverhampton and from 1936 the aircraft were fitted with a Frazer-Nash hydraulic turret. It was the success of this aircraft that led Boulton Paul to produce the Defiant, also with a rear turret but considerably less successful. The painting shows Demons of No. 23 Squadron's A and C Flights — in April 1933 the squadron was the first to convert to Demons.

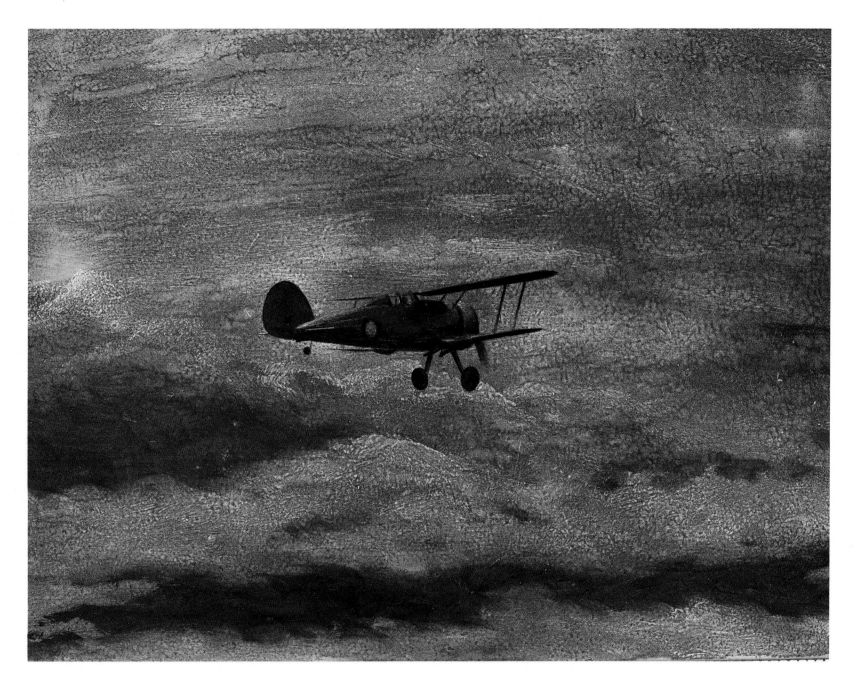

Left:
Bristol Bulldog

Waller

Above:
Gloster Gladiator

L. Williams

The Bulldog entered service with No. 3 Squadron, R.A.F., in June 1929 and would go on to become the R.A.F.'s most widely used fighter until the mid-1930s, 312 were supplied, equipping nine squadrons.

Disappearing into the sunset in Williams' evocative oil painting is the R.A.F.'s last serving biplane. The Gladiator entered service in 1937 and over 480 had been delivered to the R.A.F. by 1940 when production ceased.

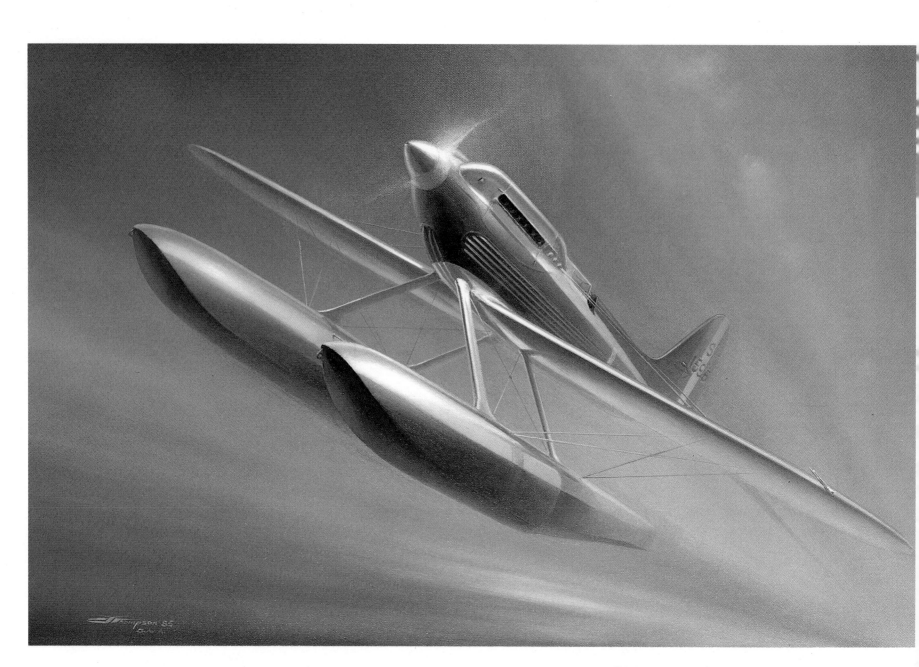

Above:
Supermarine's Speed Machine

Charles J. Thompson

Right:
The de Havilland Comet *Grosvenor House*

Norman Wilkinson

Supermarine S6B S1595 captured the Schneider Trophy for Britain on September 13, 1931. Flt. Lt. J. N. Boothman took the aircraft to a speed of 340 m.p.h. — later it would raise the record to 407 m.p.h. R. J. Mitchell's design would be a significant stepping stone on the momentous journey that ended with his design of the Spitfire.

Grosvenor House is seen winning the England-Australia Air Race in October 1934 when it flew the 11,300 miles in seventy hours fifty-four minutes, piloted by Charles W. A. Scott and T. Campbell. Norman Wilkinson is better known for his maritime paintings, but shows his ability in this remarkable portrayal of cloud.

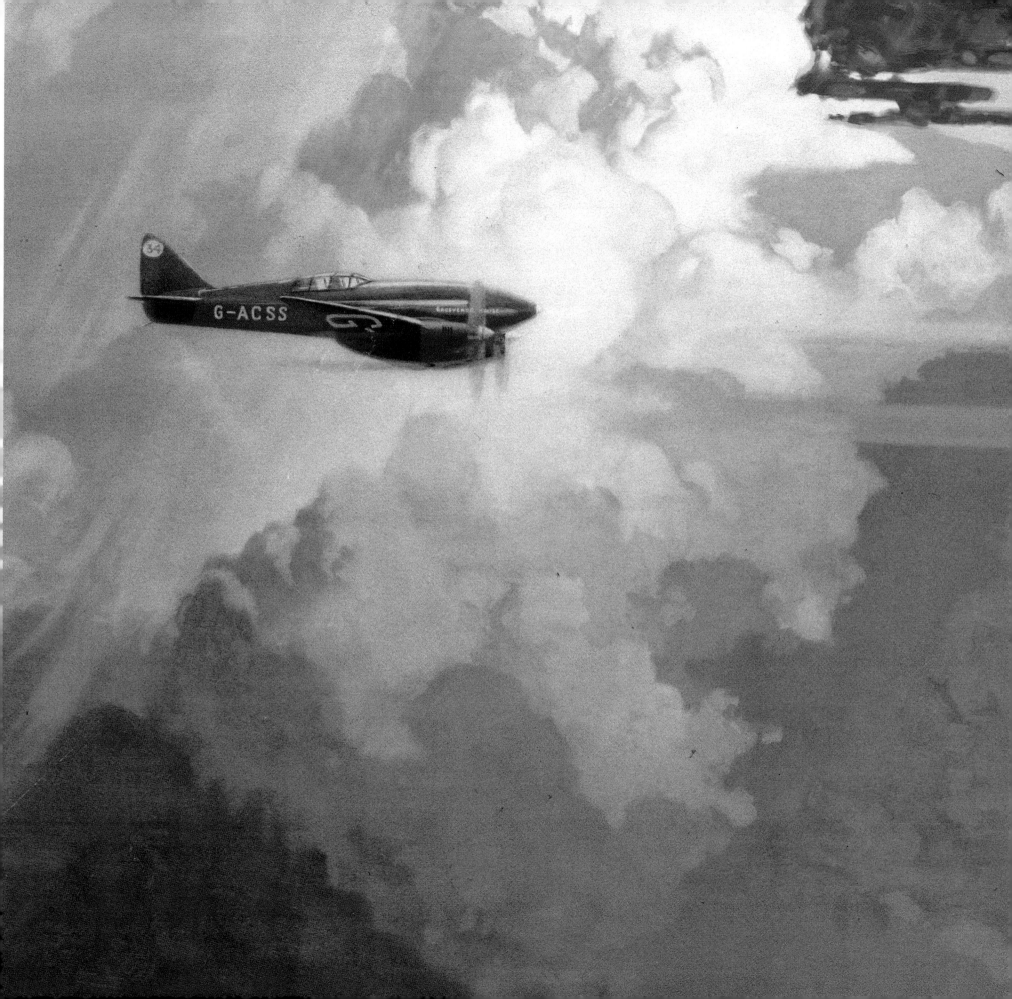

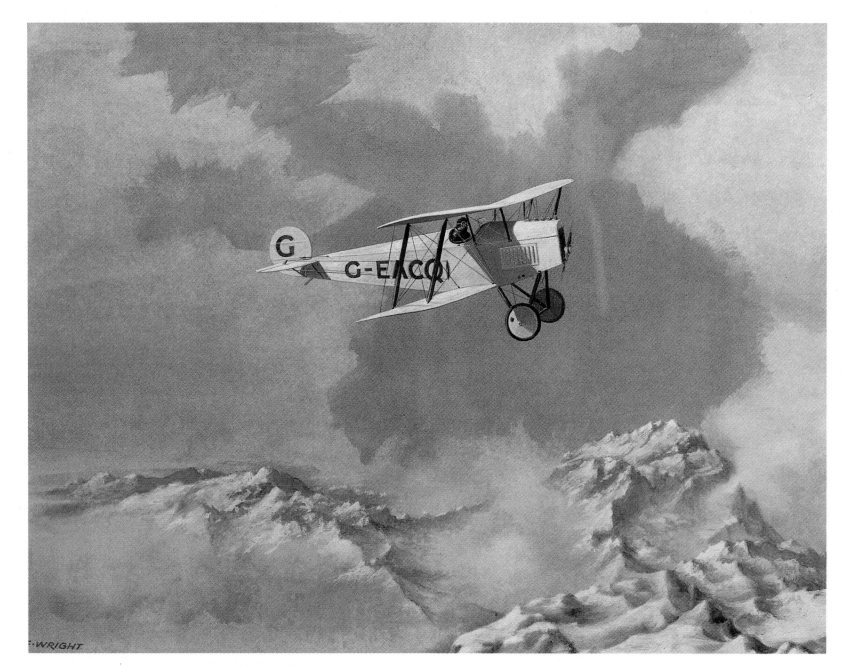

Avro Baby

G. F. Wright

One of the great names of British aviation, A. V. Roe & Co was established in 1910 and would go on to gain immortality during World War II with its Lancaster heavy bomber. This painting shows the 534 Baby (G-EACQ) over the Swiss Alps.

Oshkosh Aesthetics

Charles J. Thompson

The Curtiss-Wright Speedwing was built during the 1930s in very small numbers. The artist observed this lovely, rare, aircraft in 1989 at the annual airshow at Oshkosh, Wisconsin. Each August, Wittman Regional Airfield plays host to a fascinating variety of aircraft such as this.

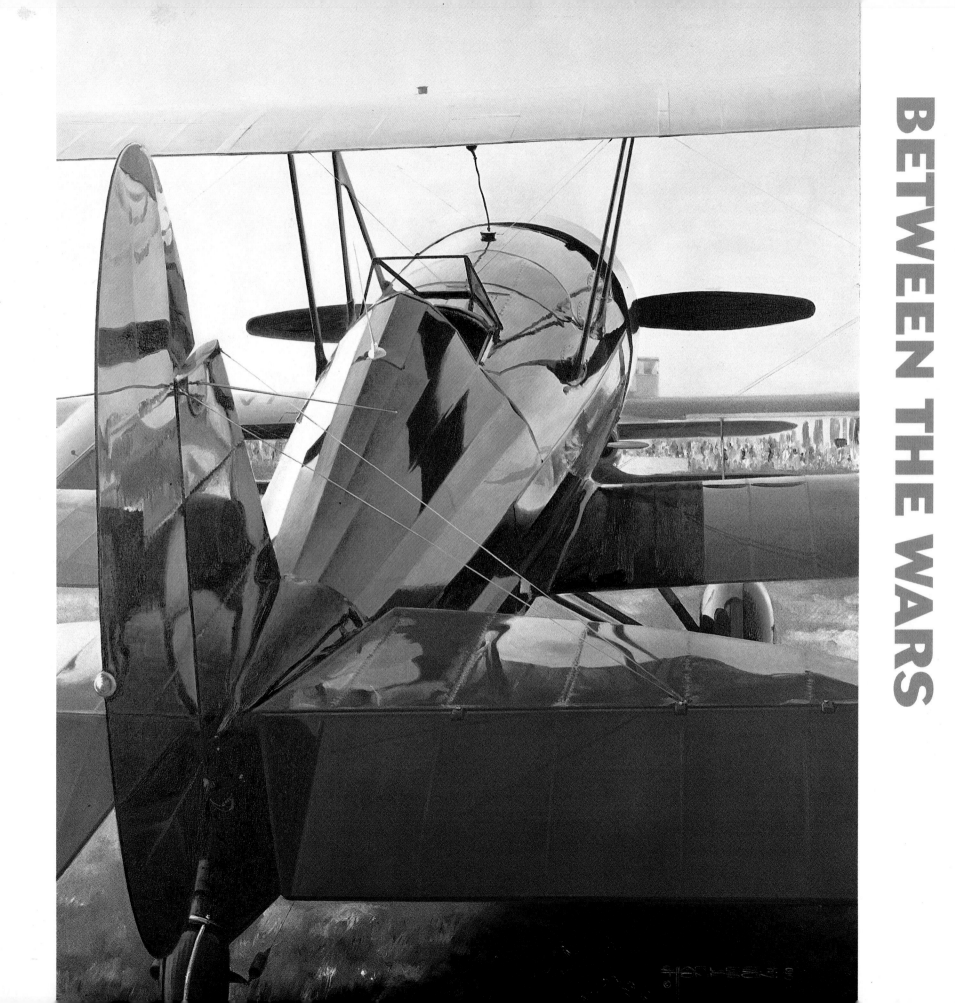

BETWEEN THE WARS

Hawker Hart

Charles J. Thompson

The clean lines of Sidney Camm's classic design are shown off in this excellent portrait. The prototype first flew in October 1928 and entered service with No. 33 Squadron, R.A.F., at Eastchurch in January 1933. The Hart was considerably faster than contemporary bombers, and also had the measure of any fighter then in service. The aircraft saw limited service in the Middle East during World War II until replaced by more modern types. It was common for R.A.F. squadrons to carry registration letters on the fuselage at this time.

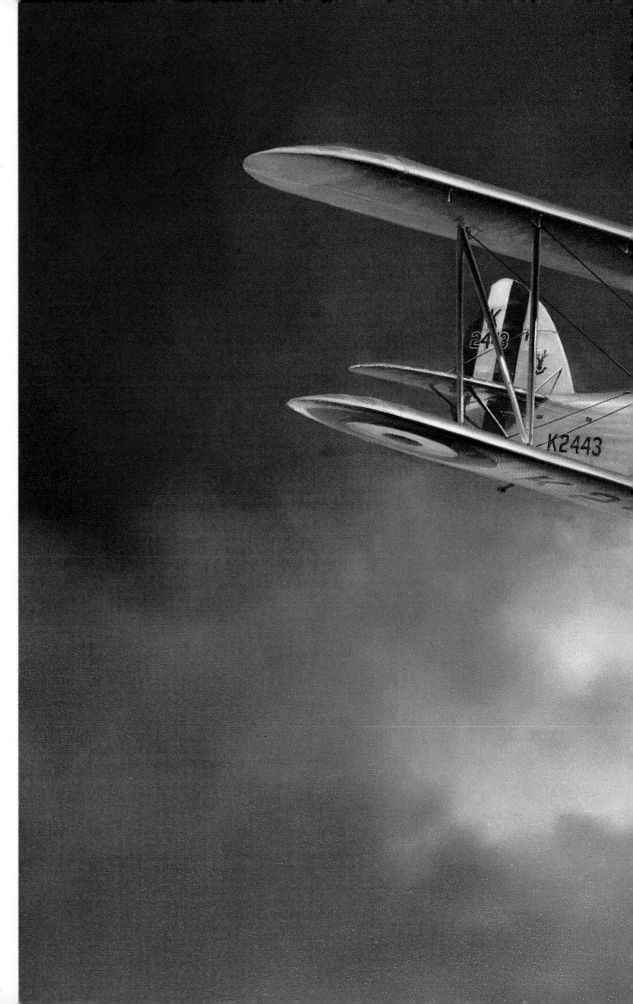

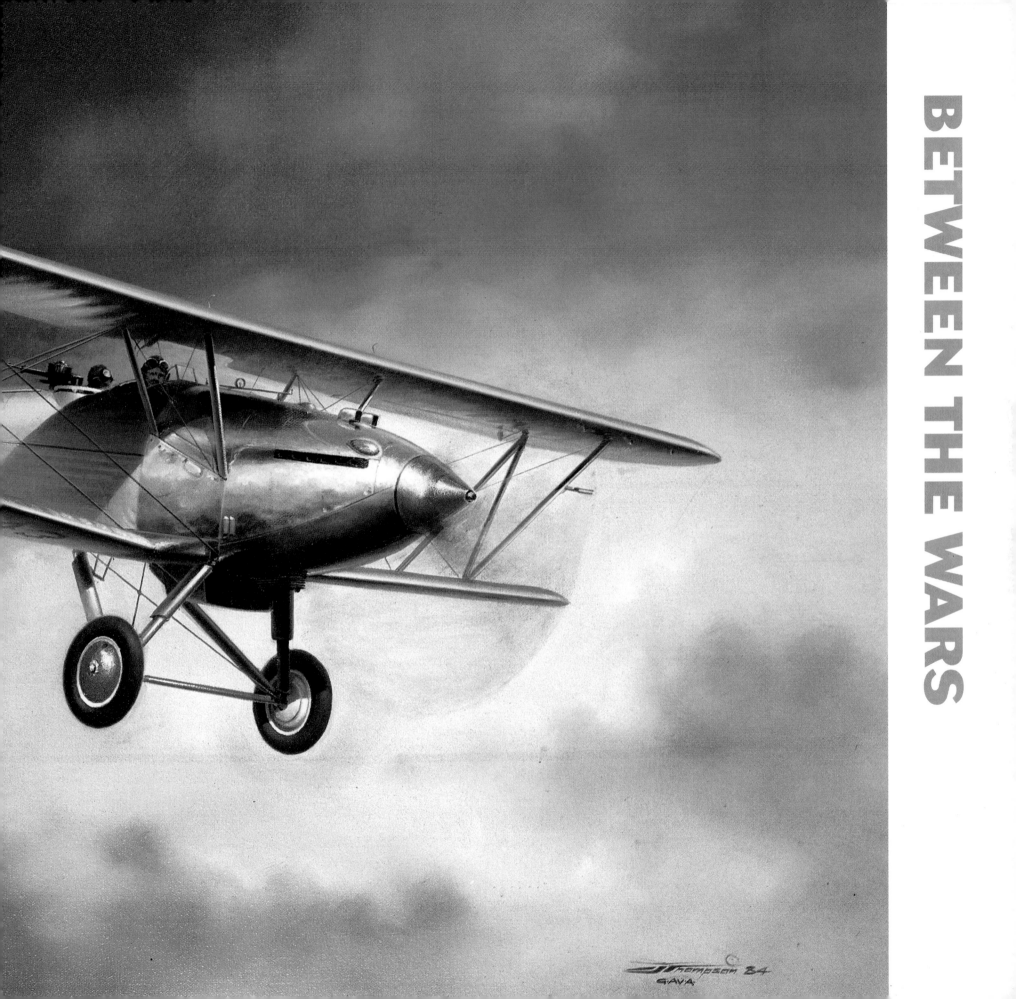

BETWEEN THE WARS

Gladiator at Rest

Charles J. Thompson

Designed by Gloster employee H. F. Folland, the Gladiator was ostensibly an improvement on the company's Gauntlet and the R.A.F.'s last biplane fighter. The prototype aircraft first flew in 1934 and the aircraft entered R.A.F. service in 1937 and R.N. service in 1939 as the Sea Gladiator. By this time the dark clouds of World War II were gathering, and the fabric-covered biplane was swiftly judged obsolete, although units did see action in Norway and Northern France in 1940.

However, the Gladiator will live on in memory thanks to the efforts of *Faith*, *Hope*, and *Charity* — three Gladiators that helped save Malta from German invasion.

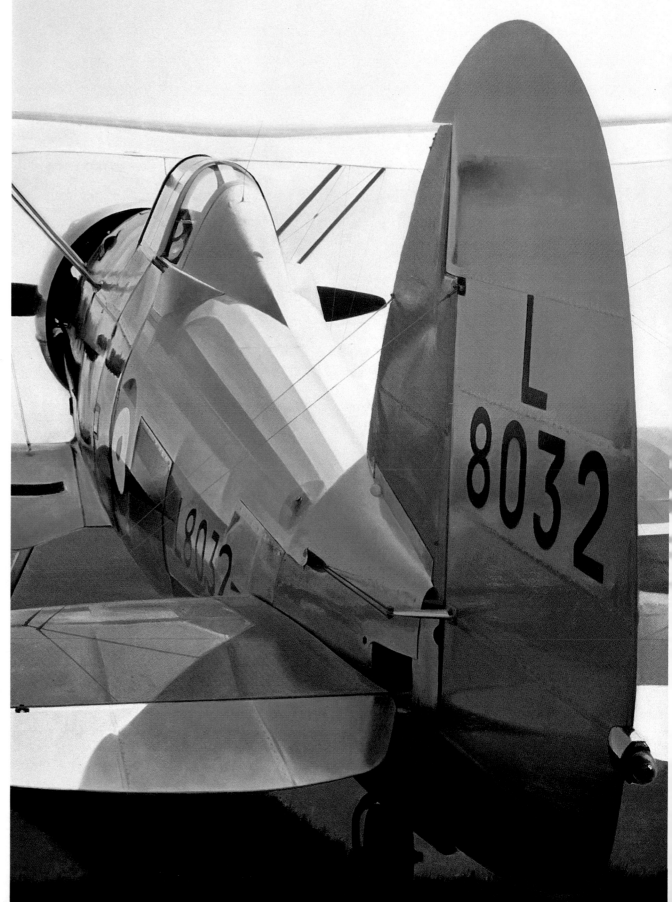

Is it a Bird? Is it a Plane?

Charles J. Thompson

The Cierva autogiros were the invention of Spaniard Don Juan de la Cierva. The early rotors were not engine-driven, but kept going purely by the forward motion of the aircraft and, if the engine failed, the rotor allowed a safe descent. Between 1925, when the C6A was brought to England at the behest of the Air Ministry, and the inventor's death in 1936, Cierva and A. V. Roe experimented with the concept. This is a C24 cabin two-seater autogiro built by de Havilland; the C24 rotor had an engine linkage.

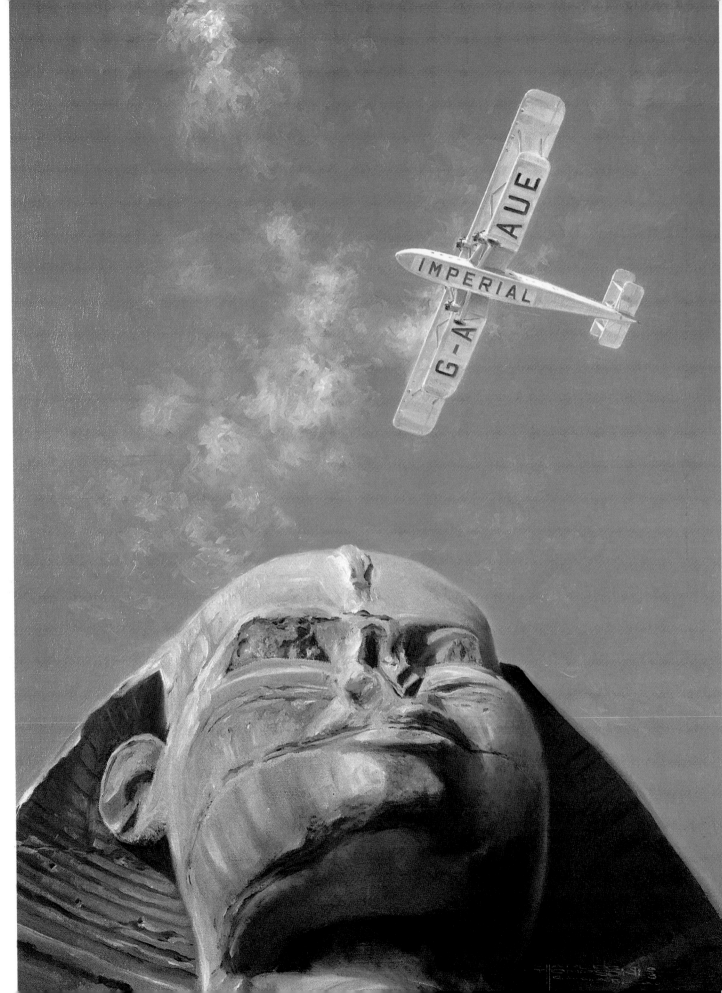

Luxury to Luxor

Charles J. Thompson

An Imperial Airways' Handley Page HP42 flies over the Sphinx. Eight HP42 all-metal biplanes were built for Imperial. Capable of carrying twenty-four passengers, the HP42s served from 1930 until World War II.

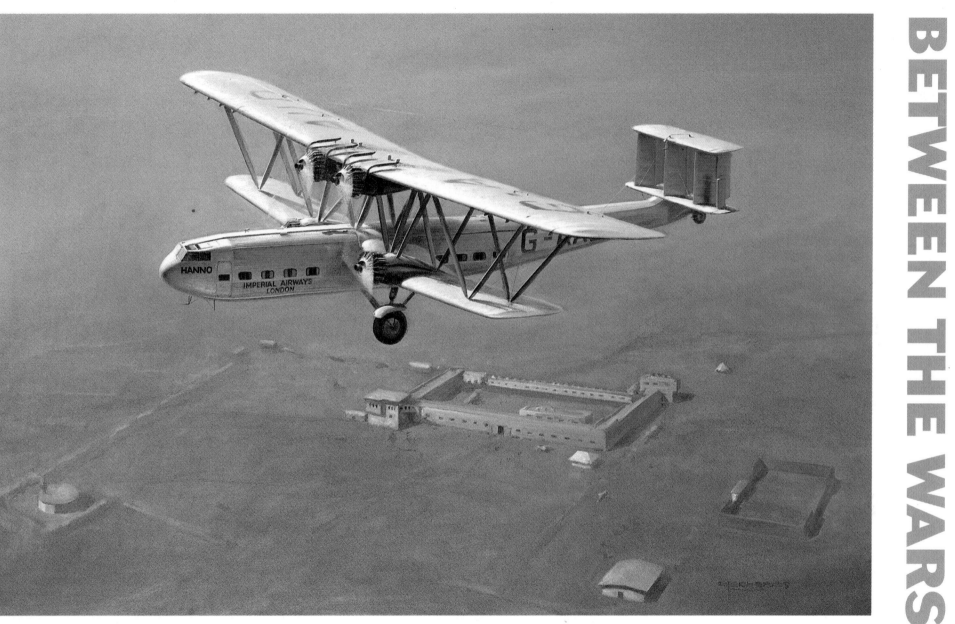

Hanno

Charles J. Thompson

Another Imperial Airways' Handley Page 42, *Hanno* was the first to use Sharjah airport while en route to India in 1932. The airport was built as a fort to ward off marauding Arabs and used as a night stop on the India route. The HP42 established a remarkable, accident free record with Imperial: no passengers were killed up to the outbreak of war when the fleet mileage had reached 2.3 million.

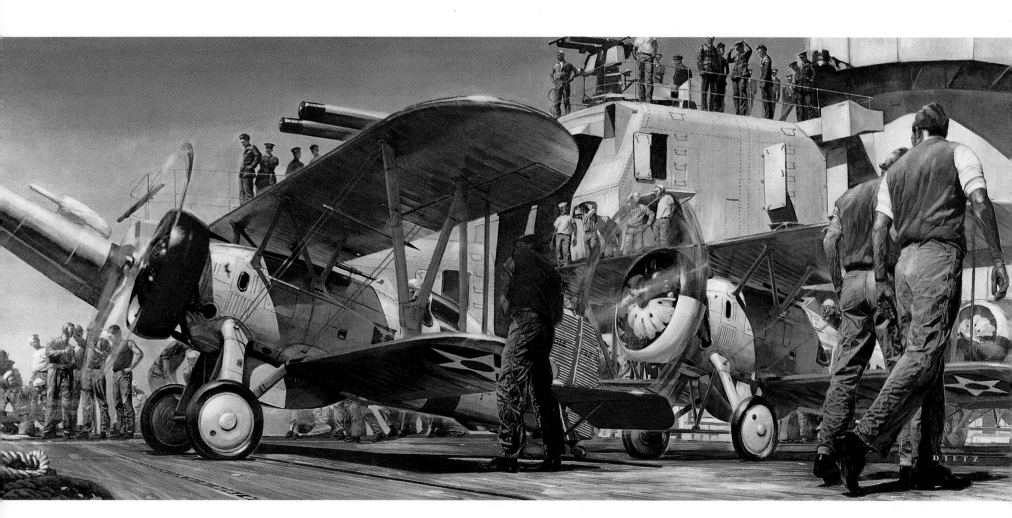

The Professionals

James Dietz

The flightdeck of U.S.S. *Lexington* buzzes with activity as F4B-4s are readied for take-off. The Boeing Model 235 F4B-4 was a naval production version of the Army P-12, with an enlarged vertical fin and, in the last forty-five aircraft produced — a liferaft stowed in an enlarged streamlined headrest. One of seventy delivered to the U.S. Navy, the lead aircraft here is navy serial 9014, serving on *Lexington* with VF-2. The painting shows to good advantage Jim Dietz's excellent eye for composition, the meticulous realism of the execution of the painting, and the blend of color and action that make him such a popular modern artist.

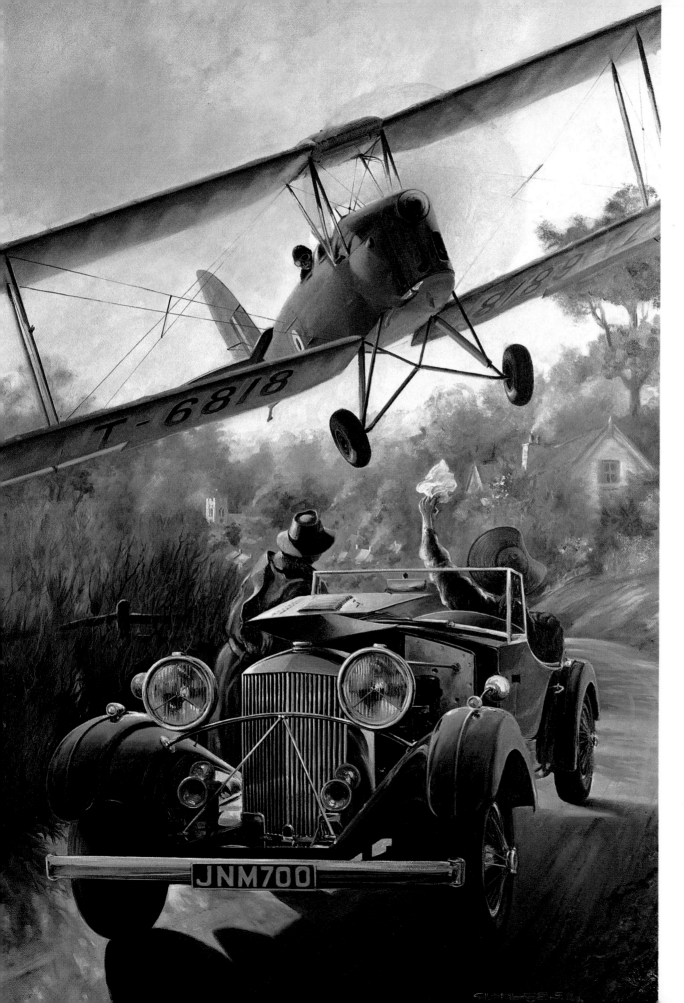

De Haviland Tiger Moth and Railton

Charles J. Thompson

Thompson recalls peaceful prewar days in this work, which depicts a Tiger Moth of an R.A.F. Elementary Flying Training School swooping low over a Railton Tourer. In the more troubled times that followed, many Tiger Moths were prepared for offensive operations to combat the threatened German invasion of Britain in 1940. In the event, the invasion did not take place and none of the Tiger Moths were used operationally. Today there are numerous preserved examples to be seen all over the world.

David's Staggerwing

Rick Ruhman

Commissioned as a surprise for their boss, two friends/employees of this lucky Staggerwing owner secretly gathered detail photos to aid the artist in his task. The background is the view from David's living room window, showing David at the controls of his "baby" with the city of Lawrence, Kansas on the horizon. The painting would be presented to David to celebrate the eventual first flight of his prize interwar-designed Beech D-17S Staggerwing aircraft, then undergoing a complete restoration. Having the painting ninety percent finished within a few months, the artist had to wait three years for the final details. With the flight only a few weeks away, the painting was finished and the two "co-conspirators" had the artwork shipped to Kansas. At a birthday dinner in early 1997, just after the airplane flew, David finally received the present from his two special friends.

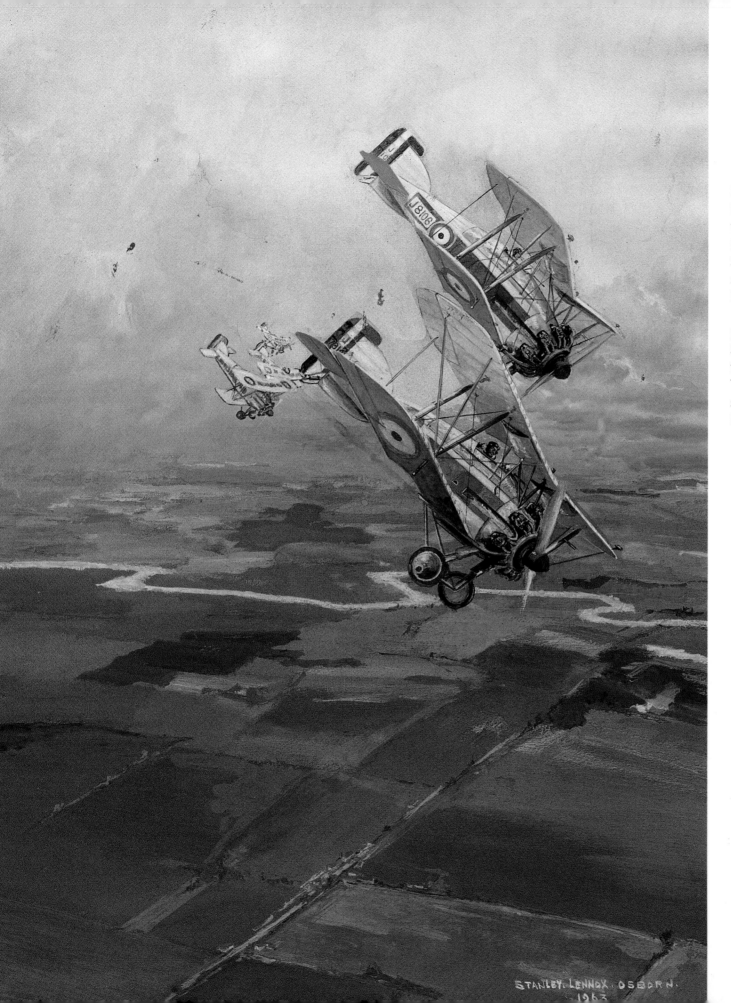

STANLEY LENNOX OSBORN
1963

Gloster Gamecocks

Stanley Lennox
Osborn

Having flown with No. 166 Squadron, from Kirmington, as a Lancaster rear gunner Stanley Osborn was shot down over Hannover on March 5, 1945, and became a prisoner of war at Stalag Luft 1 where he took up sketching. This early painting shows Gamecocks of No. 23 Squadron, R.A.F.

BETWEEN THE WARS

AVIATION ART

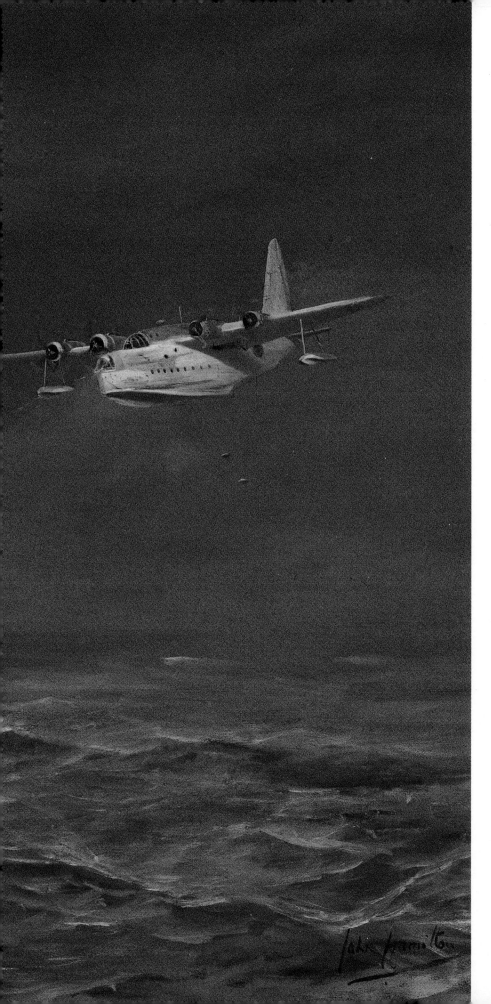

WORLD WAR II

Caught on the Surface

John Hamilton

Although more easily detected on the surface, U-boats were forced to spend a considerable time out of their natural element. They were far quicker on the surface than when submerged and also needed to surface to recharge their electric batteries, which were used when the submarine dived to maintain contact with their operational centers, and to be resupplied. During the early days of the Battle of the Atlantic, detection by air was rare. However, with the introduction in 1942 of the radar-equipped Short Sunderland Mk. III, which had an operational range of nearly 2,700 miles, the Battle of the Atlantic became more evenly matched. The heavily armed Sunderlands of R.A.F. Coastal Command took a heavy toll of the U-boat fleet during the latter days of the war. An example of this is *U-246*, a Type VIIC U-boat which was commissioned in January 1944. On April 30, 1945, it was caught on the surface of the Irish Sea by Sunderland ML783 flown by Flt. Lt. K. H. Foster, D.F.C., of No. 201 Squadron, R.A.F. *U-246* was bombed, hit, and lost with all forty-eight hands.

Right:
Weary Warrior

Charles J. Thompson

Its fighting days long over, this B-25 Mitchell now resides at Southend Museum in eastern England.

Far right:
Gabby's Twenty-Eighth

Troy White

Completed in 1996, this scene depicts the 28th and last victory in the European theater for Colonel Frank Gabreski, the highest score of any American pilot in that harsh arena. Flying his trusted P-47D Thunderbolt over Evreux, France on July 5, 1944, Gabreski atacked and shot down a Messerschmitt Bf109 from an unidentified unit.

In combat, the Thunderbolt built up a solid reputation for its ability to absorb battle damage and its stability as a gun platform. The reputations of many pilots were made on the hefty and demanding "Jug."

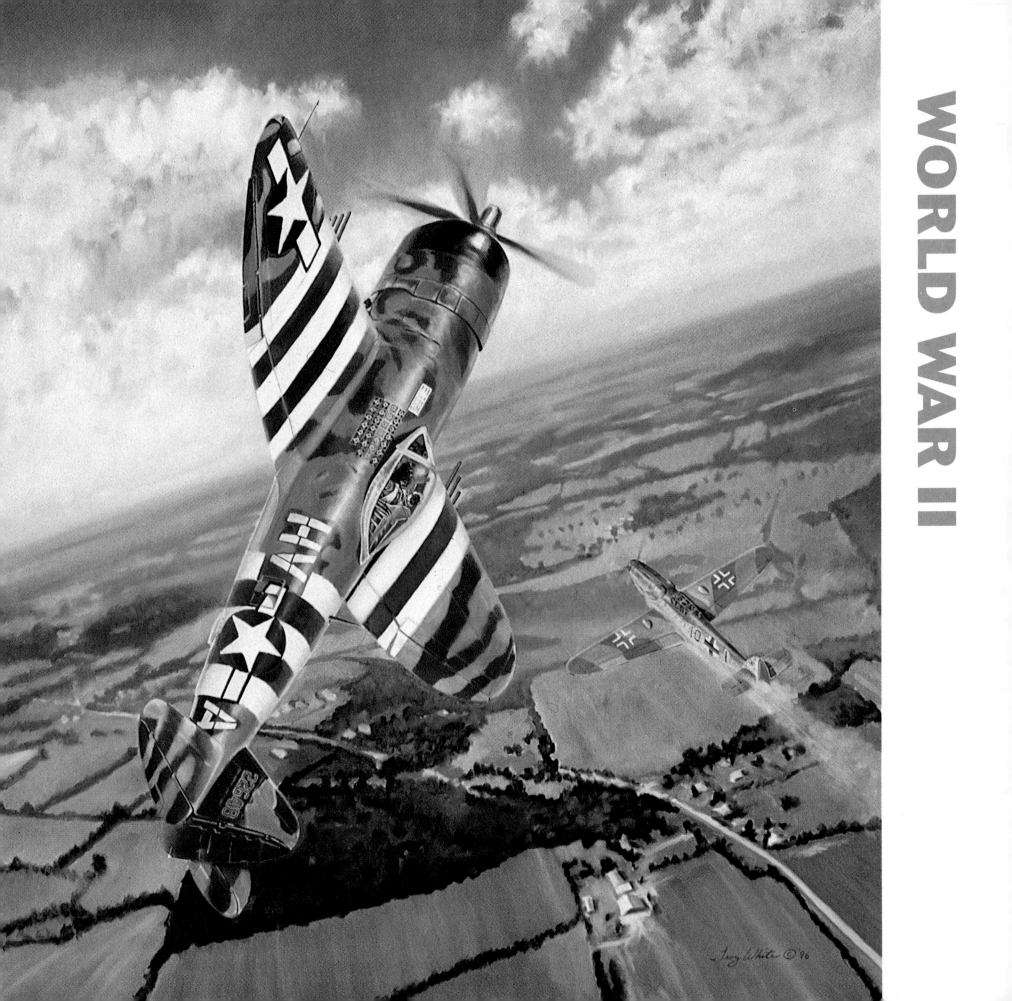

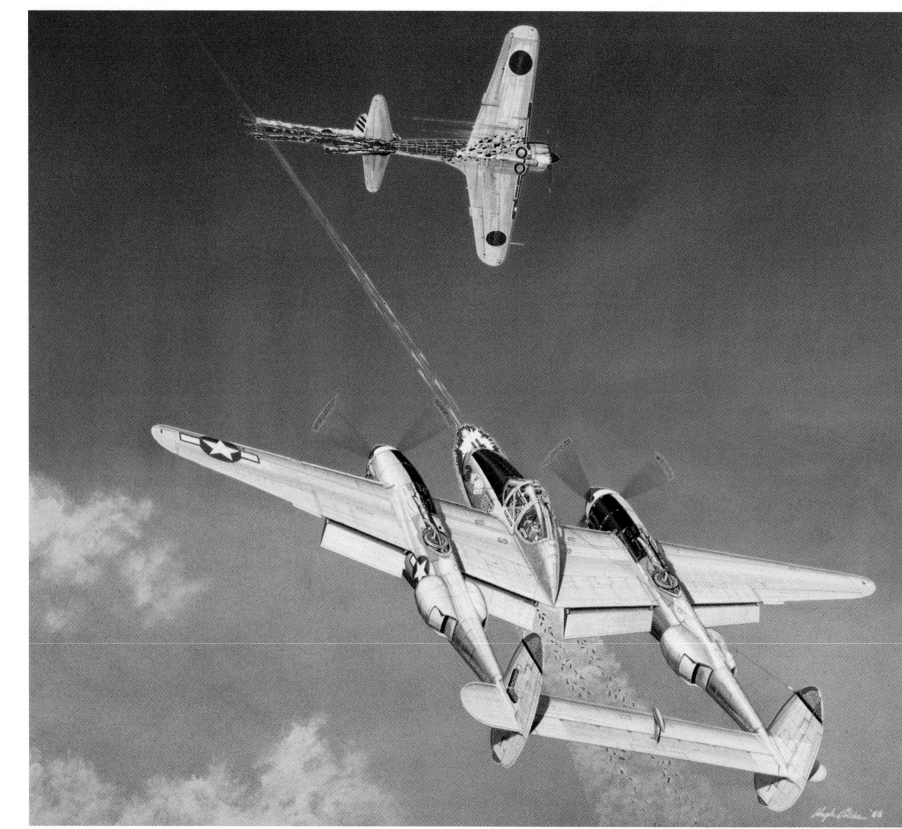

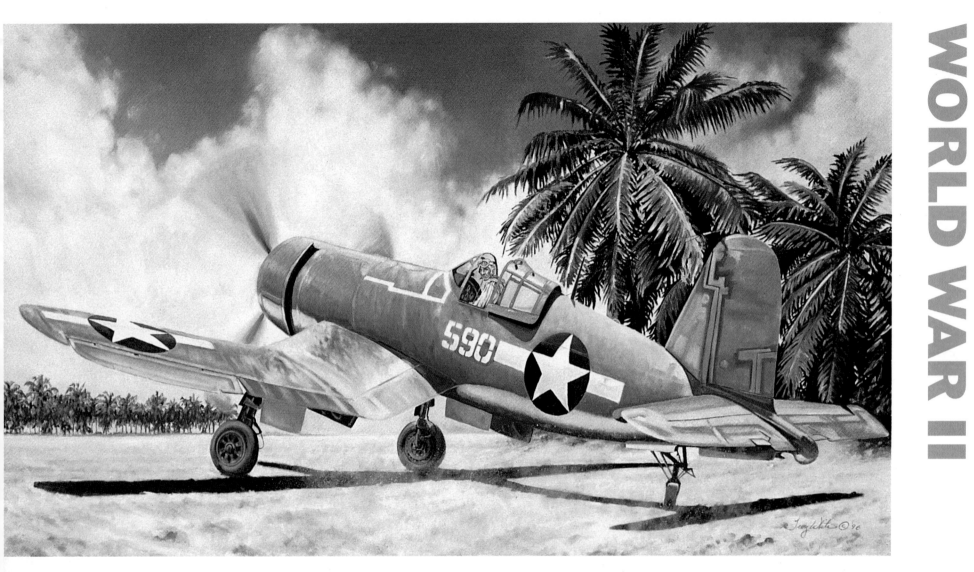

Left:
Captain Richard West

Hugh Polder

Captain Richard West, flying a P-38 Lightning, gains his fourteenth victory as the Japanese "Oscar" — the codename for the Nakajima Ki43 *Hayabusa* (Peregrine Falcon) — rolls away smoking. West was the top ace of his unit, — he served with 35th Fighter Squadron, 8th Fighter Group. The Lockheed P-38 Lightning entered service in 1941 and destroyed more Japanese aircraft than any other in the Pacific theater.

Artist Hugh Polder served with the U. S. Air Force between 1951 and 1954.

Above:
Bougainville Boogie

Troy White

Captain Roger Conant of VMF-215, stationed on the Solomon Islands, taxies out from Torokina on Bougainville after refuelling during an escort mission on January 14, 1944. Bougainville was invaded on November 1 as part of the American counter-offensive through the Central Solomons.

Captain Conant had been escorting Douglas SBD Dauntless dive bombers and, en route to Rabaul, he downed a Japanese Mitsubishi A6M Zero. The long nose on the Vought F4U Corsair, the aircraft that Conant used to score all nineteen of his kills, made taxying a tricky business.

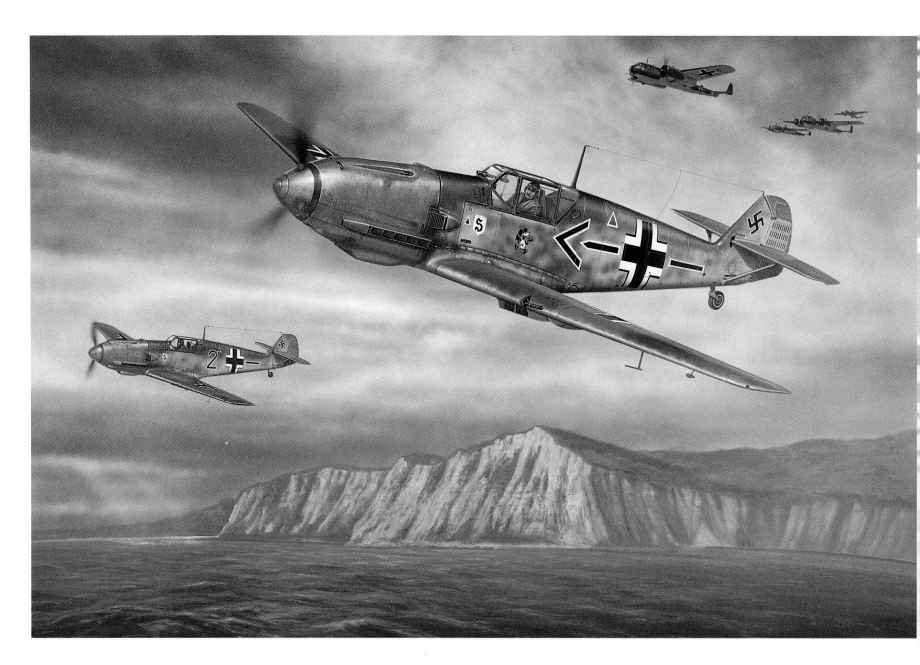

Adolf Galland

Jerry Crandall

Adolf Galland — flying a Messerschmitt Bf109E-4/N W. Nr. 5819 — and his wingman, Feldwebel Hegenauer, escorting a flight of Dornier Do172-2s back to their bases in Northern France. Galland became the most famous of Luftwaffe fliers of the war. He scored over 100 air-to-air victories, was the last living recipient of the Reich's supreme decoration for gallantry and leadership — the Knight's Cross with Oak Leaves, Swords and Diamonds — and, at thirty, became the youngest general in the German armed forces. He went on to become Inspector-General of Fighter Forces, survived the war, and died in 1996, respected by friend and foe alike. Jerry Crandall worked at McDonnell Douglas as an artist before devoting his time to aviation art and research.

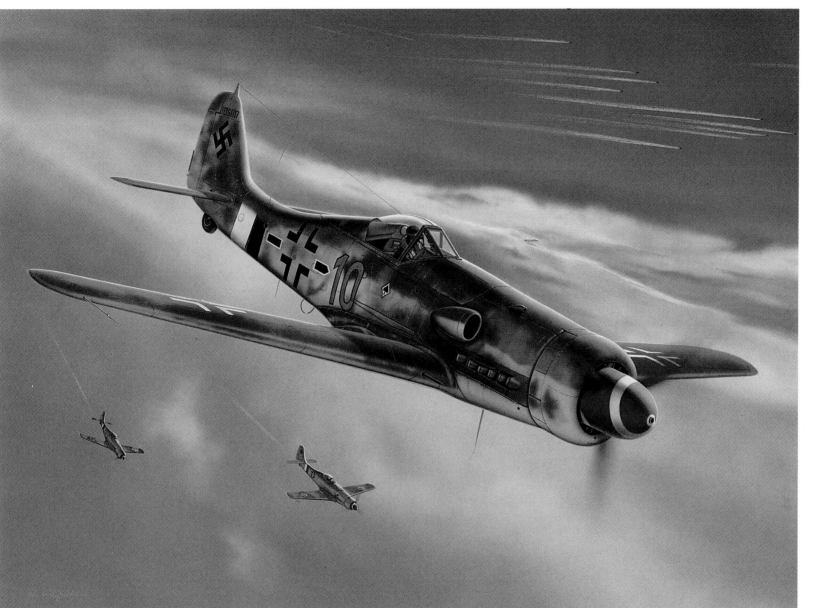

Focke-Wulf FW190 D-13/R11

Jerry Crandall

The D-13 variant of the fearsome Focke-Wulf FW190 had an armament consisting of three MG151 cannon, one firing through the prop hub and two in the wing roots. The aircraft in this picture was the personal mount of Major Franz Gotz, Kommodore of JG26 later in the war. The FW190 had a truly impressive service career spanning four years, the prototype first flying as early as June 1939. By the end of the war nearly 20,000 FW190s had entered service. This particular aircraft — "Yellow 10" — was captured by the Canadians at the war's end. The only surviving D-13, it was discovered in a vacant lot in Georgia by artist Jerry Crandall in 1965. It now resides in the Champlin Fighter Museum.

Right:
Take-off

Laura Knight

The crew of a British Avro Lancaster bomber make their pre-flight preparations before setting off on another night mission. In the foreground, the wireless operator sets his equipment to the prescribed frequency while his navigator checks the course. The Lancaster flight engineer sits to the right of the co-pilot, who is focussing on his own set of checks.

Far right:
Out in the Midday Sun

Charles J. Thompson

Baked under the remorseless midday sun, a Vultee Vengeance dive bomber of the Royal Australian Air Force runs up its engine at Imphal airfield in India. Imphal was the site of a major battle in the attempted Japanese invasion of India from Burma. On March 6, 1944, General Mutaguchi's Fifteenth Army attacked and Kohima and Imphal were besieged. Resupplied by air, it would only be on June 22 that the Imphal-Kohima road was declared clear and the Japanese were forced to retreat to the River Chindwin.

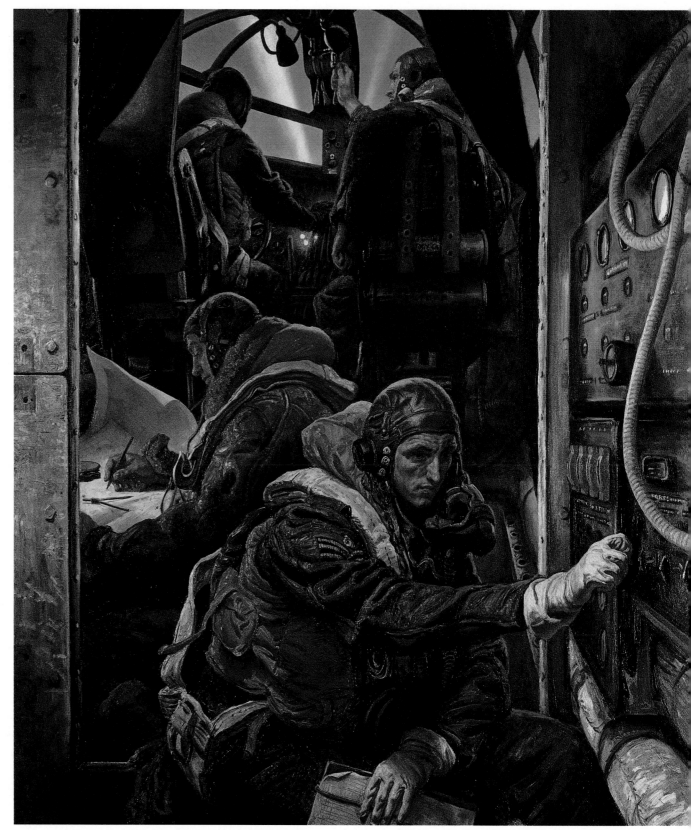

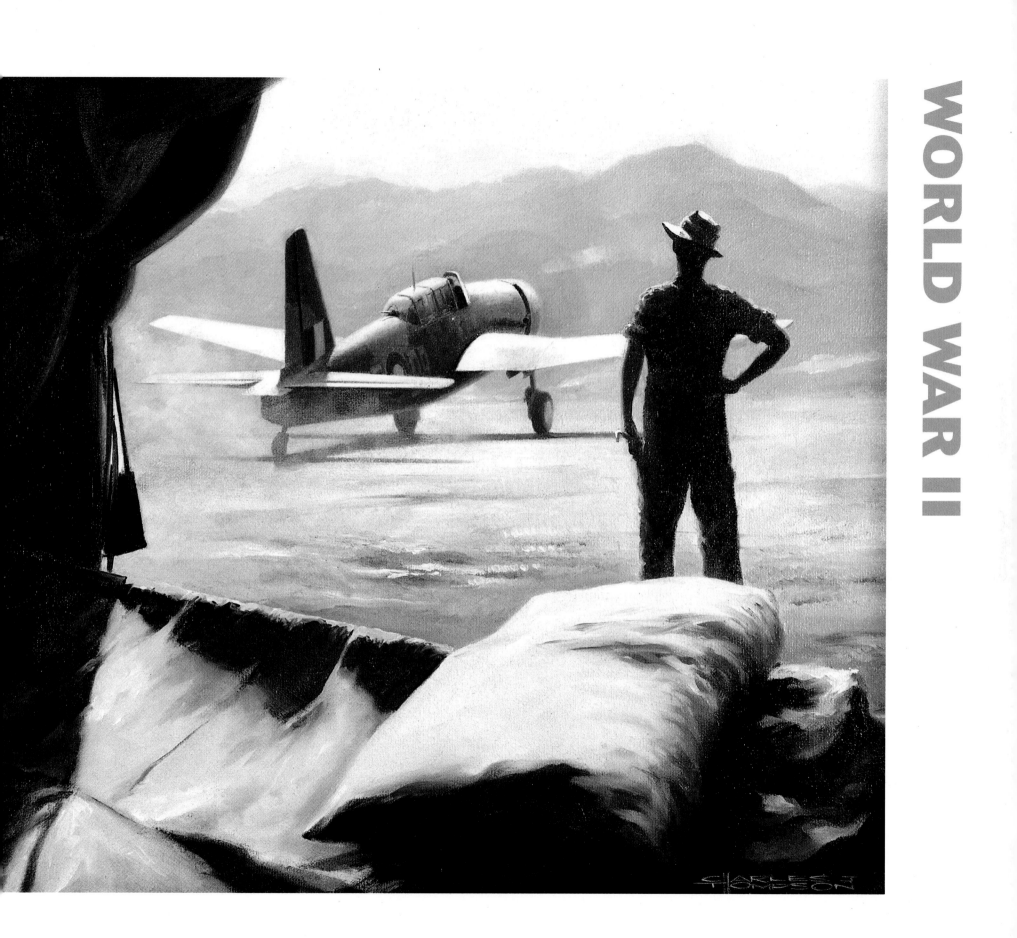

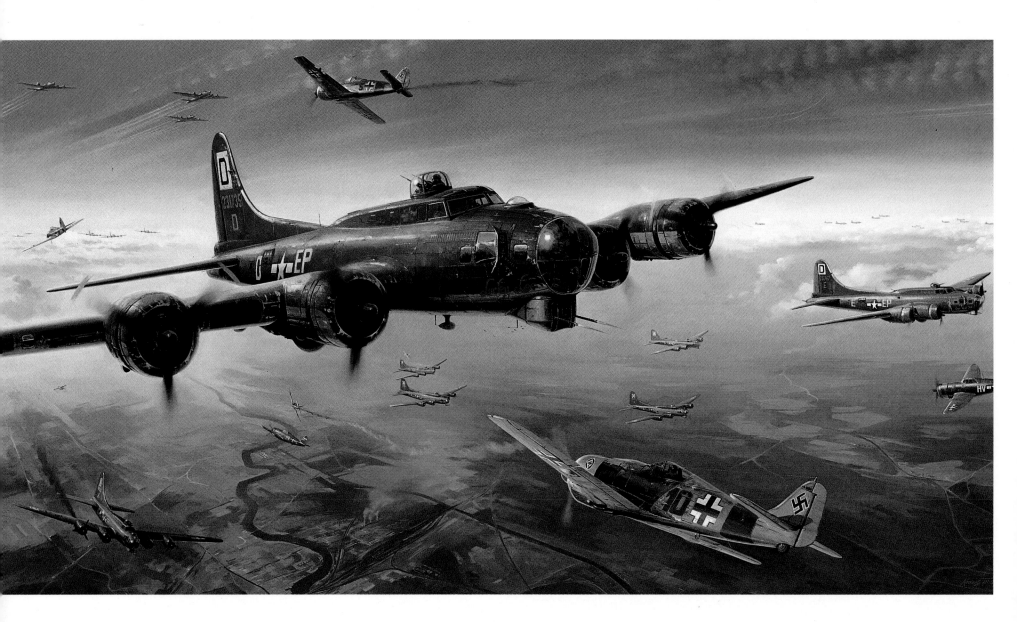

First Strike on Berlin

Nicolas Trudgian

B-17 Flying Fortresses of the 100th Bomb Group en route to Berlin, March 6, 1944. The U. S. 8th Air Force — the "Mighty Eighth" — flew daylight operations against the Reich from airbases in East England. On this particular day, 262 B-17s of the 1st Bomb Division were given Berlin as the primary target — specifically industrial areas in the suburbs. In total the Mighty Eighth put up 672 bombers that day and were protected by 801 fighters — the bulk of them (over 600) P-47 Thunderbolts. The 100th Bomb Group lost fifteen aircraft on the 6th, and the overall losses for the day were sixty-nine aircraft and 686 crew posted missing in action (the B-17 had a crew of ten.) The 100th also had one aircraft interned in Sweden. Nick Trudgian's graphic painting shows Luftwaffe FW190s getting in amongst the defensive boxes.

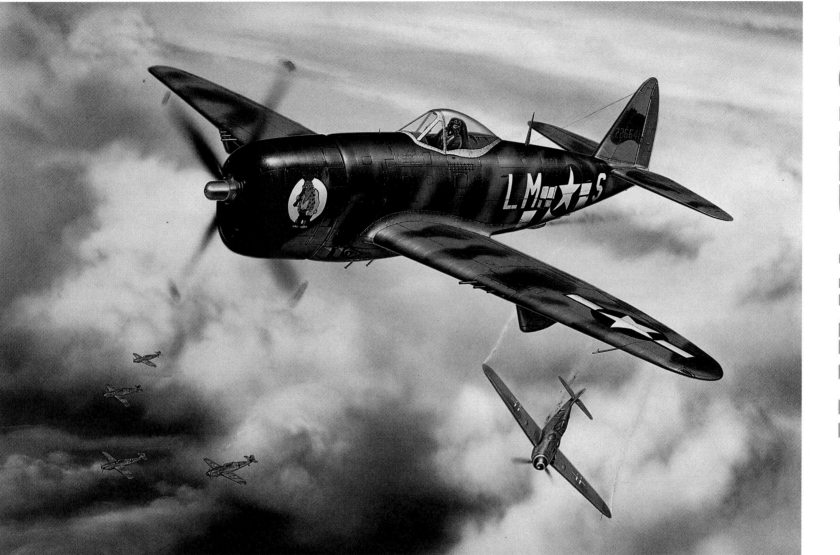

Wolfpack Leader Downs Five
Col. David Schilling's Thunderbolt *Hairless Joe*

Jerry Crandall

On December 23, 1944, the 56th Fighter Group, as part of a mixed force of 8th Air Force P-47 and P-51s, encountered 100 German aircraft over Bonn. The group commander, Colonel David Schilling, added three Bf109s and two FW190s to his tally of victories that day and as a whole the 36th downed thirty-seven Germans. Schilling would end the war as a top ace with 22.5 aerial and 10.5 ground victories. (Put in perspective, the U.S. forces' top ace was Major Richard Bong with 40 aerial kills.) The Republic P-47 Thunderbolt was nicknamed the "jug" (as in juggernaut!). It had been originally designed as a lightweight fighter, but when produced it was the heaviest single-seat fighter built.

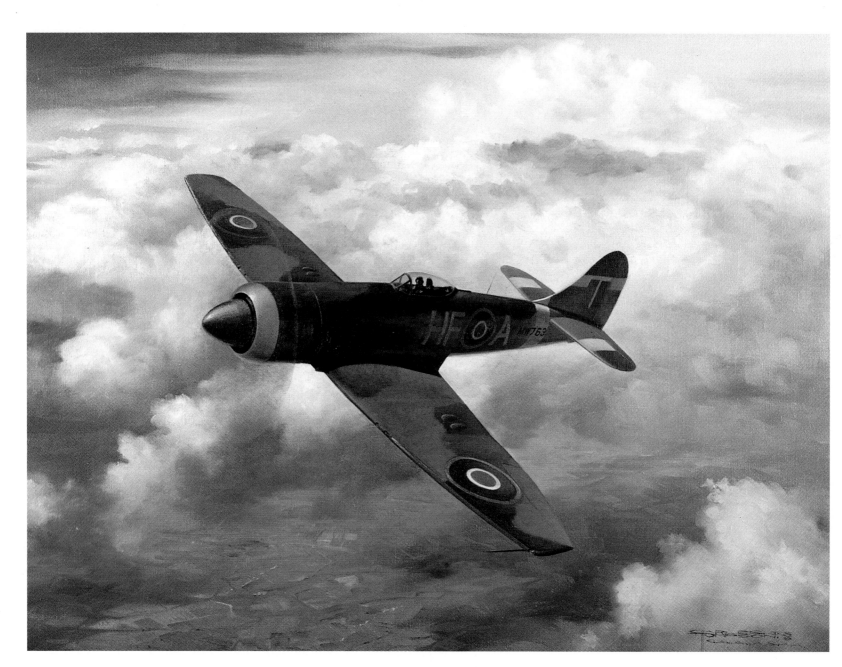

Tempest Two

Charles J. Thompson

The mighty Hawker Tempest was a major development of the company's Typhoon aircraft. The Typhoon was not a success in its intended role as an interceptor, and the Tempest was designed to meet the Air Ministry's changing requirements. The Mk. II aircraft in Charles Thompson's painting was powered by the 2,520 h.p. Bristol Centaurus radial engine and finally entered service in November 1945, after the war had finished. Compared to the Napier Sabre-powered Tempest Mk. V (which confusingly entered service in April 1944) the Mark II was a much quieter and more pleasant aircraft to fly.

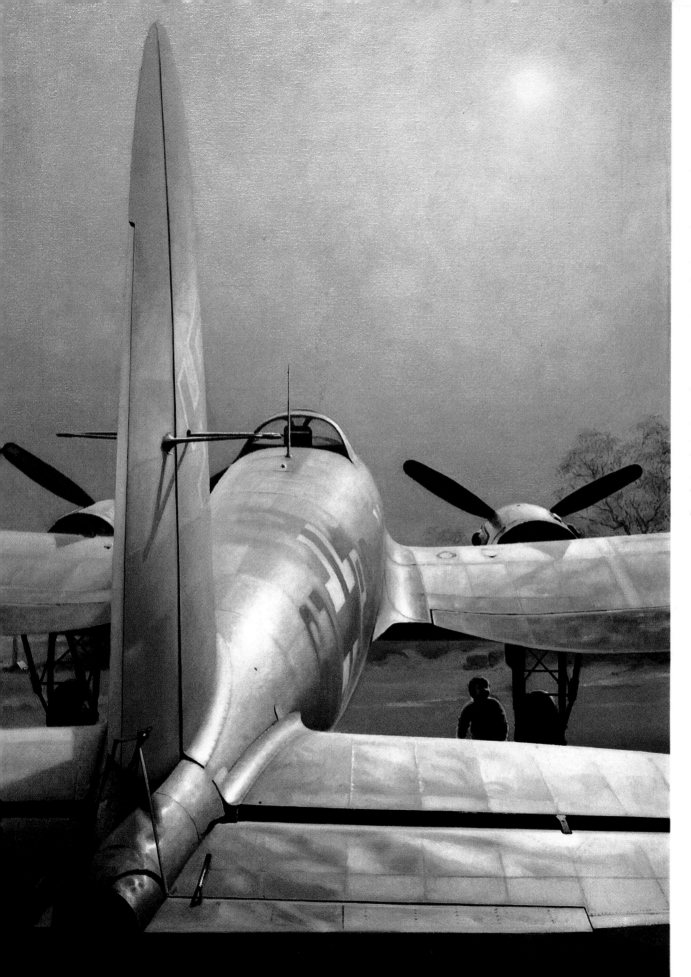

One Last Look

Charles J. Thompson

This scene will be familiar to anybody who visited an air museum as a child. Sometimes there just don't seem to be enough hours in the day, not for the young man gazing into the wheel bays of this Spanish-built CASA C.2111, anyway. CASA built the Heinkel He 111 under licence as the C.2111. Delivered to the Luftwaffe in 1936, it saw action in the Spanish Civil War and its relative success in that engagement hid frailties exposed by the R.A.F. during the Battle of Britain. This aircraft was brought to England for use in the film *Battle of Britain*.

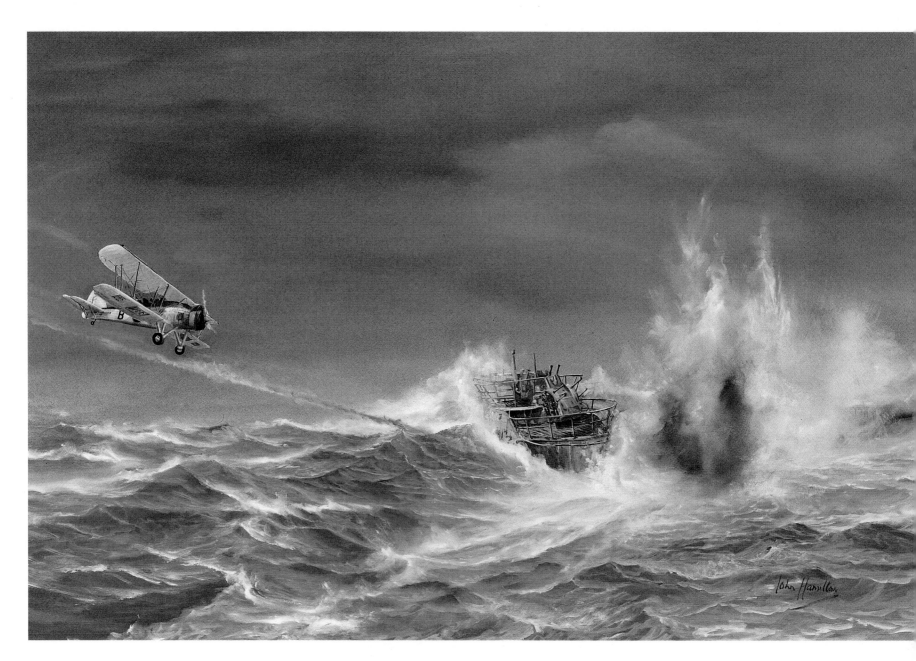

The Sinking of *U-752*

John Hamilton

There are numerous stories about the amazing Swordfish. The "Stringbag," as it was affectionately known by its Fleet Air Arm crews, looked outmoded even when it was introduced to service in 1934. However, it served with distinction and was directly involved in some of the most important actions of the war — the most famous of these being the British attack on the Italian fleet at Taranto in November 1940. Here, John Hamilton's oil painting captures rocket-equipped Swordfish "B" of 819 Squadron, R.N., surprising *U-752* on the surface, 670 miles southeast of Greenland, near Convoy SC130, on May 23, 1943. Sub-Lt. Horrocks, R.N., fired his eight 60 lb. rocket projectiles and *U-752* sank with the loss of twenty-nine men.

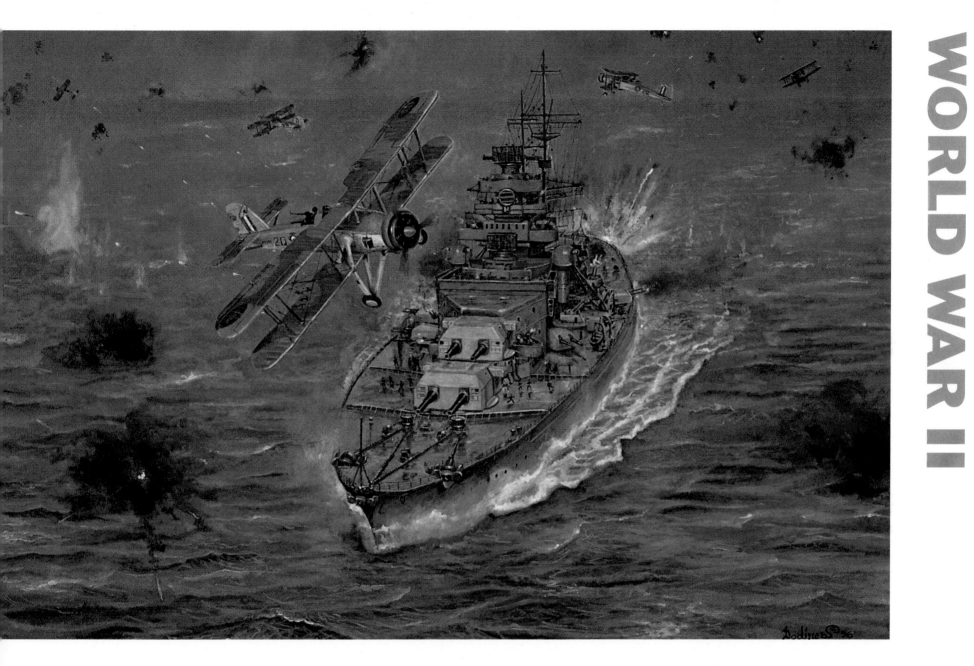

Mortal Hit on the *Bismarck*

Henry Godines

The Swordfish was also instrumental in the sinking of the German pocket battleship *Bismarck*. The German capital ship was sighted between Greenland and Iceland on May 23, 1941, and early the next morning it sank H.M.S. *Hood* and badly damaged *Prince of Wales*. *Bismarck* turned for St. Nazaire and was held up by H.M.S. *Victorious*'s Swordfish in an early morning attack on May 25. On May 26, it was the turn of Swordfish of 810, 818 and 829 Squadrons, F.A.A., from H.M.S. *Ark Royal*. Torpedo hits damaged *Bismarck*'s rudder, leaving her helpless. She finally sank on May 27, at 11:00 hrs, the *coup de grâce* being delivered by H.M.S. *Dorsetshire*. This painting shows the attack by *Ark Royal*'s Swordfish.

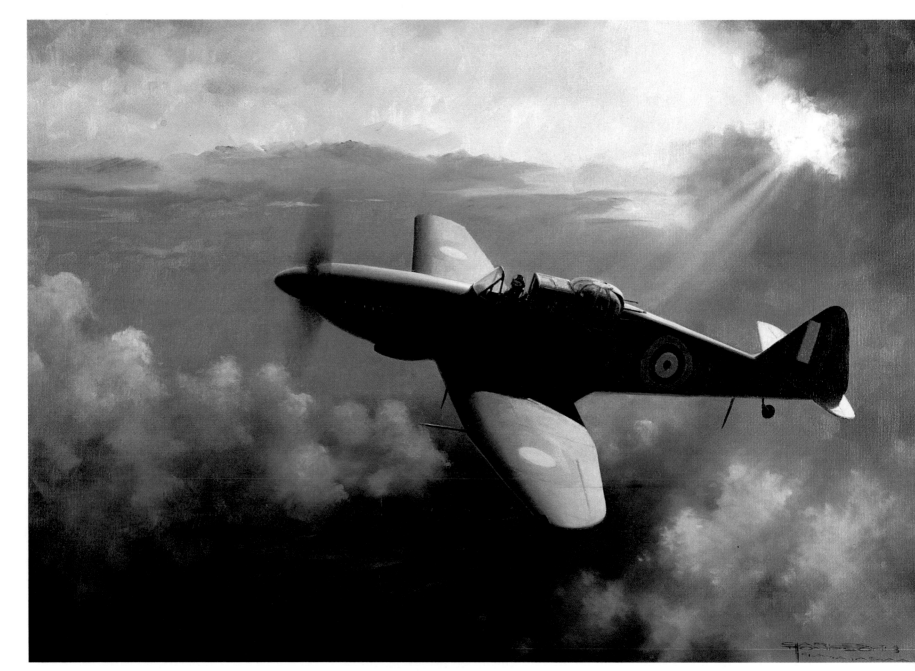

Night Fighter

Charles J. Thompson

Evening sunlight captures a lone Boulton Paul Defiant nightfighter as it sets out for its mission. The aircraft first entered service as a day fighter in 1937 but was discovered to be particularly vulnerable to head-on attacks. Equipped with radar, the Defiant N.F. Mk. IA and II proved valuable additions to Britain's night defences in the winter of 1940-41. During this period they recorded more "kills" per interception than any other contemporary nightfighter — but by spring 1942 they were relegated to target towing duties, the Mk. III being built for this purpose, and most still in service were converted to this role.

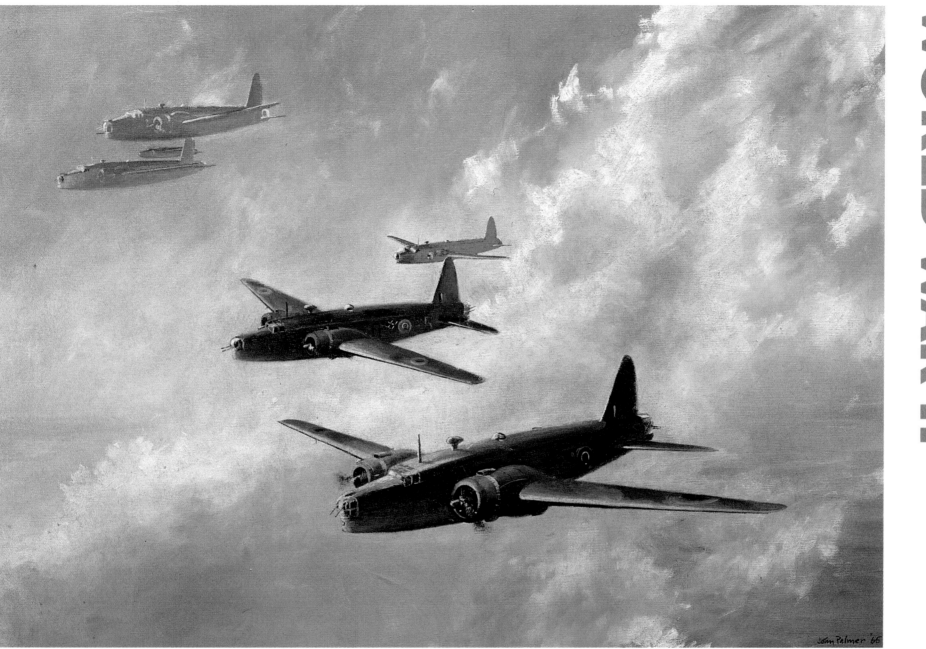

The Start of the Offensive

John Palmer

The Vickers Wellington was designed by Barnes Wallis — creator of the bouncing bomb of "Dambusters" fame — with a revolutionary geodetic frame construction that allowed it to sustain a large amount of punishment and still come home. Wellingtons made the first raid of the war (against Wilhelmshaven), dropped the first 4,000 lb. bomb, and were the mainstay of the R.A.F. until the arrival of the four-engined heavies — the Lancaster and Halifax.

Lady's Men

Troy White

Following a mission over the Pacific, a formation of Curtiss SB2C Helldivers heads back to U.S.S. *Yorktown*, known as "The Fighting Lady." The Helldiver, less flatteringly, was often referred to by pilots as the "Son of a Bitch 2nd Class." Some 7,000 were built during the war, making it the most extensively built of all U.S. Navy dive bombers, and it saw significant use in the Pacific, where it was welcomed as a big improvement on the Dauntless.

Two aircraft carriers carrying the name *Yorktown* were built during the war. The first was sunk during the Battle of Midway on June 6, 1942. The second *Yorktown* was commissioned in 1943 and fought through the Pacific island campaign to the end of the war.

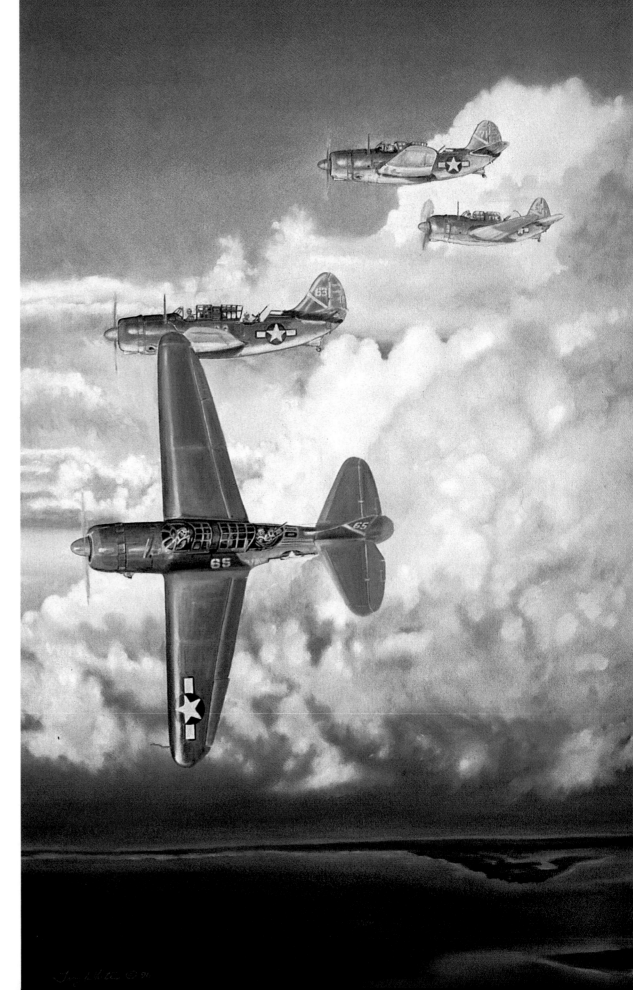

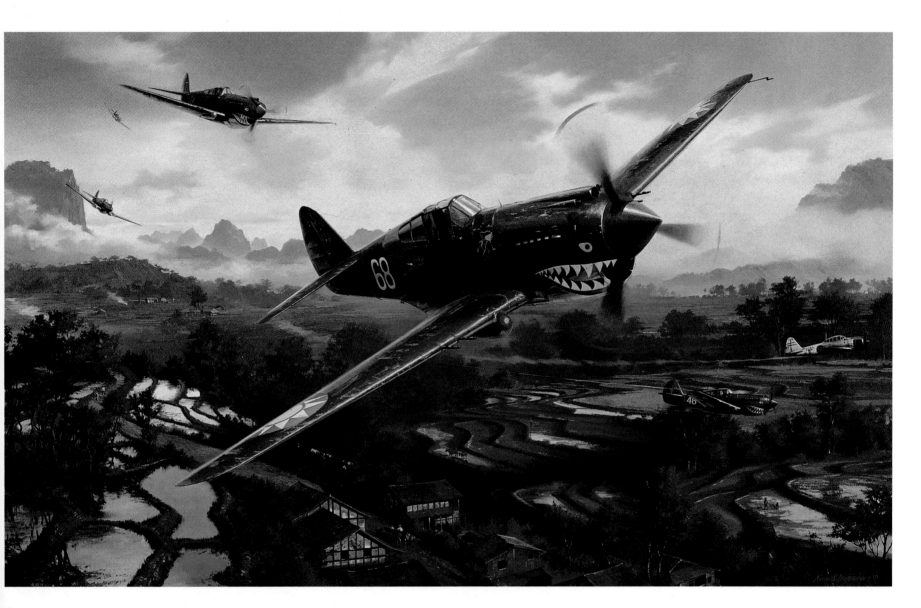

Tiger Fire

Nicolas Trudgian

P-40 Hawks of the "Flying Tigers" pursue Japanese Zeroes over China, early in 1941. The Japanese attacks on China had started some years before World War II and it was only after 1939 that the western allies began to provide backing to the regime of Chiang-Kaishek. In early 1941, 100 P-40s were sent from the United States, along with a band of American fliers, with the tacit approval of President Roosevelt. These fliers, commanded by Claire Chennault, quickly became known as the "Flying Tigers" and painted sharks' teeth on the side of their aircraft. They would fight on in uniform after the United States entered the war, leaving only after the Japanese captured their airfields in 1944.

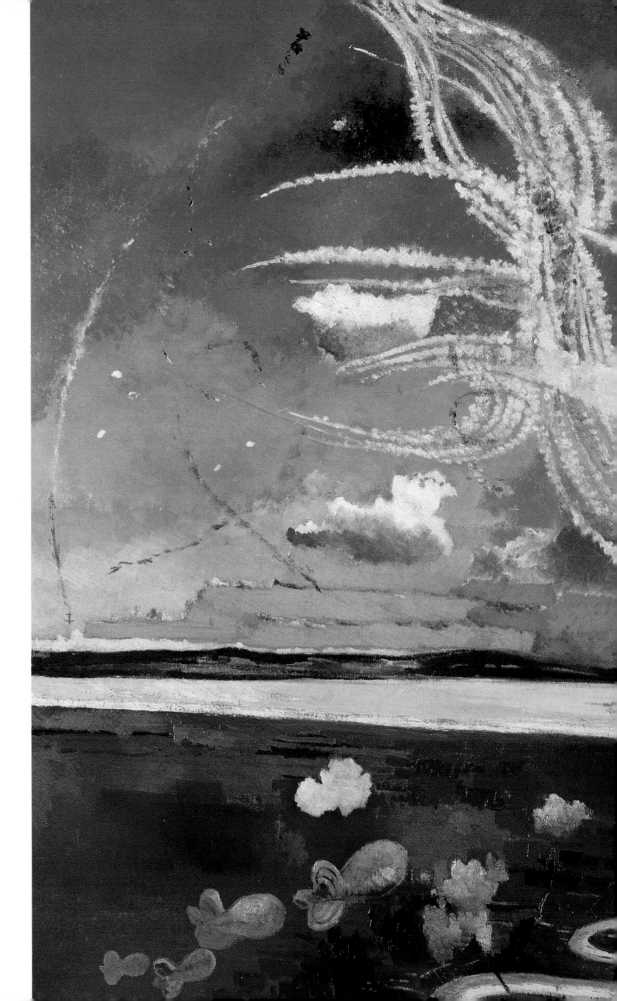

Battle of Britain

Paul Nash

Nash painted this scene in 1941 to mark the R.A.F.'s slender victory in the Battle of Britain. For most people in London during the summer and fall of 1940 this would have been a regular scene as the desperate battle was waged in the skies above. The battle culminated in the events of September 15, still kept as Battle of Britain Day. On that day the R.A.F. claimed 185 Luftwaffe aircraft downed, and although these claims have been proved to be wrong, it was still a turning point. The invasion of Britain did not take place and German attacks were turned to other targets.

Paul Nash (1889-1946) is recognized as one of the foremost British artists of the twentieth century. His talent and distinctive style came to the fore during the Great War, but the body of works he produced on aviation subjects is slender. Sadly, Nash died five years after executing this, his most famous work of aviation art.

He described his painting thus:

"The painting is an attempt to give the sense of an aerial battle in operaton. The scene includes certain elements constant during the Battle of Britain — the river winding from the town and across parched country, down to the sea; beyond, the shores of the Continent, above, the mounting cumulus concentrating at sunset after a hot brilliant day; across the spaces of sky, trails of airplanes, smoke tracks of dead or damaged machines falling, floating clouds, parachutes, balloons. Against the approaching twilight new formations of Luftwaffe, threatening . . ."

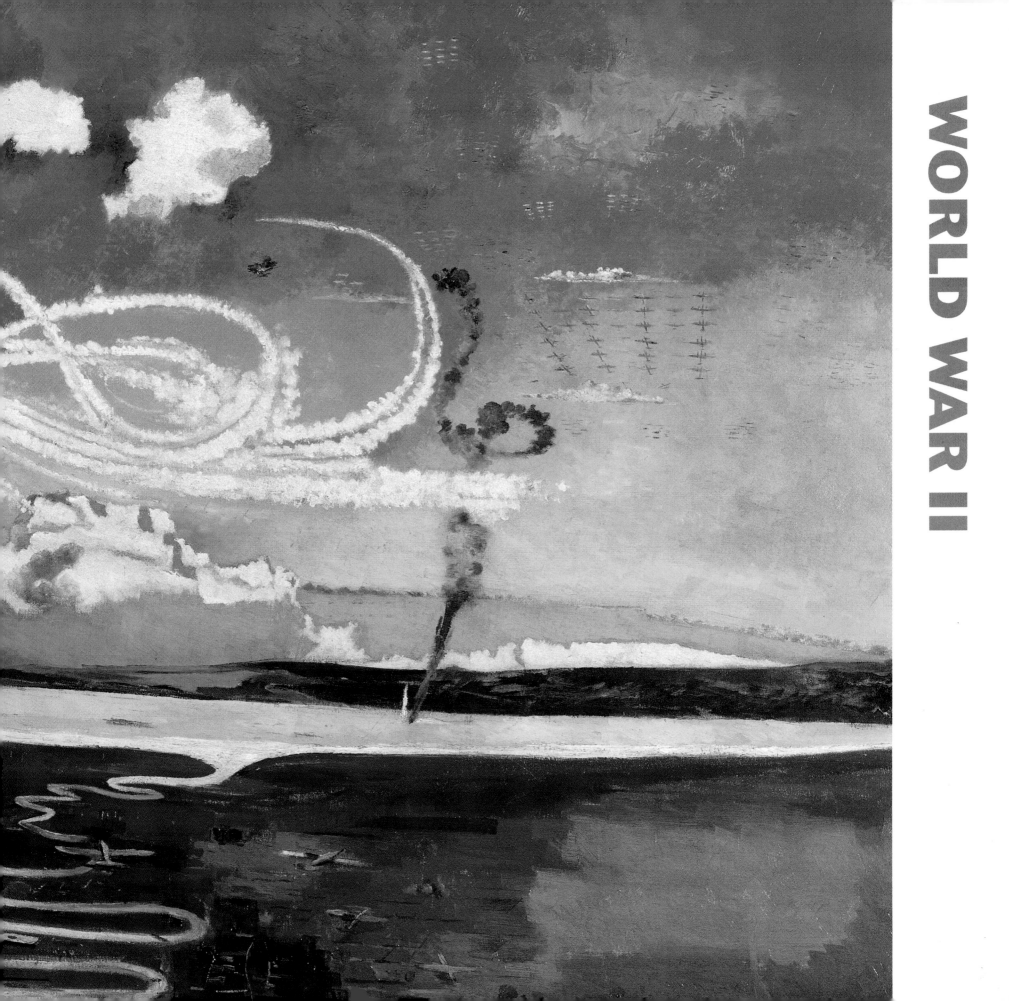

Target area: Whitley bombers over Berlin

Paul Nash

Nash chose as the subject of this painting one of Bomber Command's less remarkable aircraft. The Armstrong Whitworth Whitley was hampered by poor top speed (222 m.p.h.) and after war broke out it was used exclusively for night bombing. Whitleys remained on bombing operations until April 1942, after which they were active as trainers, paratroop transports, and leaflet droppers. The fleet was withdrawn in the summer of 1943.

This is no time to lose an engine!

Craig Kodera

This sardonic understatement by respected aviation artist and American Airlines First Officer Craig Kodera commemorates the men who flew "The Hump," the air route over the Himalayas in the China-Burma-India theater. Over 500 miles of unpredictable and trecherous weather saw thousands die but some 721,000 tons of indispensable supplies carried in more than 150,000 individual missions. The workhorse of the route was the Curtiss C-46 Commando — as seen here.

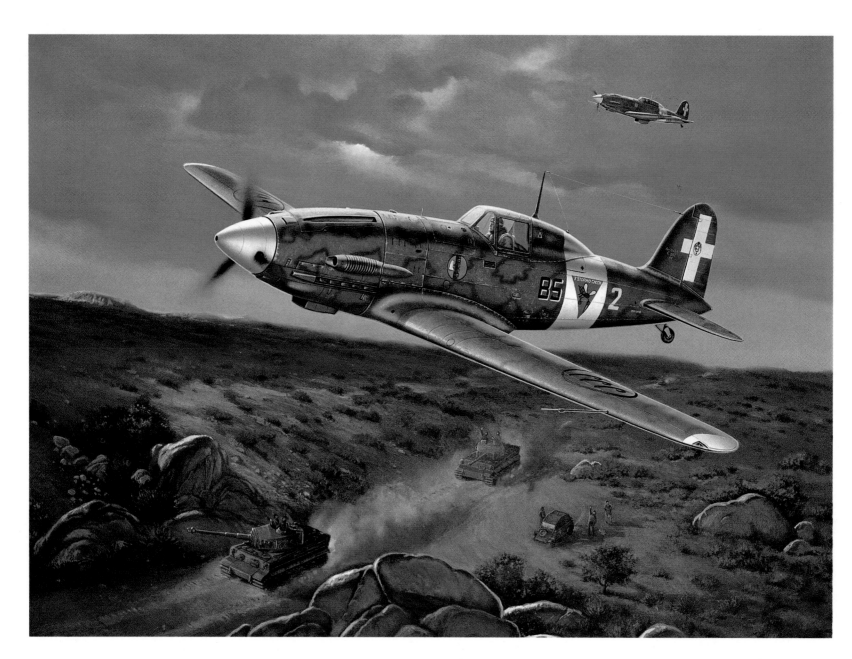

Storm Clouds over Tunisia

Jerry Crandall

Italian pilots were often handicapped by inept leadership and inferior aircraft during World War II. The Macchi MC202 certainly did much to redress the imbalance in the air war over North Africa. Designed by Mario Castoldi around a licence-built Daimler Benz DB691A engine, the Folgore (Thunderbolt) was the mount of Italy's top scoring ace of the war, Sergente Maggiore Luigi Gorrini. Gorrini would win three Silver Medals and the Medaglia d'Oro for valor while despatching twenty-four Allied aircraft. He served in the Italian Air Force until 1979. Crandall's painting shows Gorrini swooping low over a column of Tiger tanks in the Tunisian desert, October 1943.

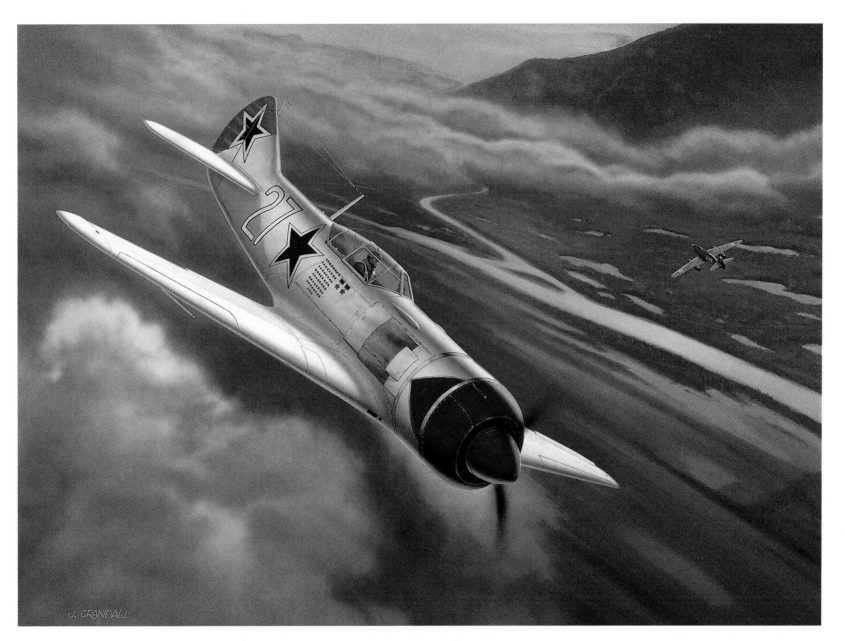

Ivan and the Lavochkin

Jerry Crandall

The Lavochkin La-7 was the last of the Lavochkin series-built aircraft to see operational service in World War II. It had a useful top speed of 413 m.p.h., armament of two 20 mm. cannon, and almost 8,000 were built. Pictured here is the personal aircraft of Major (later an honorary Air Marshal) Ivan N. Kozhedub, the leading Allied and Soviet ace of World War II with sixty-two confirmed kills. In his trademark "White 27" La-7, Kozhedub scored a memorable victory against an Messerschmitt Me262 on February 19, 1945 — the aircraft visible on the right of the painting. He was honored with no fewer than three Hero of the Soviet Union awards. His La-7 is in the air museum at Monino, Russia.

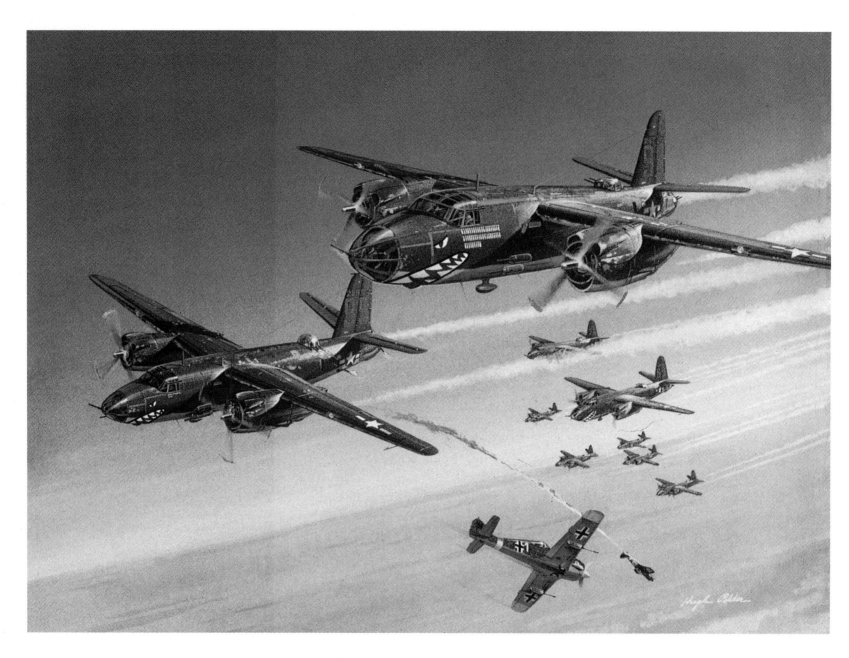

B-26s over Europe

Hugh Polder

Shark-nosed B-26 Marauders somewhere over Europe attacked by FW190s. The Martin Marauder was called the "Widowmaker" in its early days and, despite being close to closure on a number of occasions, the production lines continued until over 5,000 had been built. The B-26 earned its keep as a medium bomber. With up to twelve 0.50 machine guns, it was nearly as well armed as the B-17. This painting shows the way that a box of well-armed bombers could keep fighters at bay.

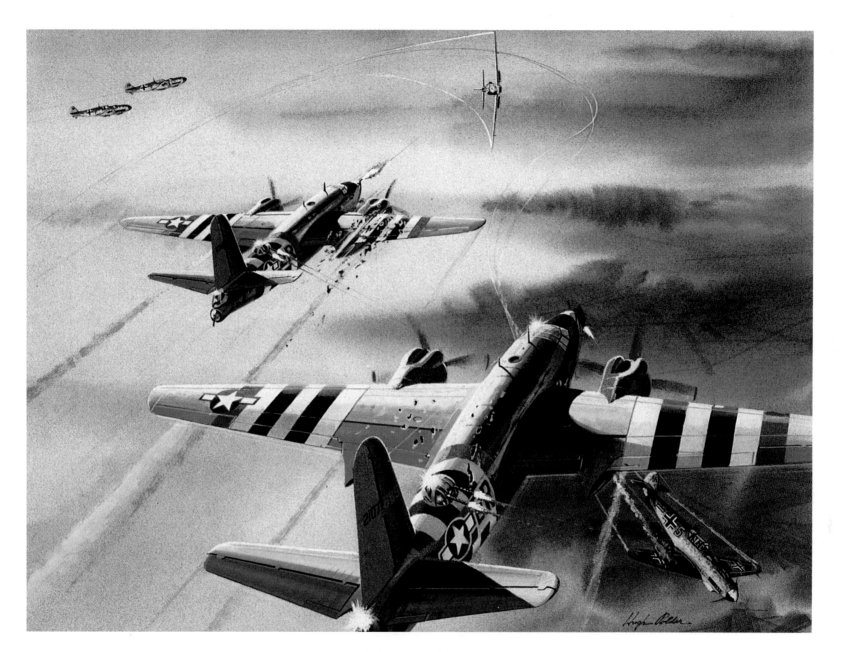

B-26s and Bf109s

Hugh Polder

This dramatic view shows a *Schwarm* of 109s attacking B-26s over France in 1944 (note the black and white invasion stripes on the wings). A *Schwarm* was composed of two two-unit cells (*Rotte*), comprising a leader (*Rotteführer*) and wingman (*Katchmarek*). They would often attack from head-on, as has happened here, a tactic that worked well until attacking large "boxes" of bombers, when much bigger units — *Gefechtsverbände* of more than 100 aircraft — were more effective. The Martin B-26 Marauder saw service from 1942, first as a torpedo bomber at the Battle of Midway. After a black day in 1943 when eleven Marauders failed to return from a mission over Holland, the B-26 was transferred to Ninth Air Force where it was discovered to be perfect for tactical support. It ended the war with the lowest light bomber loss rate in U.S. service.

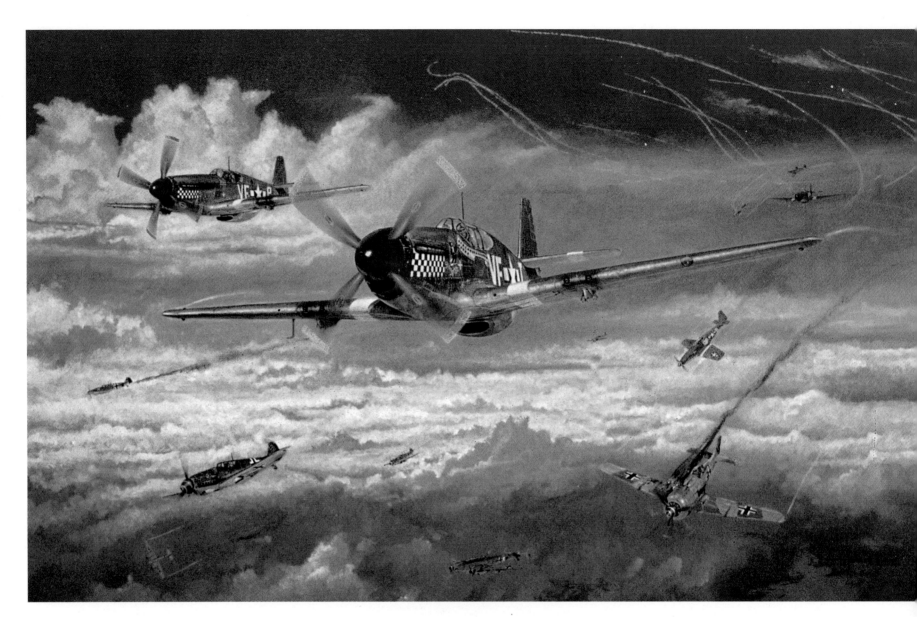

Gentile and Wingman

Henry Godines

Vibrant color and drama distinguish the work of Californian artist Henry Godines, a member of the American Society of Aviation Artists. By the spring of 1944, the 336th Fighter Squadron of the 4th Fighter Group had fully converted from the Republic P-47 Thunderbolt to the faster, sleeker P-51B Mustang. Two pilots who came to the fore and established their names during this crucial stage of the European air war were Don S. Gentile — seen here flying *Shangri-La* — and his wingman John T. Godfrey. They proved the importance of fighter teamwork above all else, and the 4th Fighter Group produced the best pair ever to fight over Germany. Göring is alleged to have said that he would gladly give two of his best squadrons for their capture. Gentile ended the war with thirty kills (seven on the ground); Godfrey with eighteen victories, with the same number destroyed by strafing.

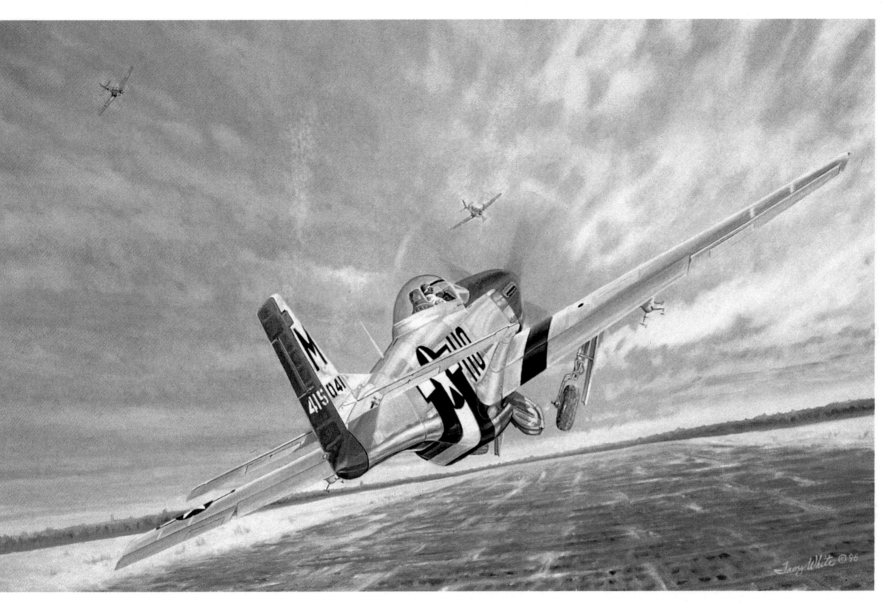

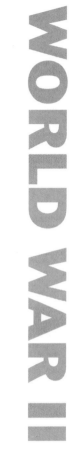

J. C. Meyer: The legend of Y-29

Troy White

Operating from forward airbases near to the front line in Western Europe, Allied pilots had established almost complete supremacy in the air by 1945. The Luftwaffe resorted to increasingly desperate attacks on these hastily constructed airstrips in the remaining four months of the war. An instant after rotating, with the wheels not yet fully retracted, Lt.-Col. John C. Meyer is faced with a head-on attack by a Focke-Wulf FW190. He shot down the German fighter, and led the 487th Fighter Squadron of the 352nd Fighter Group to a decisive victory over JG11 at Asch, Belgium that day — January 1, 1945. His oustanding leadership, foresight, and ability to anticipate the enemy's next move earned him a third Distinguished Service Cross for that day's work. Meyer's P-51 still carries the distinguishing invasion stripes on the rear fuselage, perhaps to indentify him as the squadron leader. Troy White has a Master of Fine Arts degree from Florida State and has been an aviation artist for over twenty-five years.

Above:
A Foggy Day

Charles J. Thompson

Right:
The Rochford Boys

Charles Thompson

The U.S.A.A.F. used many British-built aircraft. This Spitfire VB belongs to the 107th Squadron, 67th Reconnaissance Group and is pictured over London in 1943, a silvery River Thames just visible through the fog.

R.A.F. Rochford in eastern England (now Southend Airport) was the sometime home of No. 54 Squadron, R.A.F., during the Battle of Britain. The usual base for the squadron was further to the east, at Hornchurch, in Essex. For this interesting scene the artist posed his son and daughter-in-law to recreate what he felt it would have been like in the summer of 1940 when the squadron roared over the village, en route to intercept another incoming enemy formation.

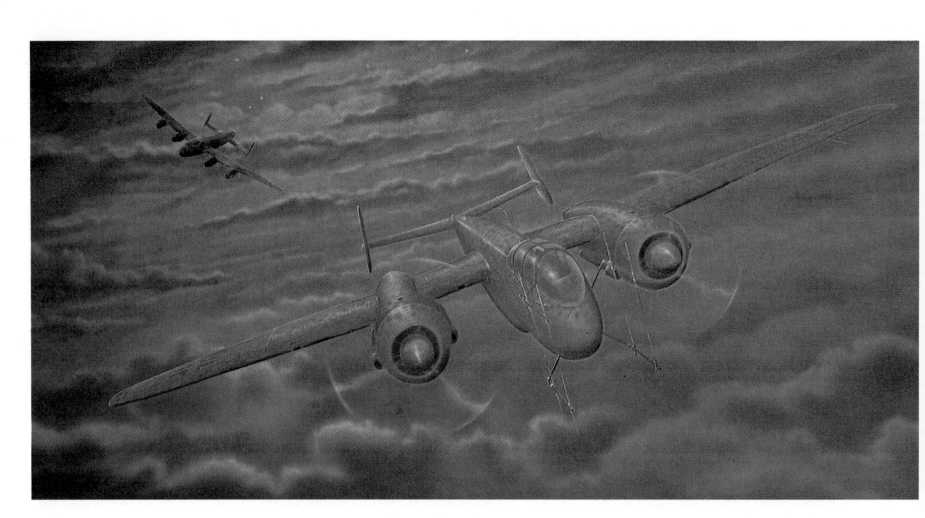

Hunter in the Night

Rick Ruhman

While the U.S. bomber forces attacked the Reich by day, their R.A.F. counterparts flew by night, forcing the Germans — as detailed on the next page — to develop nightfighter defences. The Heinkel He219 *Uhu* (Owl) was designed as a high altitude interceptor in the early years of the war but was retasked with a nightfighting capability in 1942. Production started in 1943, although only some 250 were built. Armed with six 30 mm. and two 20 mm. cannon, note the nightfighter's radar aerials in the nose. Fast, heavily armed and armored, and equipped with ejection seats, the innovative *Uhu* was, luckily for the Allies, a "too little, too late" venture for the Luftwaffe. Political infighting kept the He219 from large-scale production. It made its debut on June 11-12, 1943, when a single He219, piloted by Major Werner Streib, brought down five heavy bombers.

An intriguing, often repeated story, tells of the great popularity of the *Uhu* with its crews — so much so that the ground crew built six examples from kits in the last days of the war and they were flown unregistered and without orders. This painting shows one of those unregistered aircraft after an attack on an R.A.F. Lancaster.

Artist Rick Ruhman's father was a combat veteran and this led to interests in aviation photography and painting. Rick lives in California and is involved in vintage and warbird airshows.

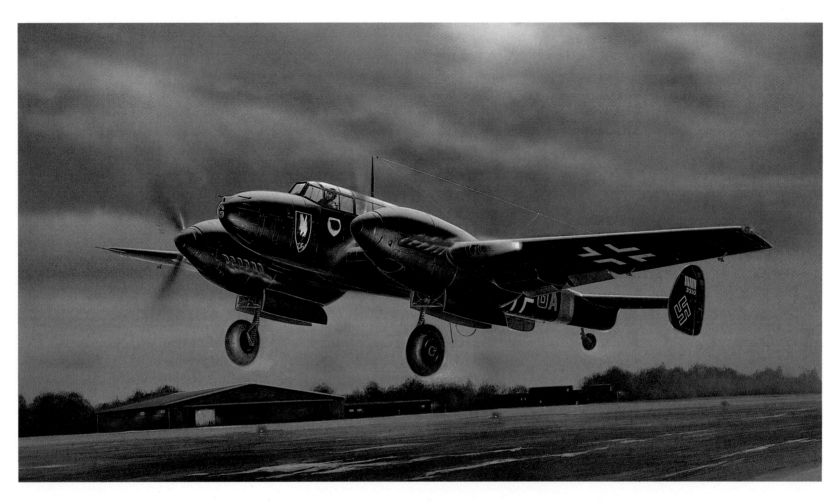

Wolfgang Falck, Messerschmitt Me 110

Jerry Crandall

Before the spring of 1940 the R.A.F. had no night-time opposition as the Luftwaffe had no nightfighter force. Wolfgang Falck, whose aircraft is depicted in this work by American aviation artist Jerry Crandall, formed an experimental nightfighter force to remedy this situation. Initially, their aircraft were not equipped with radar. Later specialized nightfighter variants of the Me 110 were introduced, distinguished by the forest of aerials on the nose fairing. Even without the benefit of radar, the unit met with success.

Wolfgang Falck had flown in the Soviet Union during the interwar period when German airmen trained at Lipetsk in clandestine units. Set up by General von Seeckt, the secret training base at Lipetsk housed 200 personnel, of which fifty were instructors, and fifty Fokker DXIII fighters — then the fastest fighter in the world. From Russia, he went back to Germany to train others and then commanded 5./JG2 "Richthofen," followed by III./JG2, which became ZG76 shortly afterwards, re-equipping with Me 110s. On June 26, 1940, Reichsmarschall Goering appointed Falck to form and command a new unit, Nachtjagdgeschwader 1 — a substantial promotion for a mere Hauptmann (Captain). He would go to various staff jobs and survive the war.

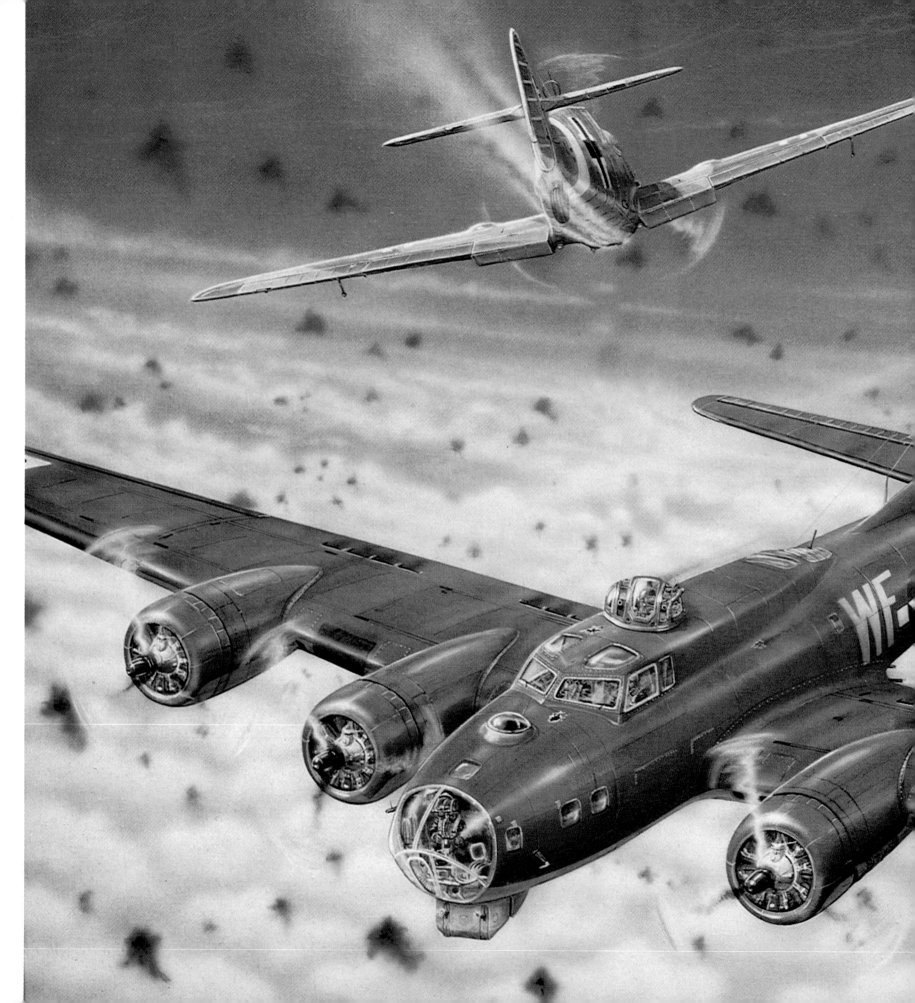

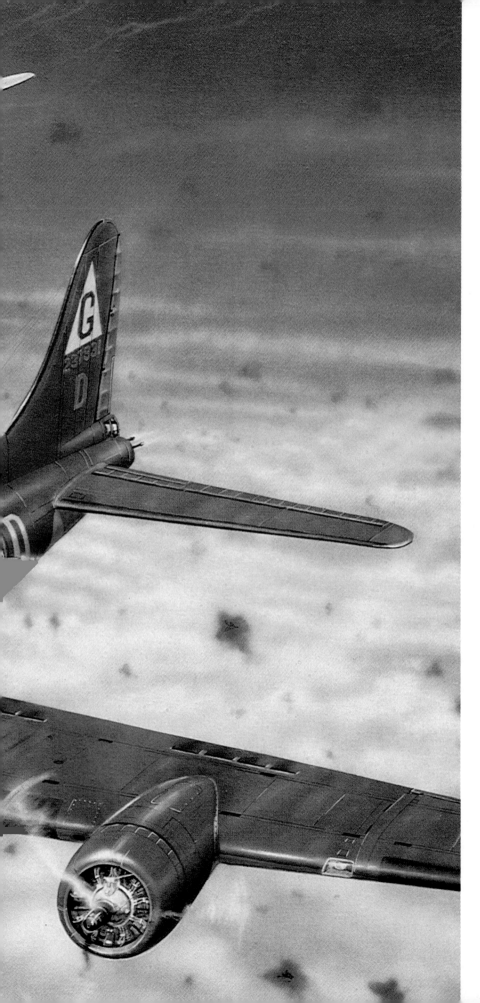

Point of no Return (The Miracle Mission)

Rick Ruhman

Painted for a close friend, Congressional Medal of Honor recipient Lt.-Col. Edward S. Michael, the artist shows the beginning of then Lt. Michael's ordeal in the air for which he received his country's highest military award. It is 10:55 hrs, April 11, 1944, and B-17G *Bertie Lee* of the 305th Bomb Group, 364th Bomb Squadron, is ten miles south of Berlin heading for Stettin, Germany. Part of a second wave of over 120 attacking fighters, a Messerschmitt Bf109 singles out Michael's bomber and hits it with 20 mm. cannon rounds. The hits severely wound Michael, knock out all but three cockpit instruments, cut two throttle controls and elevator linkage, knock out the top turret, and set the bomb load of forty-two 100 lb. incendiary bombs on fire.

At the same moment the B-17's top turret gunner, Jewel Phillips, and bombardier/chin turret gunner, John Leiber, hit the 109 and the fighter goes down with his plane severely damaged. Unable to jettison the burning bomb load, Michael orders his crew to bail out and seven leave the stricken bomber. Finding they now have only two serviceable parachutes among the three remaining crew (Michael, Lieber, and co-pilot Frank Westberg), they decide to ride it out together. Through a series of miracles the trio succeed in bringing their battered "Fort" back to a successful belly landing on the R.A.F. Lancaster base at Grimsby, England.

All ten crew members survived and Michael was presented the Medal of Honor in the White House by President Franklin D. Roosevelt. A gift from Michael and the artist to the U.S. Air Force, *Point of No Return* now hangs in the Hall of Honor in the Pentagon.

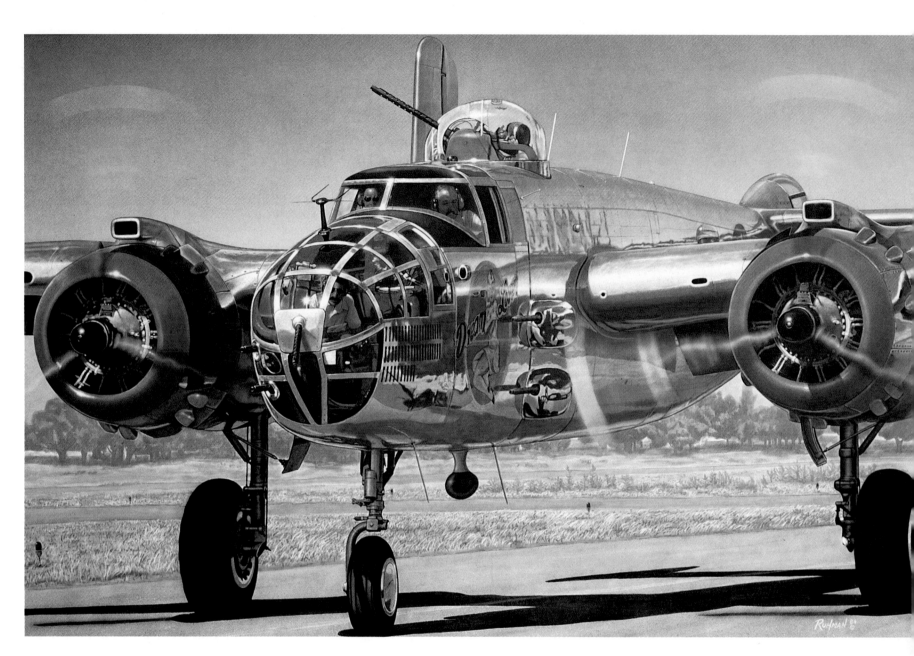

Above:
North American Thunder

Rick Ruhman

Right:
The Shepherd

Troy White

This gleaming North American B-25J Mitchell *Dream Lover* was one of over 4,000 of this model built between 1943 and 1945. Armed with thirteen 0.50 in. machine guns, it could carry up to 4,000 lb. of bombs. *Dream Lover* was meticulously restored by Jim Rickett and has been an important part of the warbird airshow scene.

Piloted by 1st Lt. Charles P. Bailey of the 99th Fighter Squadron, 332nd Fighter Group, a P-51D Mustang banks over a squadron of B-24 Liberators from the 451st Bomber Group as they fly over the Alps en route to Berlin. The 99th FS was the first all black fighter squadron to become operational in the U.S. Army Air Force — the original "Tuskeegee airmen."

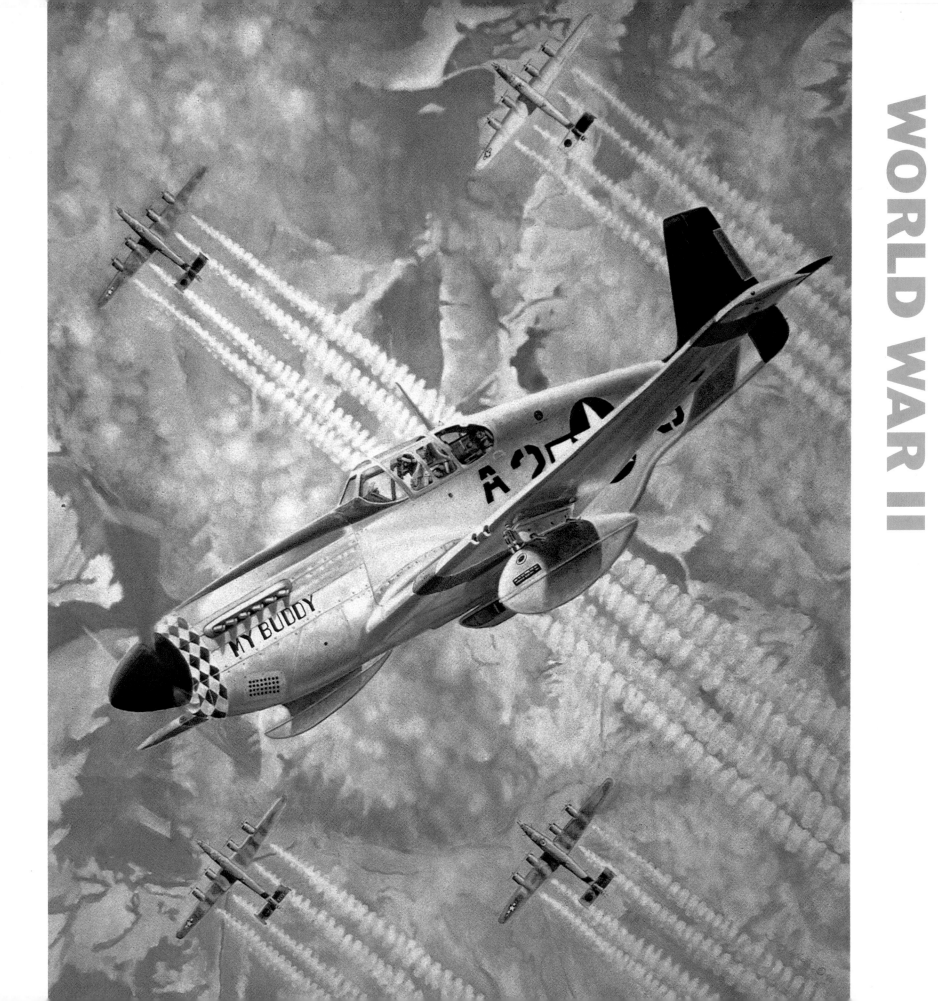

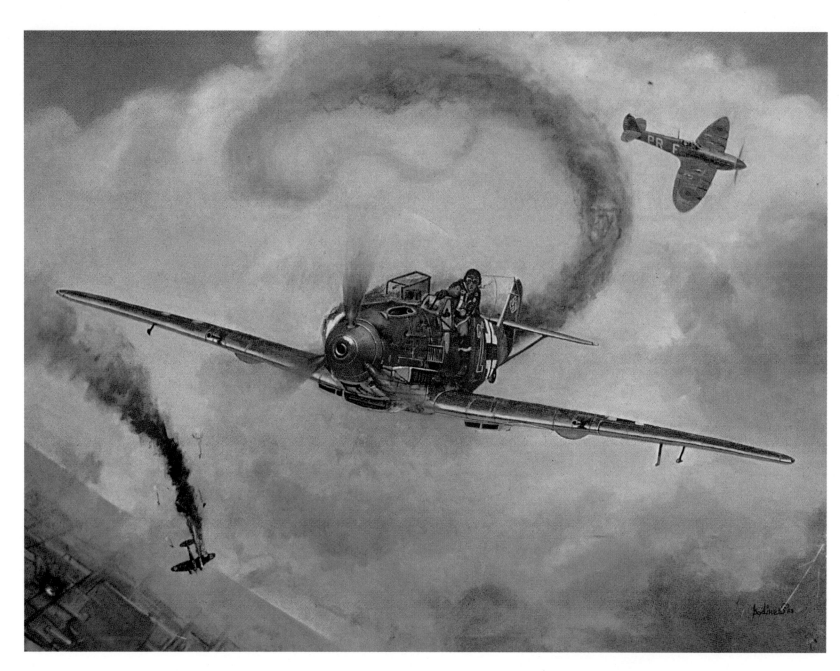

Above:
Early Days

Henry Godines

Another Battle of Britain scene shows a German pilot clambering out of his smoking Messerschmitt Bf109 before bailing out. The victorious Spitfire moves on to his next target.

Right:
For the Motherland

Henry Godines

The Ilyushin Il-2 *Shturmovik* was the most famous aircraft to appear in Red Air Force colors during the war. Well armed and well armored, the Il-2 was an excellent close-support aircraft. It was crewed initially by one man, but the cockpit was lengthened and a rear gunner added to operate a 12.7 mm. MG.

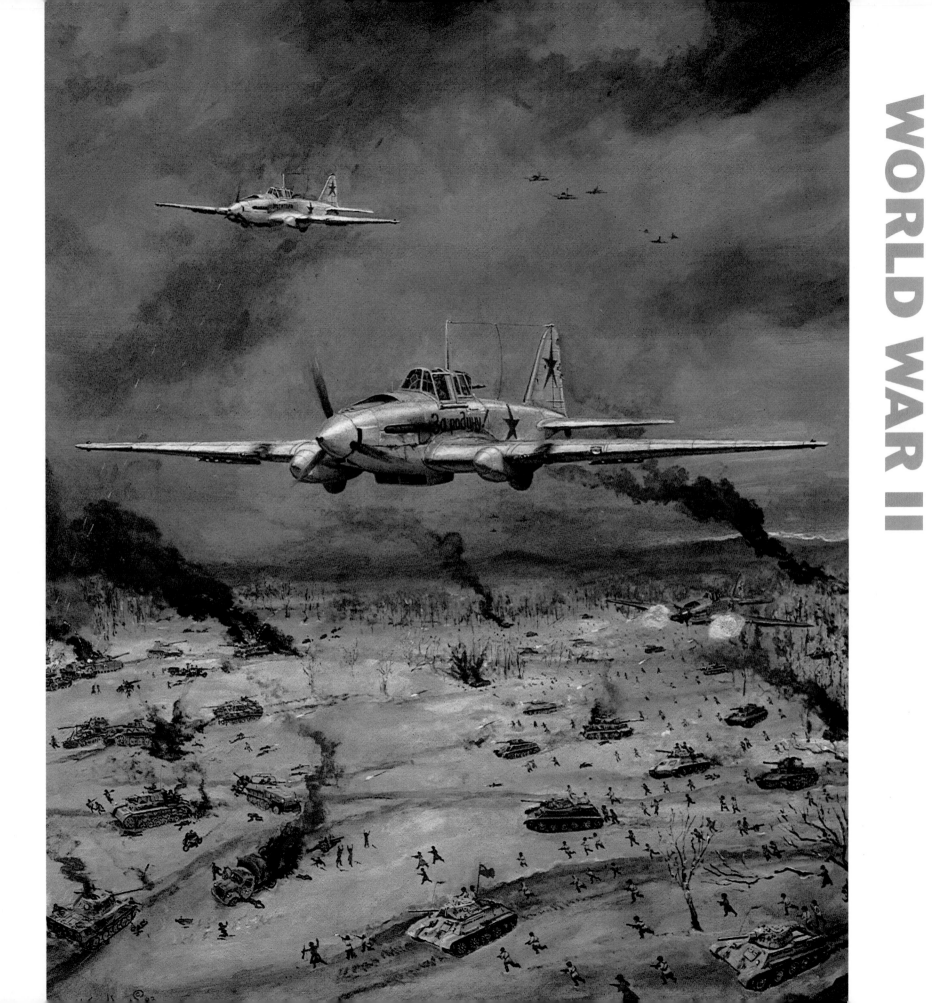

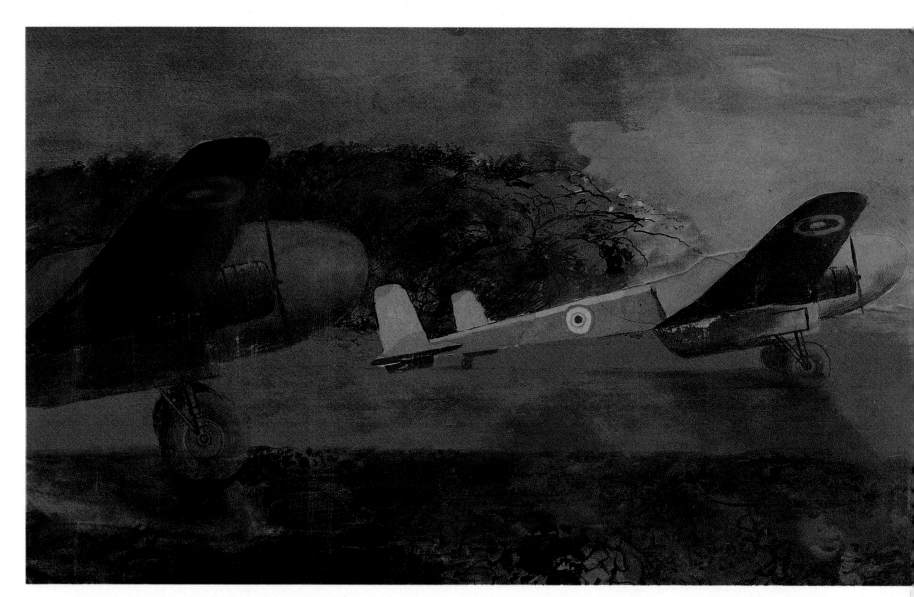

Above:
Picketed Aircraft

Graham Sutherland

Right:
Southern England, 1944. Spitfires Attacking Flying Bombs

Sir Walter Thomas Monnington

The Handley Page Hampden was the last twin-engined mono-plane bomber to go into service with the R.A.F. during Bomber Command's interwar rearming. Faster than most of its contemporaries, it was less well armed at first. Nevertheless, it served until 1943, latterly as a torpedo bomber. Influenced by Palmer and Blake, Sutherland (1903-80) painted World War II scenes as an official war artist from 1941 to 1944. His controversial 1954 portrait of Winston Churchill was destroyed by the great man's wife.

In June 1944, the rumors of a new German "terror" weapon became a reality: London's "Baby Blitz" began one week after D-Day. Operation "Crossbow" was launched by General Eisenhower in an attempt to eradicate the V-1 launch sites. Fighter pilots discovered that it was too dangerous to shoot down a V-1 from too close behind — less than 200 yards away. Another method was to fly alongside and place a wingtip under one of the bomb wings. By quickly banking away, the pilot could upset the bomb's balance causing it to crash.

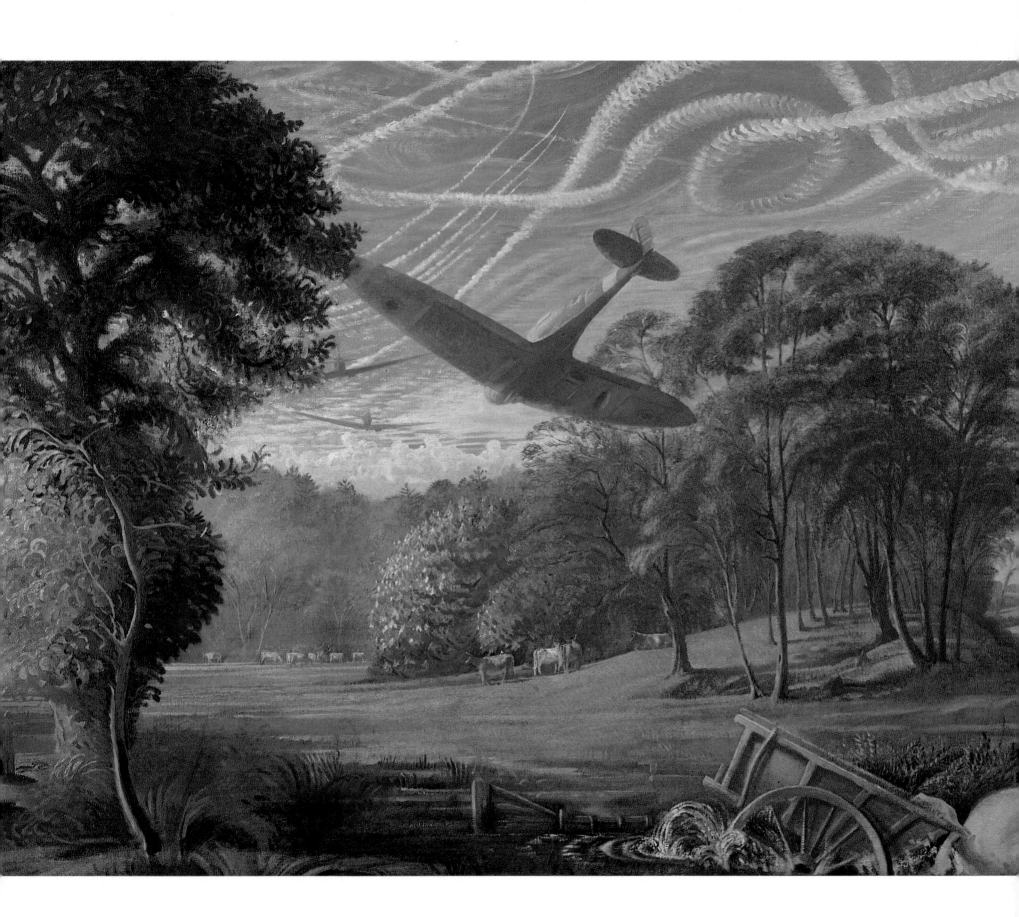

Hitting the Kwai

Craig Kodera

While there was no bridge over the Kwae Noi River, the classic film *Bridge over the River Kwai* was based on a true story. The bridge was built — Bridge No. 277, the Kanchanaburi Bridge along the Thailand-Burma Death Railway. Here that bridge is under attack by B-24 Liberators. Designed in 1939, the B-24 entered service in 1941 and when production stopped on May 31, 1945, over 19,000 Liberators had been built — more than any other U.S. aircraft in history.

Artist Craig Kodera's uncle was the second in command of the famous carrier-launched Doolittle raid on Tokyo, and with a background like that it is unsurprising that he became a flier himself, being commissioned into the Air Force Reserve before going on to fly for American Airlines.

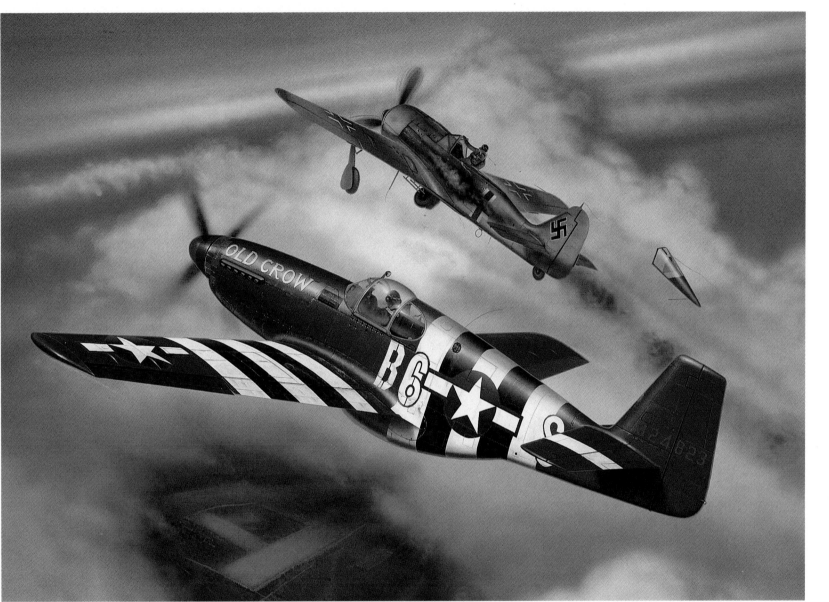

C. E. "Bud" Anderson's P-51B *Old Crow*

Jerry Crandall

The scene depicts June 29, 1944, the day that "Bud" Anderson downed no less than three Focke-Wulf FW190s over Leipzig, while flying with the 363rd Fighter Squadron, 357th Fighter Group. The FW190 pictured is Anderson's second that day, his eleventh overall (he would finish the war with 16.25): the canopy has come away and the pilot is climbing out of the cockpit. Still wearing its invasion stripes in this work, *Old Crow*, Anderson's aircraft, is a P-51B. A second generation Mustang, the P-51B was fitted with a Packard-built Rolls-Royce Merlin engine. With this engine, the potential of the Mustang was finally realized and it went on to become one of the most effective fighter aircraft ever built.

Canadian Corsair

Charles J. Thompson

The Chance Vought F4U Corsair was the most powerful single-seat naval fighter/bomber of its generation; indeed, it was the last piston-engined fighter built in the U.S.A. It entered production in 1941 and first flew operationally in 1943. Over 12,000 were built, of which over 2,000 went to the R.Nz.A.F. and R.N., where they equipped some nineteen Fleet Air Arm squadrons. This restored R.N. Corsair is seen at Hamilton, Canada.

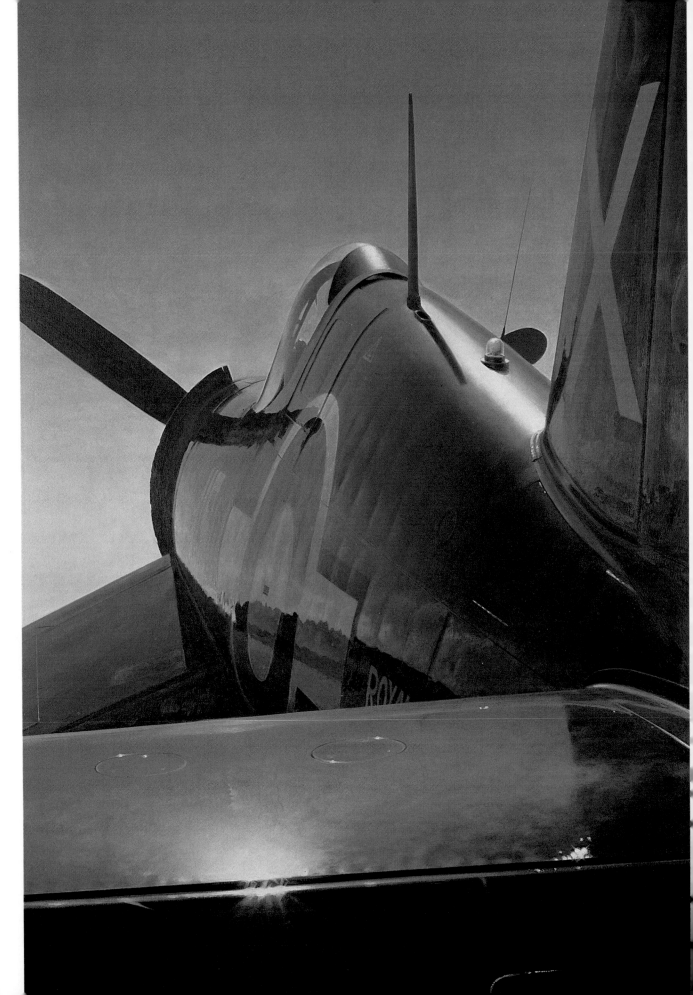

Milne Bay

Charles J. Thompson

July, 1942: the Japanese campaign in Papua New Guinea is threatening to take Port Moresby, the last step before Australia. The Japanese, in an attempt to outmaneuver the Australians holding the port, landed at Milne Bay at the eastern tip of Papua. Two squadrons of Royal Australian Air Force P-40 Tomahawks flew close support missions to drive back the attacking forces which were at times only 100 yards from the airfield perimeter.

Alpine Armada

Charles J. Thompson

Boeing B-17 Flying Fortresses of the 4th Bombardment Wing, U.S.A.A.F. flying over the Alps to bases in North Africa on August 7, 1943. At this early stage in the air offensive against Germany the Americans were experiencing heavy losses during their daylight raids. As a ruse to try and fool the German interceptors it was decided that some of the wing should fly on to North Africa, rather than returning to England, following the completion of their bombing of Regensburg.

B-29 Superfortress *Dinamight*

Hugh Polder

The Boeing B-29 Superfortress was the heaviest of World War II's combat aircraft and made its first flight in 1942. It began operations in mid-1944 and would be the chosen vehicle for the two atomic bombs dropped on Japan at the end of the war. Armed with twelve 0.50 in. machine guns and a 20 mm. cannon, the B-29 could carry around 12,000 lb. of bombs. Here, a B-29 is under attack from Kawasaki Ki.61 *Hien* (Swallow) aircraft. The Ki.61 was codenamed "Tony" by the Allies.

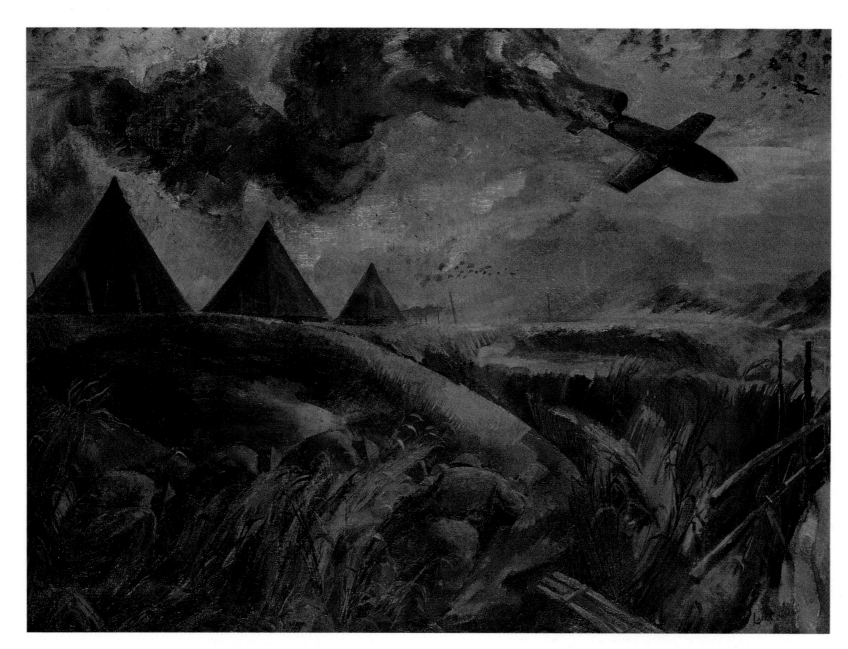

Above:
**Battle of London: Royal Marine AA Gunners
bring down a Flying-bomb**

Leslie Cole

Right:
Major Hans Ulrich Rudel's Ju87B—2

Hugh Polder

It was no easy task to shoot down a V-1. The best chance was on the south coast. By July 19, 1944, there were some 1,600 guns ranged against the threat of the flying bombs. Cole's work shows a burning missile tumbling down among the fields. Anti-aircraft fire accounted for at least 500 of these weapons.

The Junkers Ju87 is better known by an abbreviation of the German for dive bomber — *Sturzkampfflugzeug* — Stuka. As the principal close support aircraft of Blitzkrieg, no one who experienced a Stuka attack will forget the fear inspired by these ugly, awkward little aircraft.

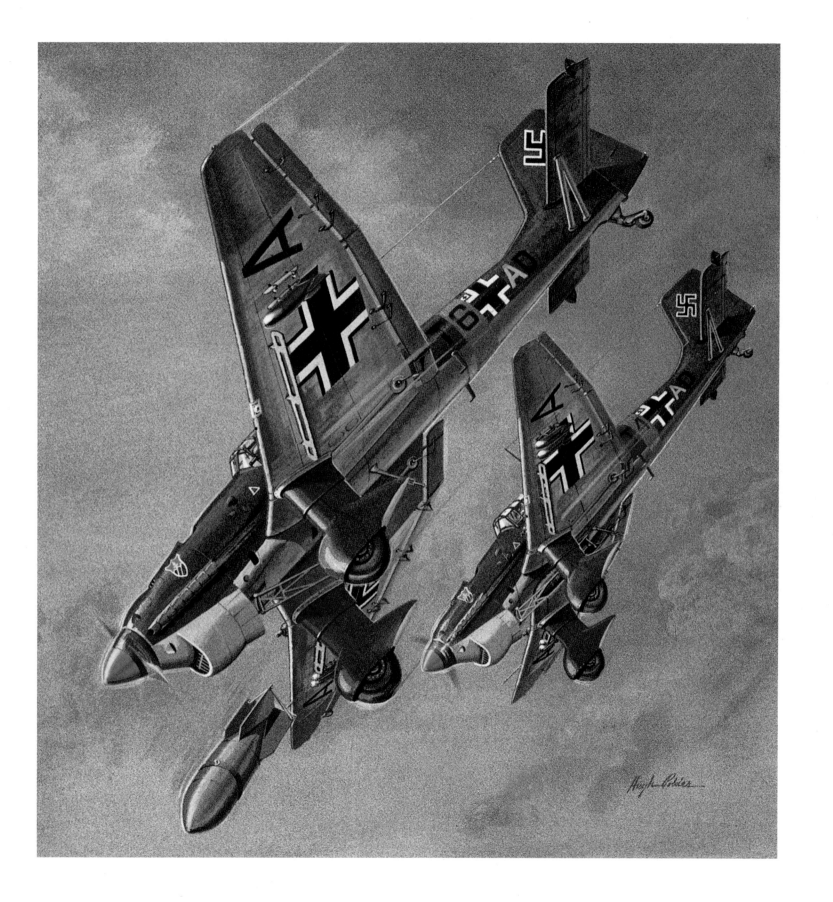

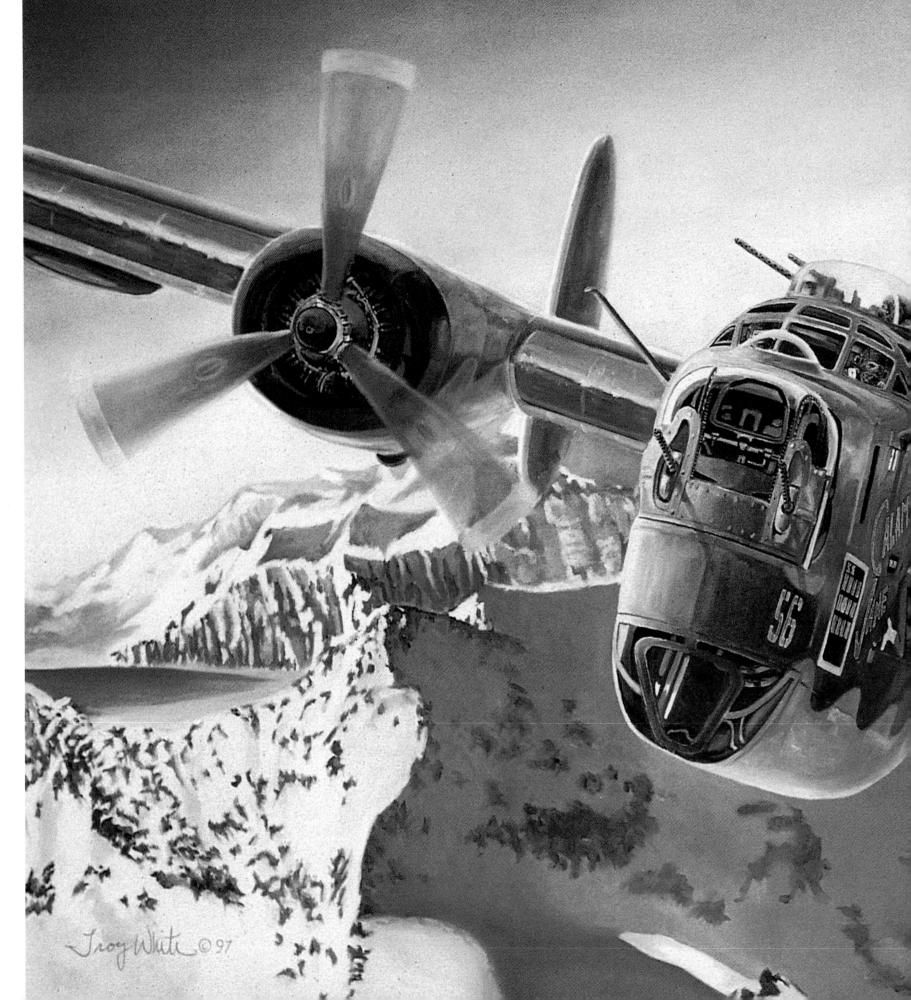

Calamity Jane's Coming Home

Troy White

An interesting view of a B-24 Liberator set against the picturesque Italian Alps. The heavy defensive armament of the B-24 is well illustrated — with nose and mid-upper turrets visible. The aircraft pictured is *Calamity Jane*, one of the aircraft serving with the 725th Bomber Squadron, 451st Bomber Group at Castellucio Airfield in Italy in late 1944. Superlatives abound for the Liberator, most of which have been used countless times. Towards the end of 1944, the total U.S. B-24 inventory was more than 6,000 aircraft, equipping some forty-five bomber groups.

Above:
Spitfires at Sawbridgeworth, Herts

Eric Ravilious

R.A.F. Spitfires in their dispersal areas at the wartime base at Sawbridgeworth in Hertfordshire. The aircraft are most likely Mk. IBs, indicated by the twin cannon armament in the wings and the early pattern insignia. Eric Ravilious was one of the few war artists to die on active service.

Right:
Sumatra Scramble

Charles J. Thompson

On January 11, 1942, the Japanese began a relentless drive through the Dutch East Indies that ended in March with complete victory. On the evening of February 16, Japanese paratroops took Palembang airfield. Charles Thompson's painting shows Hurricanes scrambling to counter the attack.

WORLD WAR II

Black Sheep Sweep

Troy White

Lt. John Bolt and Maj. Henry Miller of VMF-214 begin their dive on a formation of Japanese "Zekes" — better known not by this Allied codename but as the Mitsubishi A6M Zero, the classic Japanese fighter of World War II, over 10,000 of which were built. The action is taking place over the St. George's Channel on December 23, 1943 and in the ensuing battle Lt. Bolt shot down two and Miller one. That day, the Black Sheep squadron downed eleven "Zekes' and two "Tonys" — the latter being the codename for the Ki61. Bolt would score six during World War II and added six MiGs in the Korean War, making him the only Marine two-war ace.

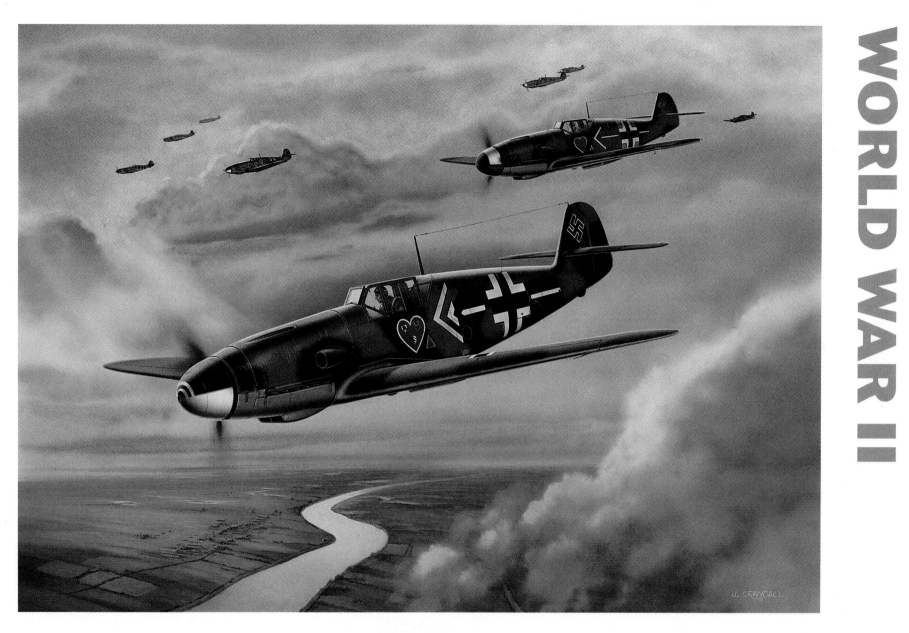

JG54 Green Hearts

Jerry Crandall

JG54 and its commander, Hannes Trautloft, have become a legend in the annals of Luftwaffe history. Taking their name from their commander's home in Thuringia, the *Grünherz* — green heart — of Germany, the unit scored more than 4,000 victories by mid-1943. By the end of the war, the *Grünherz* total stood at more than 9,600. In July 1943, Trautloft was taken off combat duties and in November became Inspector of Day Fighters. In this scene he is leading a flight of Messerschmitt Bf109F-4s over Rijelbitzy Airfield, Russia, during the summer campaigns of 1942.

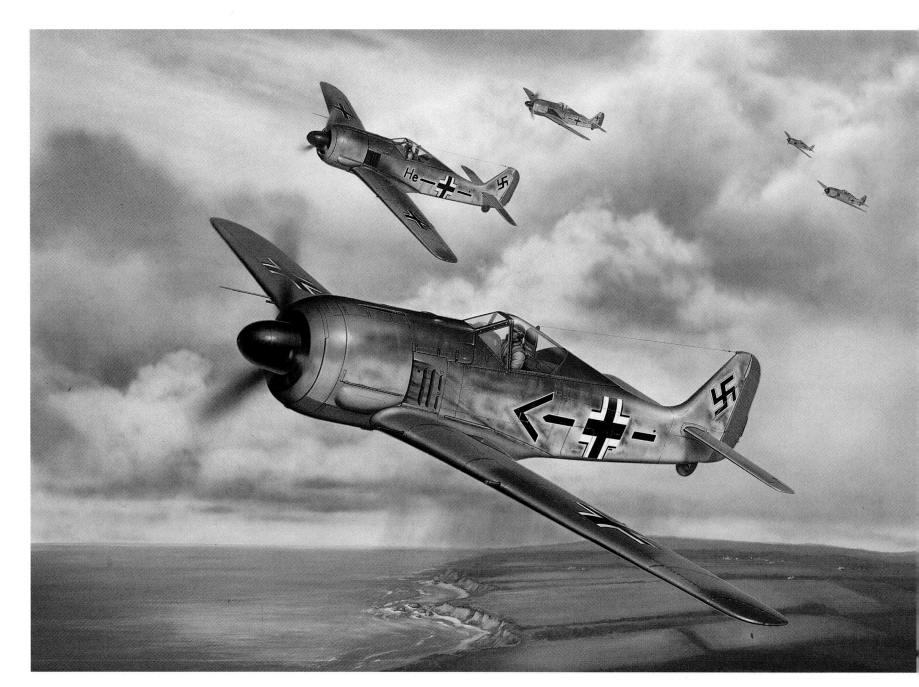

The Abbeville Kids

Jerry Crandall

JG26 was one of the most feared of all Luftwaffe wings. Led at various times by Adolf Galland, Gerhard Schöpfel, and "Pips" Priller, the wing gained a fearsome reputation with R.A.F. pilots during the Battle of Britain, and later with U.S. pilots. Aircraft operating out of Abbeville had engine cowlings and rudders painted yellow for identification purposes, earning them the dubious nickname of "the yellow-nosed bastards." During summer 1941, II./JG26 received the first FW190As. Although the aircraft suffered from overheating problems, it was far superior to the Spitfire V, at that time the best the R.A.F. could pit against it.

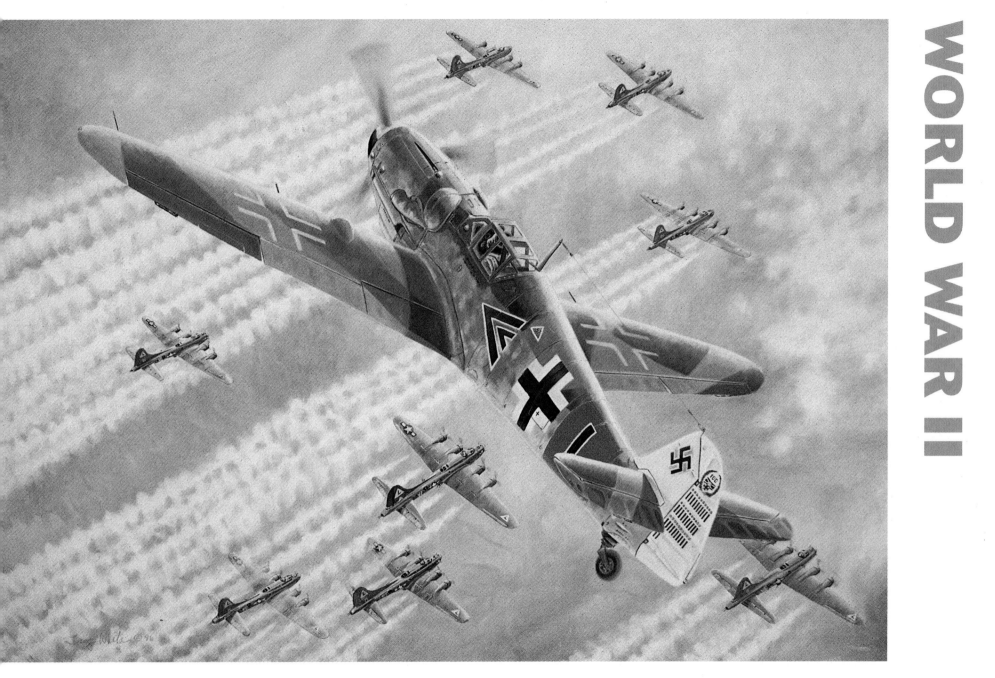

Dicke Autos! (lit: "Fat Cars")

Troy White

At high altitude, Gruppenkommandeur Anton Hackl banks his Bf109 "Gustav" over a formation of 381st Bomb Group B-17s. On January 11, 1944, this group lost eight Fortresses on a mission to Oscherleben. The B-17s in White's painting are unescorted, but following the raid, long-range fighter escort in the shape of the P-51B Mustang became available. With its arrival, the U.S.A.A.F.'s bombing force dominated aerial combat over Europe and Luftwaffe losses soared. However, experienced pilots like Hackl remained a serious threat. He was credited with 192 confirmed kills, thirty-four of which were four-engined bombers.

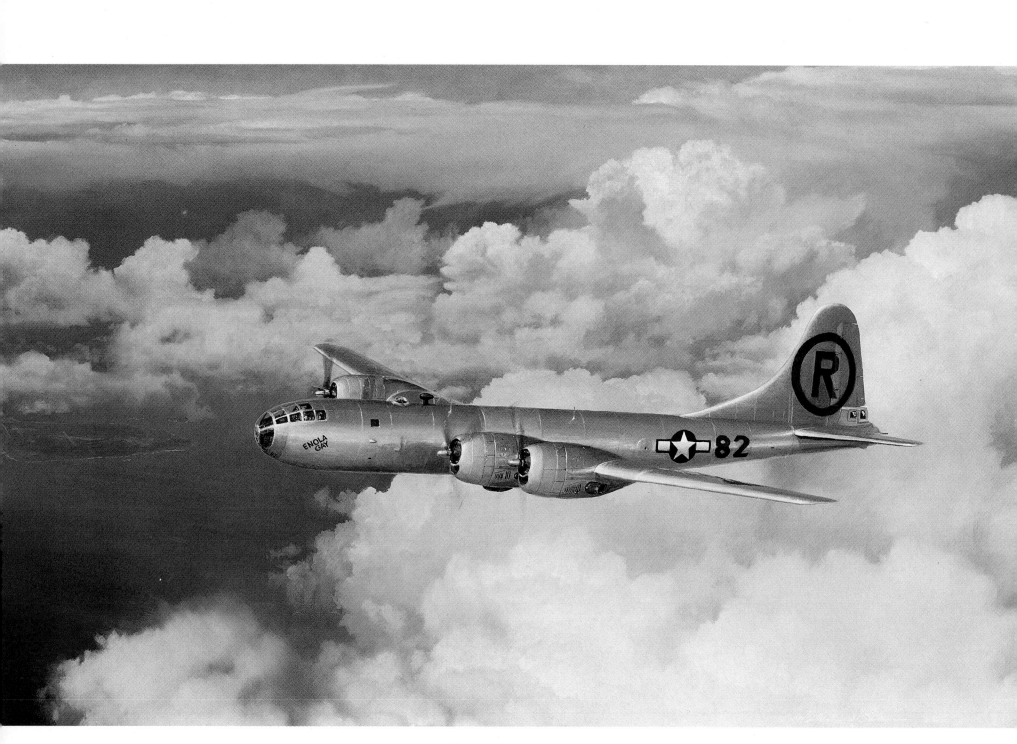

The Beginning of the End

William Phillips

Enola Gay was the name of the B-29 Superfortress that dropped the first atomic bomb — *Little Boy* — on Hiroshima. Piloted by Colonel Paul Tibbets, *Enola Gay* left Tinian in the Marianas early on the morning of August 6, 1945. The bomb exploded at 08:15 hrs and flattened forty-seven square miles in seconds. Three days later a second bomb was dropped on Nagasaki: the combined death toll of nearly a quarter of a million convinced the Japanese that further resistance was futile.

On the Prowl

Troy White

Lt. Leo Martin Ferko of squadron VC-4 defends his carrier, U.S.S. *White Plains,* against Kamikaze attacks on October 25, 1944, during the decisive Battle of Leyte Gulf. The battle was the largest clash of naval forces in history, and ended effective Japanese naval operations in the Pacific. In Troy White's painting, Ferko has just crippled a Nakajima B6N "Jill," moving his score for the day up to two. Grumman's "cat" family was the mainstay of the U.S. Carrier Groups throughout the war. The Wildcat was the first in the family, which also spawned the Hellcat and Bearcat. Tough, reliable, and maneuverable, the pugnacious Wildcat made a significant contribution to the Pacific War.

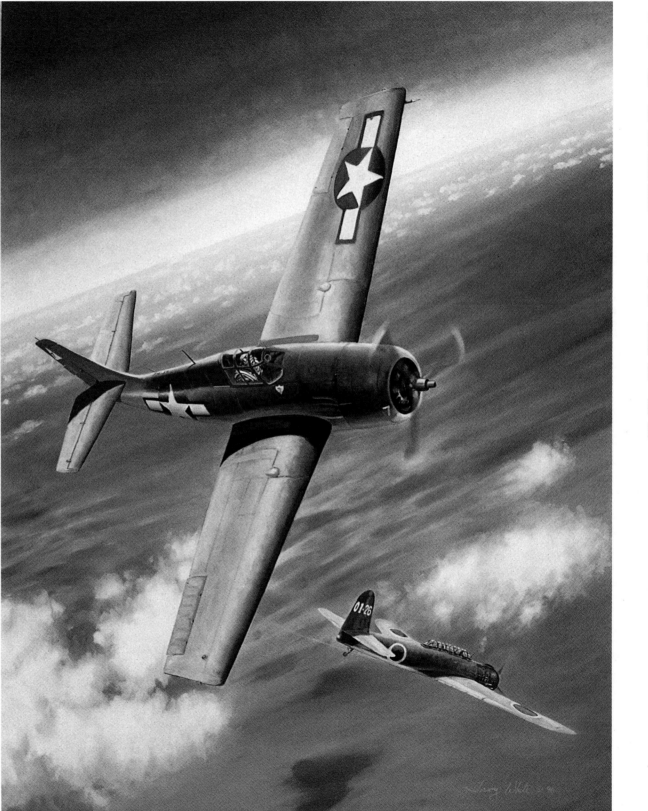

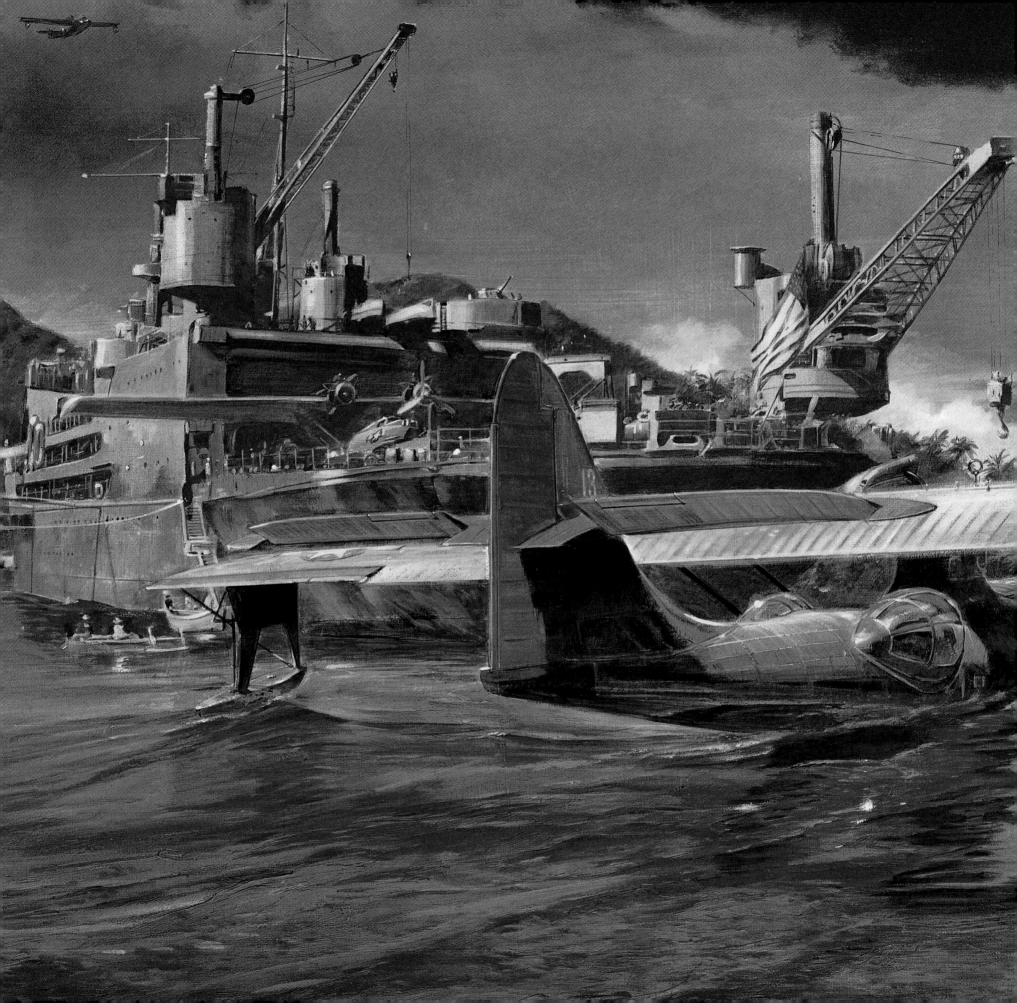

Safe Harbor

James Dietz

This superb painting shows in minute detail the arrival of a Consolidated PBY Catalina at a waiting seaplane tender. These tenders moved from island to island and were able to provide the "Cats" with parts and maintenance that forward bases couldn't. Long in the tooth by the time the United States entered the war, the first of more than 3,000 PBYs flew in 1936. They saw service as bombers, torpedo carriers, escorts, anti-submarine aircraft, in the air/sea rescue role, and as freighters. They were invaluable as long-range reconnaissance aircraft in the Pacific theater.

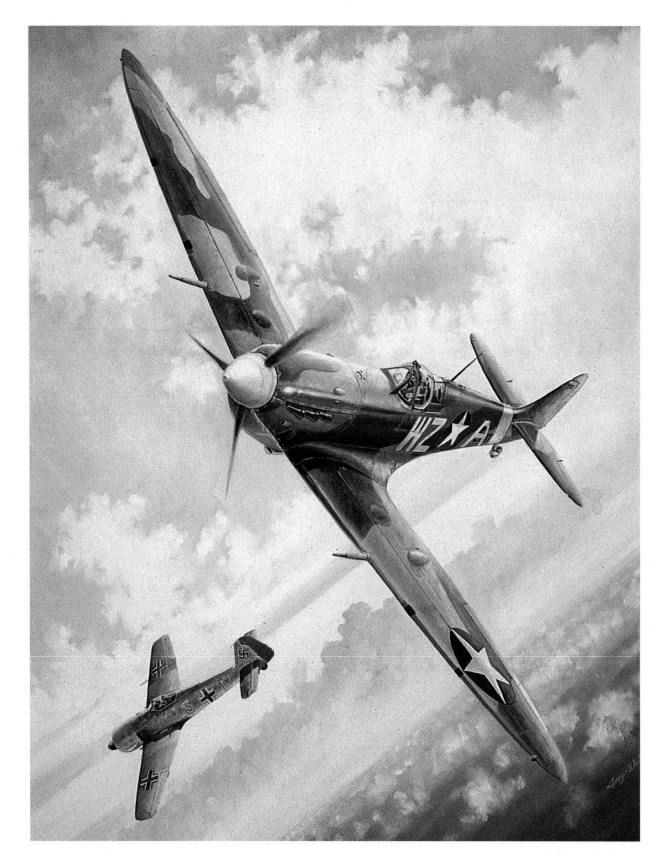

First Encounter

Troy White

On August 8, 1942, the 8th Air Force scored its first victory against the Luftwaffe. The 309th Fighter Squadron, 31st Fighter Group ran into FW190s from III./JG2 "Richthofen" and engaged them over the Channel. Captain Harrison Thyng damaged one of the German aircraft and thus became the first American pilot to enter a claim against the Luftwaffe. At this time the 31st Fighter Squadron was operating the Spitfire Mk. V, an aircraft that was decidely inferior to the FW190. Thyng went on to score six victories in World War II, and shoot down five MiG-15s in Korea.

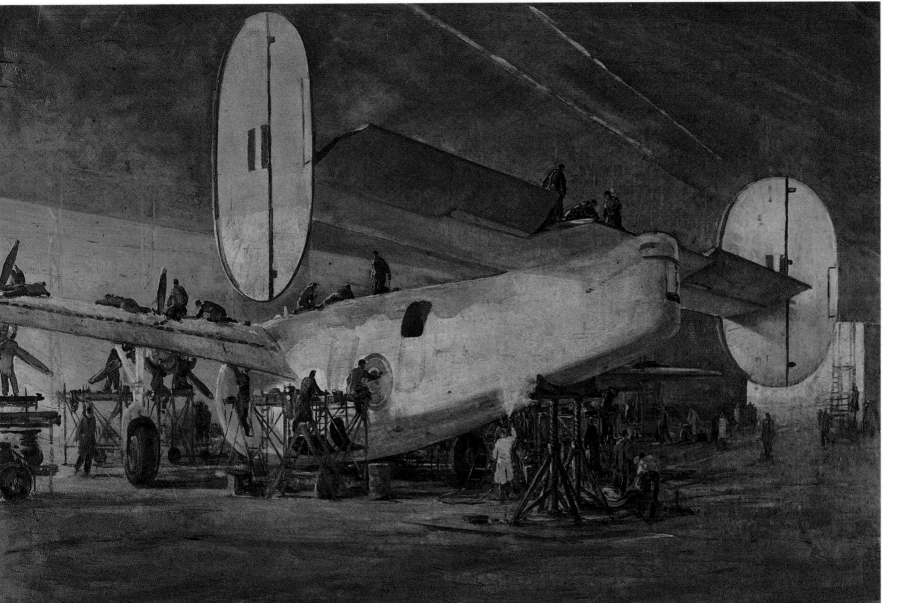

Servicing a Liberator

Charles Ernest Cundall

A Liberator, painted in the colors of R.A.F. Coastal Command, in a darkened hangar. Cundall captures the measured haste of the service crew as they work to prepare the aircraft for another marathon flight over the North Atlantic. Such aircraft helped to close the Atlantic Gap, and to bring Britain back from the brink of defeat in the Battle of the Atlantic. The Liberator was by far the most complex and expensive combat aircraft in the world when it was introduced to service in March 1941. Despite this fact, it was built in bigger numbers than any other Amercan aircraft in history, in more versions for more purposes than any aircraft in history, and served on every front in World War II and with every Allied nation.

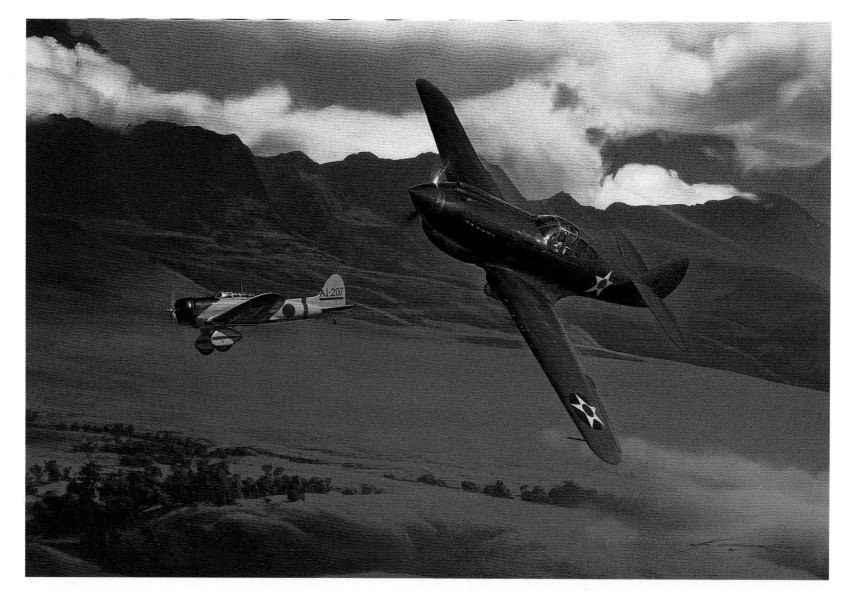

Above:
This is No Drill

Craig Kodera

The pre-emptive strike by the Japanese on the United States' naval assets at Pearl Harbor in the Hawaiian Islands on December 7, 1941, was an audacious plan. The result — eighteen warships and 187 aircraft destroyed, 2,400 service-men killed — was, indeed, a date which will live in infamy. But the strike missed the carriers which would go on to prosecute the war against the Japanese. Here, a Curtiss P-40B and a Japanese Aichi D3A "Val" are seen above Oahu island.

Right:
Battle over Malta, 1942: Spitfire attacking Ju88s but in a dogfight with Me 109s

Denis A. Barnham

This is a memorable wartime work, with its Messerschmitt Bf109 hanging like a cross in front of the diving Spitfire cock-pit interior. Behind the 109, Junkers Ju88s dive towards the white cliffs. The Ju88 was more versatile than most aircraft produced by the Germans. Intended as a bomber, and used as such in the Battle of Britain, the Ju88 became a nightfighter, a close support aircraft, and was also used for reconnaissance.

AVIATION ART

Tracy White © 97

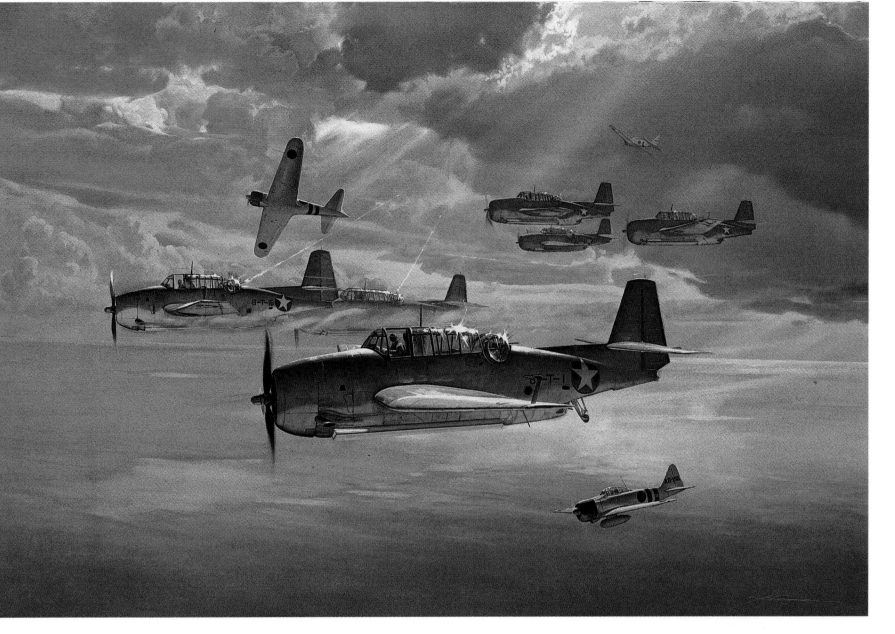

Left:
Moonlight Serenade

Troy White

One of the final actions in the air war over England took place on the night of March 16-17, 1945. Flg. Off. Eric Loveland, R.A.F., in an N.F. Mk. 30 Mosquito, intercepted a Ju88. In bright moonlight and with the help of radar Loveland and his navigator Jack Duffy attacked and brought down the intruder.

Above:
Only One Survived

Craig Kodera

The Battle of Midway was the turning point of the Pacific War. It started with the interception, at 07:00 hrs, on June 4, 1942, of VT-8 Squadron Grumman TBF Avengers by Japanese Mitsubishi A6M Zero fighters. Only "A-T-I" survived the encounter, but the U.S. Navy would go on to win the day.

Thumbs up over Normandy

Charles J. Thompson

Together, these two paintings form a diptych showing a panoramic view of the Normandy beachhead. The aircraft are: North American B-25 Mitchell III of No. 226 Squadron, R.A.F., operating from Hartford Bridge, Hampshire on "No Ball" sorties. (Below left. "No Ball" was the codename for attacks on V-weapon sites.) De Havilland Mosquito P.R. Mk. XVI of the 653rd Bombardment

Squadron (L) of the 25th Bombardment Group, U.S.A.A.F., operating out of Watton, Norfolk, on weather reconnaissance duties (Above left). Also shown is a North American P-51C Mustang III of No. 306 (Polish) Squadron, R.A.F., operating out of Coolham, Sussex, on armed reconnaissance. (Above: No. 306 "Torunski" Squadron was the first Polish unit to receive the Mustang.) Making up the quartet is a Spitfire Mk. VB of No. 85 (Base) Group 2nd Tactical Air Force (2TAF) Air Spotting Pool flown by a pilot of VCS-7 — U.S. Navy Cruiser Scouting Squadron 7 — on gun spotting duties. 2TAF was a force formed from R.A.F. and U.S. units during the preparations for the invasion. Below the flight a glider force can be seen heading for its landing zones; in the gray waters of the Channel, ships roll in toward the shore.

Above:
The Overhaul

Henry Lamb

Overhauling a Lysander — used in a clandestine role to carry agents and arms at night to the the resistance movement in France — by a highly regarded member of the Royal Academy.

Right:
Corsair Aircraft with Folded Wings in Hot Sunlight

Leonard Henry Rosoman

Another Royal Academician, Rosoman pictures a Chance Vought Corsair of the F.A.A. The U.S. designation for aircraft supplied to Britain under the Lend Lease scheme was F4U-1B.

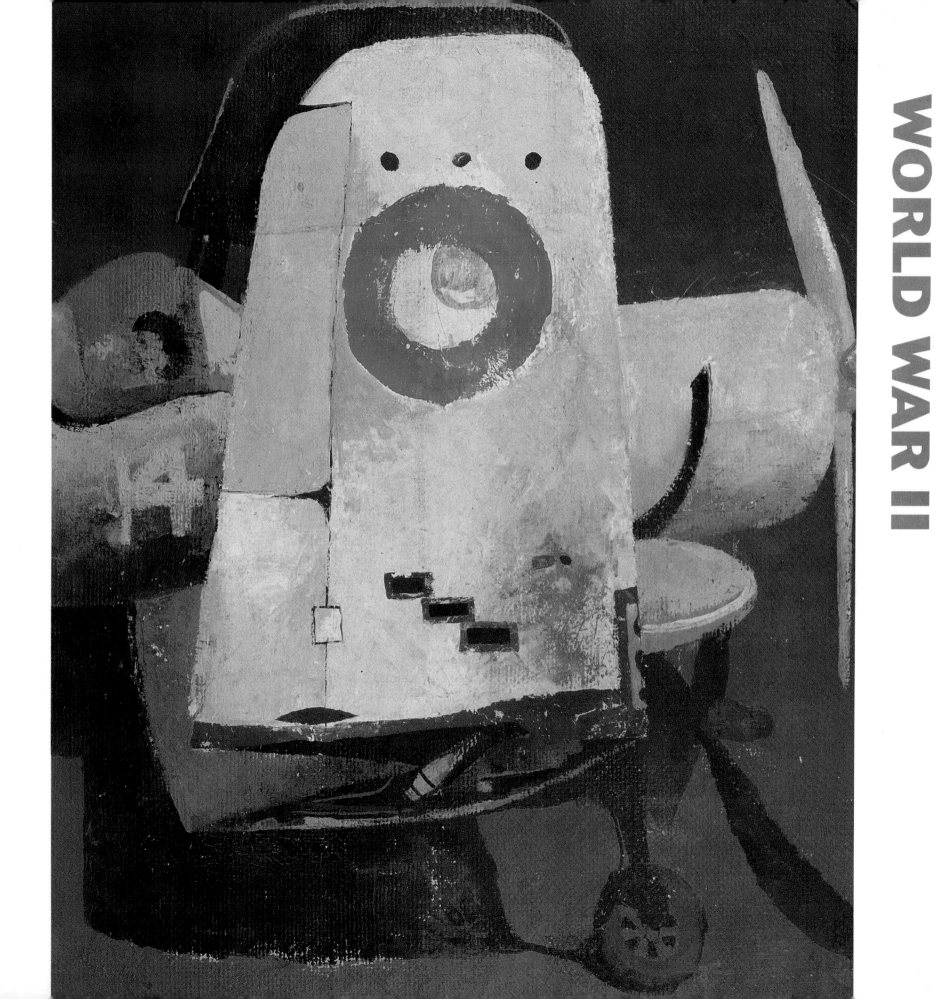

WORLD WAR II

Rochford Rendezvous

Charles J. Thompson

Thompson returns to one of his favored topics for this study. Two flights of Spitfires are seen banking over the Thames Estuary near Southend Pier in 1940. A convoy begins to form up out at sea. The cloud is nicely observed.

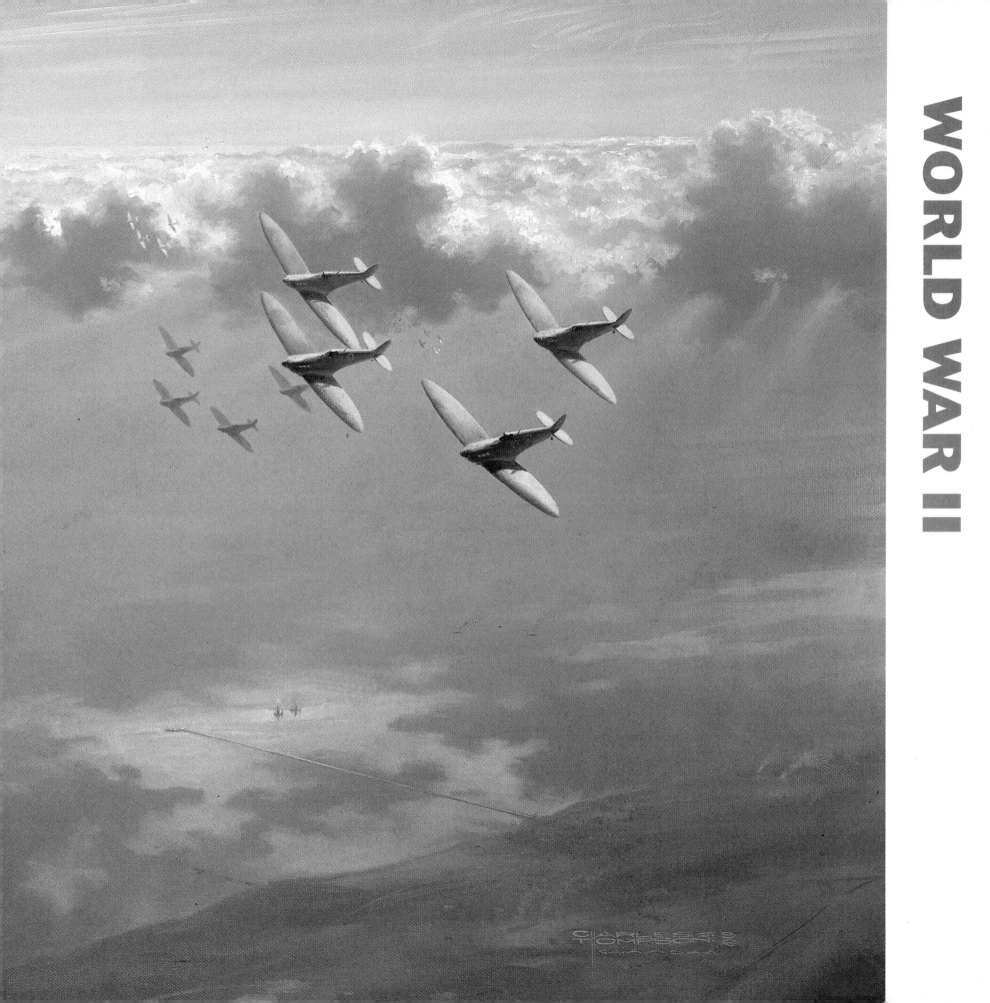

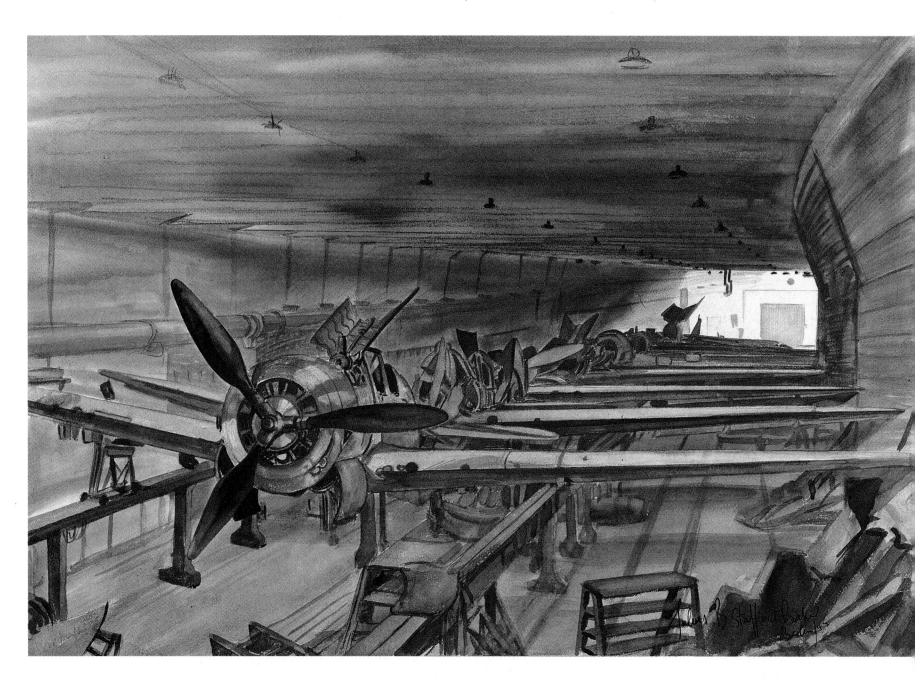

The aircraft works under Tempelhof Airport, Berlin

Julius Barkis Stafford-Baker

As the intensity of Alllied bombing attacks mounted during 1944, many German factories were forced to seek shelter deep underground. This watercolor, painted soon after the German surrender, shows Focke-Wulf FW190s under construction in a concrete bunker underneath Berlin's main airport.

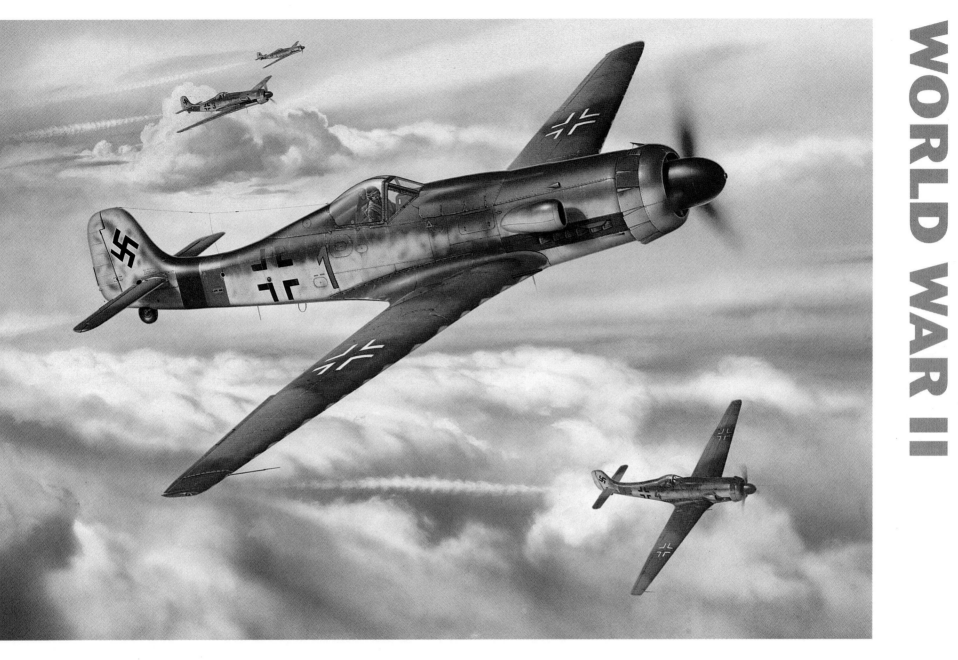

JG301 *Stabsschwarm* **Ta152**

Jerry Crandall

Further improvements to the FW190D series airframe to provide an even better performance at high altitude led to the introduction of the Ta152. The first unit to receive the graceful new fighter was the staff flight (*Stabsschwarm*) of JG301, one of the units tasked with home defense. One of the most prominent roles of JG301 was the defense of bases used by Messerschmitt Me262s, which were particularly vulnerable during take-off and landing. Although its pilots scored some notable victories over the Tempest V and the potent YAK-9, the unit could not expect to compete in the face of overwhelming odds. The aircraft in the foreground is that of Knight's Cross winner Willi Reschke, who achieved twenty-eight kills in only seventy missions.

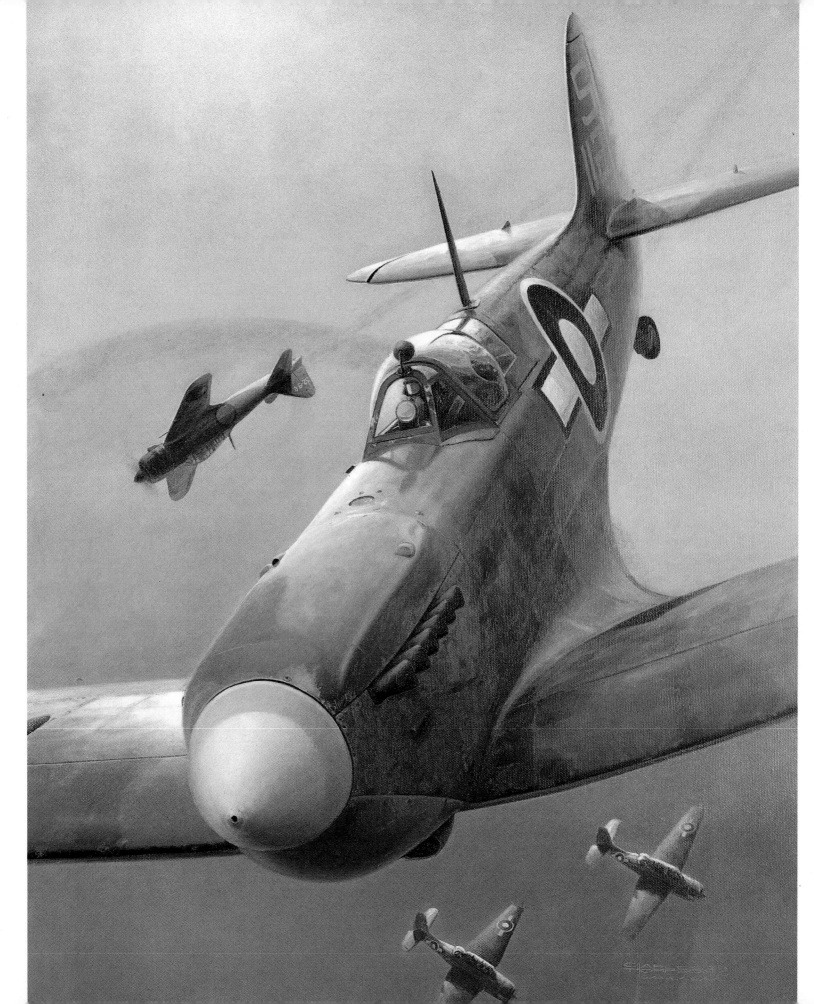

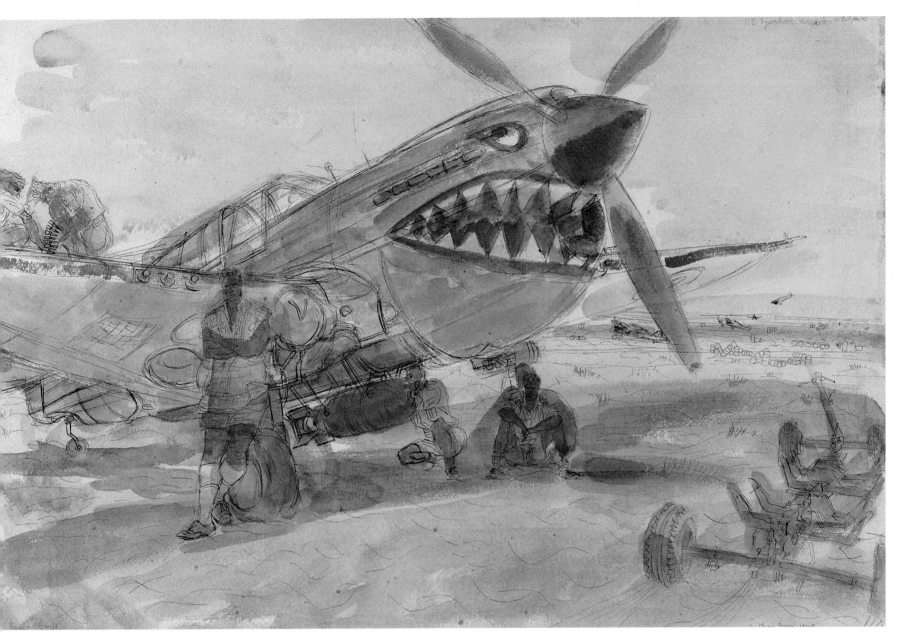

Left:
The Final Victory

Charles J. Thompson

Victory in the east was a long time coming, not least for the pilots of the Fleet Air Arm. On August 15, 1945, Seafires of 887 Squadron, R.N., attacked and destroyed a Mitsubishi A6M Zero in the skies over Japan, in the final fighter action of the war. Charles Thompson's picture shows the moment before the Japanese aircraft began it steep dive to destruction.

Above:
The Battle of Egypt, 1942. Bombing up

Anthony Gross

In R.A.F. service the Curtiss P-40 was known as the Tomahawk, and later the Kittyhawk. It was an extremely tough and reliable aircraft, particularly in the close support role. The R.A.F., the R.A.A.F., and the S.A.A.F. took 885 of the three marks of Tomahawk. It was popular practice to add a shark's mouth to the nose, a design popularized by the Flying Tigers.

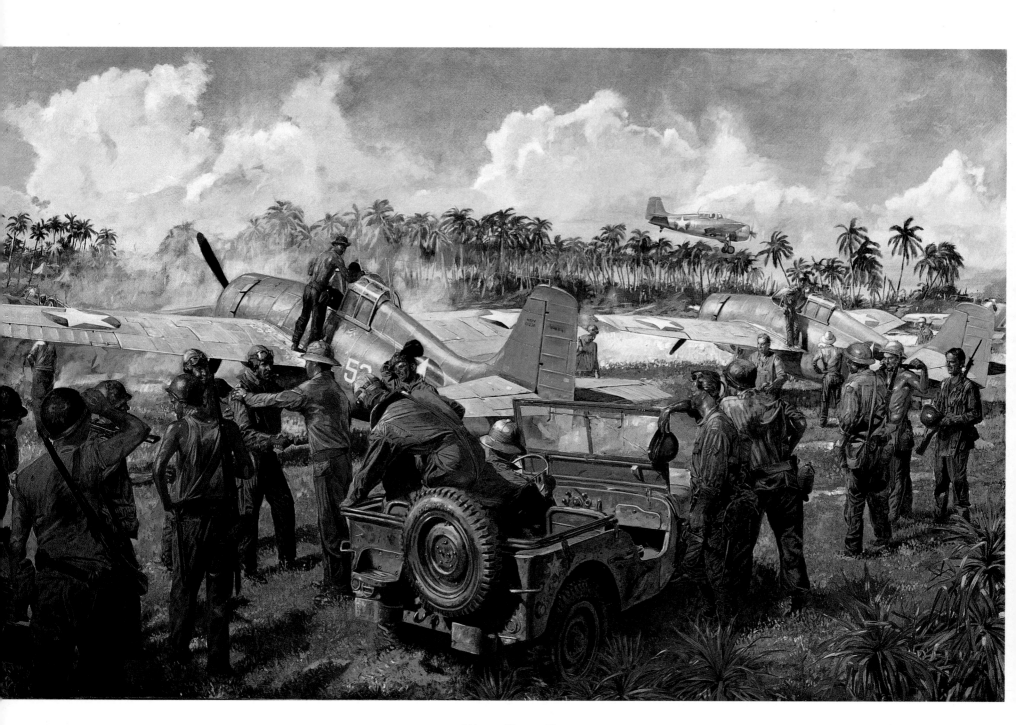

Warm Reception
Foss's Bluff Saves Guadalcanal

James Dietz

On January 25, 1943, Captain Joe Foss — who would go on to record twenty-six victories — led his VMF-121 squadron of eight Wildcats, plus four P-38 Lightnings, from Henderson Field and intercepted an enemy force of over 100 aircraft, which were threatening Guadalcanal. He fooled the Japanese into thinking they were outnumbered and caused them to turn back.

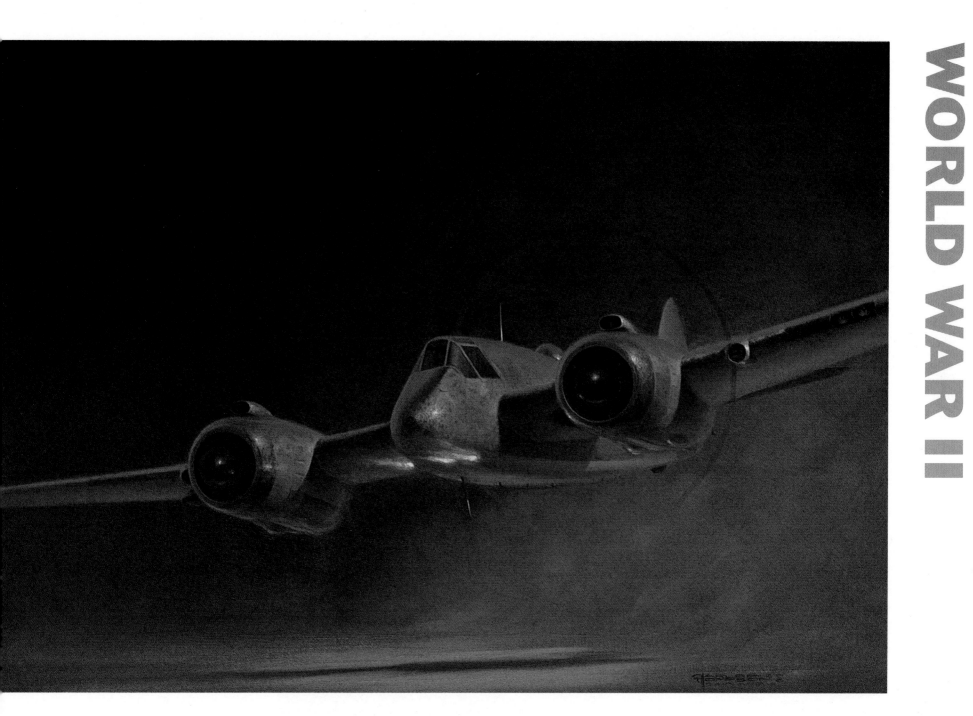

Beat up

Charles J. Thompson

A weathered Bristol Beaufighter of the Desert Air Force flies at low level across the sand, stirring up a dust storm in its wake. The Beaufighter was designed to an R.A.F requirement for a long-range fighter, and was heavily armed with four 20 mm. cannon and eight 0.303 in. machine guns. The nightfighter version of the aircraft is, reportedly, one of the reasons that the Luftwaffe gave up the Blitz! Charles Thompson's painting effectively juxtaposes the beat up aircraft with the "beat up" of the desert.

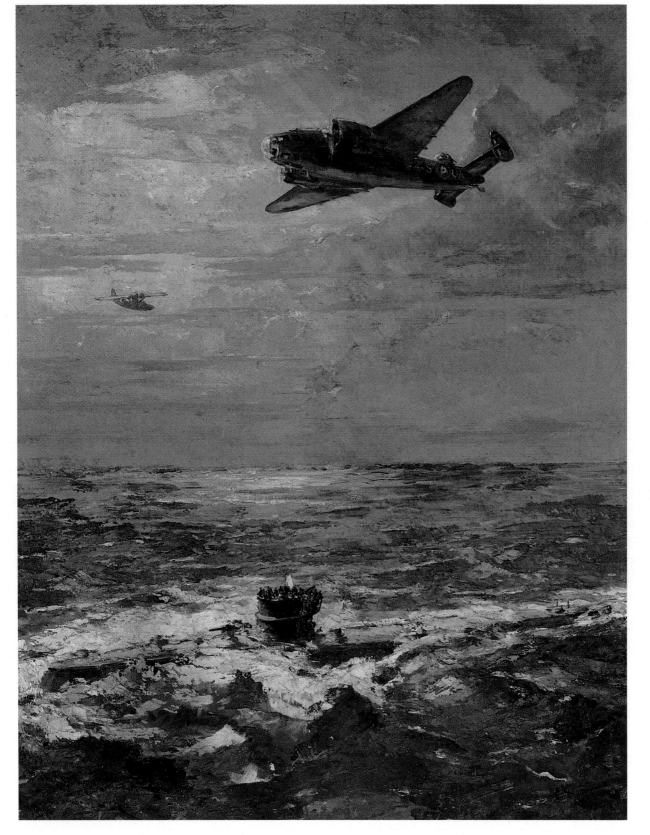

Left:

A U-boat surrenders to a Hudson aircraft

Charles Ernest Cundall

By mid-1944 Coastal Command had the measure of the Dönitz's U-boat Wolfpacks. Equipped with squadrons of radar-equipped aircraft, much needed protection was provided to the vulnerable merchantmen trudging across the North Atlantic. With a range of nearly 2,000 miles the Lockheed Hudson played a vital role in the battle.

Right:

New Year's Bash

Troy White

On January 1, 1945, Captain William T. Whisner downed a Messerschmitt Bf109 after a head-on pass that resulted in extensive damage to the oil tank and wing surfaces of his P-51D. Incredibly, this victory brought Captain Whisner's total for the day to four, and his overall total to 15.5. Like many of his contemporaries Whisner took the combat experience he had gained in the skies over Europe to Korea, where he was credited with 5.5 MiG-15s.

AVIATION ART

D-Day Dawning

Charles Thompson

A fully laden General Aircraft Hamilcar lumbers into the air behind a Halifax relegated to towing duties for Operation "Overlord," on June 6, 1944. The Hamilcar was the largest glider available to the Allies for the operation, and was primarily designed to carry the heavy equipment needed by airborne forces, including light tanks and artillery. Many tons of equipment were carried across the Channel during the early hours of "Overord," and landed at sites behind the beaches during the course of operations. General Aircraft was amalgamated into the Blackburn company in 1950.

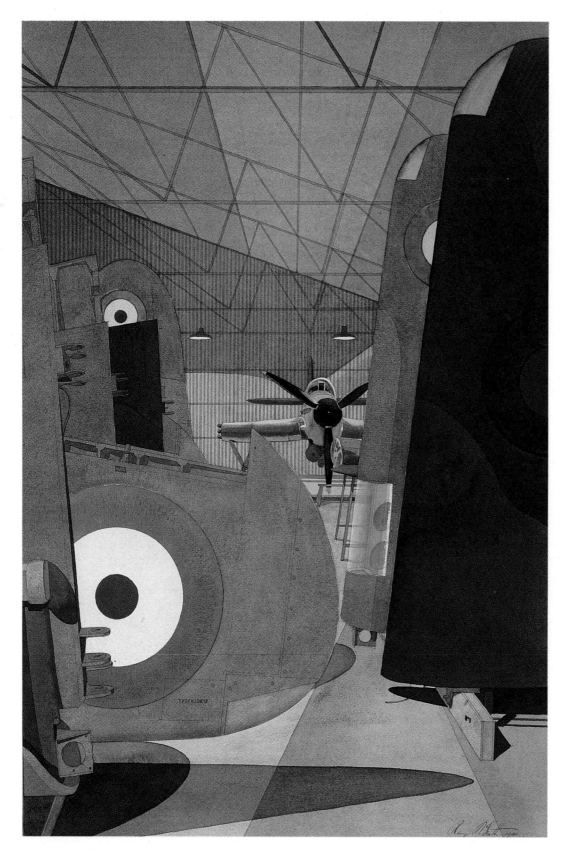

Training aircraft under construction

Raymond McGrath

This watercolor composition is dated 1940 and shows the interior of a construction shed, looking through a line of wings and tailplanes to a half-finished aircraft in the background. The yellow denotes that the aircraft are to be trainers, of which there was a great variety in service with the Allies during World War II, including such as the Boeing-Stearman Kaydet, de Havilland Tiger Moth, Miles Magister, Percival Proctor, and North American AT-6 Texan or Harvard.

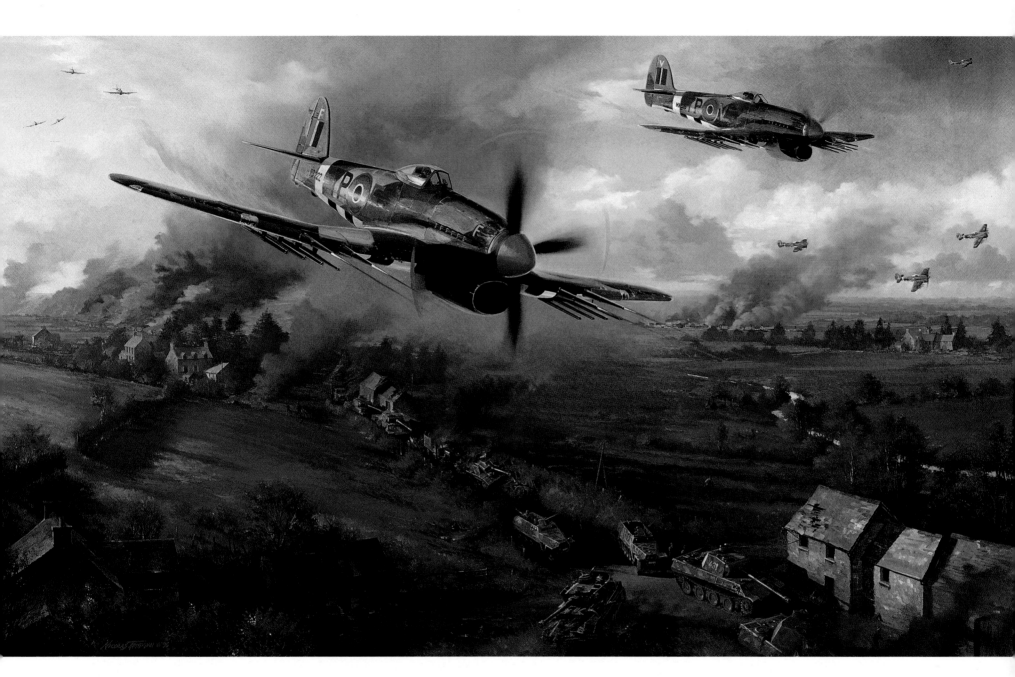

Typhoons at Falaise

Nicolas Trudgian

The rocket-firing Hawker Typhoon was the best ground-attack aircraft on either side during the war. The prototype Typhoon fighter first flew in 1940, but it was as a tank buster that it would gain notoriety. On one day during the Normandy campaign — August 7, 1944 — Typhoons were responsible for killing 135 German tanks. Following the successful break-out from the Normandy beachheads — Operation "Cobra" — by the U.S. Ist Army, the German forces were squeezed from the north and south and only had one avenue of escape: the Falaise Gap — which became a killing ground as Allied aircraft, with complete air superiority, destroyed armor and vehicles.

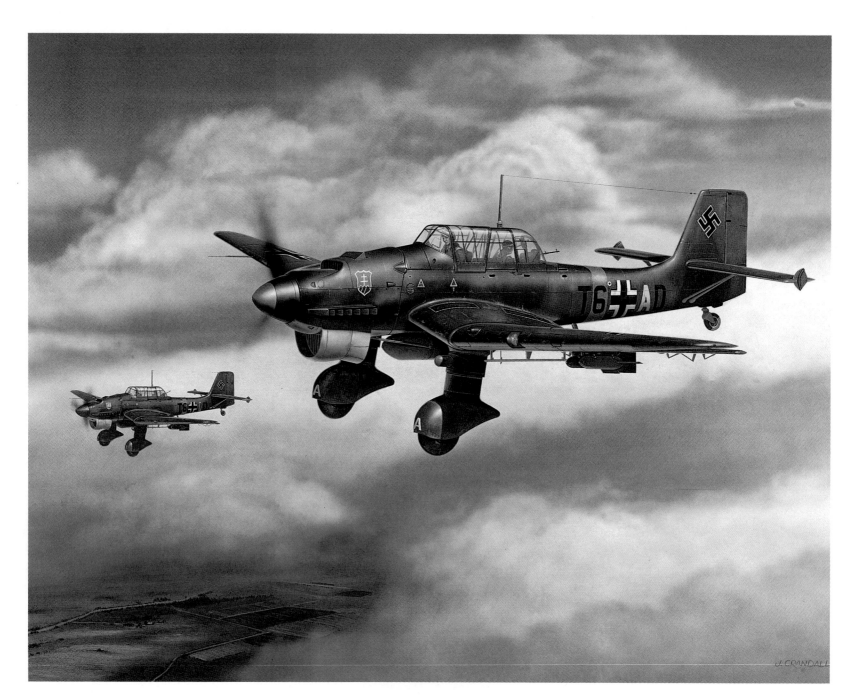

Rudel's Stuka

Jerry Crandall

Hans-Ulrich Rudel was the most highly decorated pilot in the history of aerial warfare. During his career with the Luftwaffe Rudel flew an incredible 2,530 missions in the Ju87, in this painting a Ju87B-2. This achievement is all the more remarkable when it is considered that, even as early as 1941, the aircraft was outmoded and highly vulnerable. Rudel was able to use it to great effect, destroying the Soviet battleship *Marat*, hundreds of trains, landing craft, about 800 vehicles, and over 500 Soviet tanks. He was the only pilot in the Luftwaffe to be awarded Golden Oak Leaves, Swords and Diamonds to his Knight's Cross.

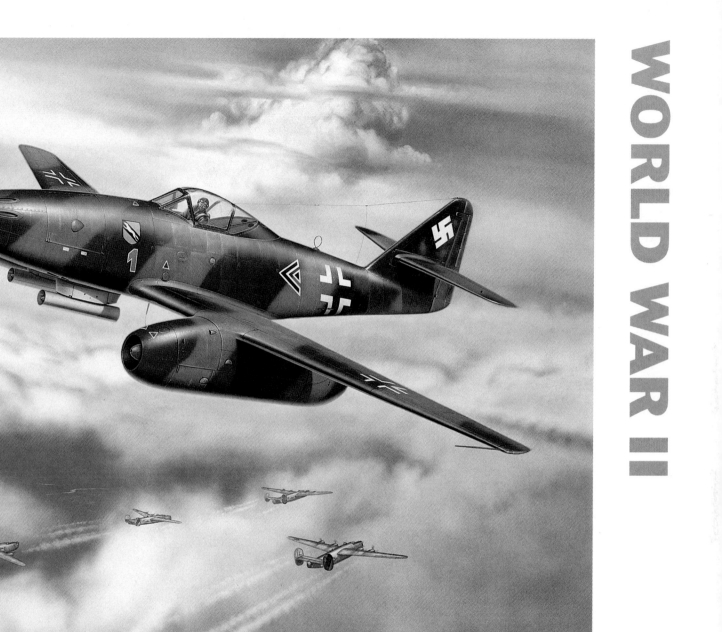

JG7 Messerschmitt Me262

Jerry Crandall

The Messerschmitt Me262 first took-off as early as March 1942, but encountered teething problems with its B.M.W. engines. Another hindrance was the insistence that the aircraft be used as a high speed bomber instead of an interceptor. When it reached front line units in July 1944, powered by Junkers Jumo turbojets, it had a top speed of 540 m.p.h. and was almost impossible to intercept. Had it entered the war earlier, the Me262 would have changed the balance of the air war.

Left:
Hawker Hurricane and Thames barges

Charles J. Thompson

An early model Hawker Hurricane skims low over barges in the Thames Estuary. The picture presents an interesting contrast with the watercolor on page 48. Note how the design of the barges has remained essentially the same, whereas the aircraft has progressed immeasurably.

Right:
The Wing's Return

Charles J. Thompson

In the face of a gathering storm, three Spitfires in vee formation return to base after a sortie. In R.A.F. parlance, a wing was a collection of two or more squadrons, first introduced in 1914. In turn, each squadron would be split into "flights" of three of four aircraft. Between the wars the wing formation was much used and during the Battle of Britain it was normal for a wing to be based at one airfield — this explains the R.A.F. rank of wing commander.

WORLD WAR II

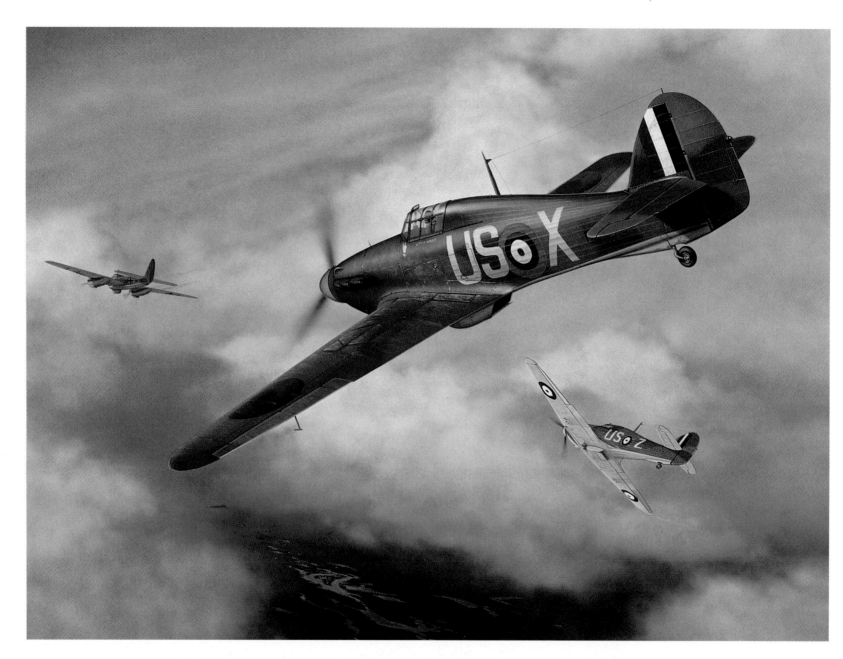

Geoffery Page's Hurricane Mk. I

Jerry Crandall

The two paintings on this spread were painted by Crandall to commemorate the fiftieth anniversary of the Battle of Britain. Although often overshadowed by the Spitfire, Hawker Hurricanes outnumbered the Supermarine aircraft almost two to one at the height of the battle, and destroyed more German aircraft than all other British aircraft types in 1940. Here, just before dawn on July 20, 1940, Blue Section of No. 56 Squadron, R.A.F., intercepts and shoots down a Ju88 on a photoreconnaissance mission. Geoffrey Page was one of the pilots of Blue Section for that mission, sharing the kill with "Jumbo" Gracie and Percy Weaver. Page ended the war with fifteen victories.

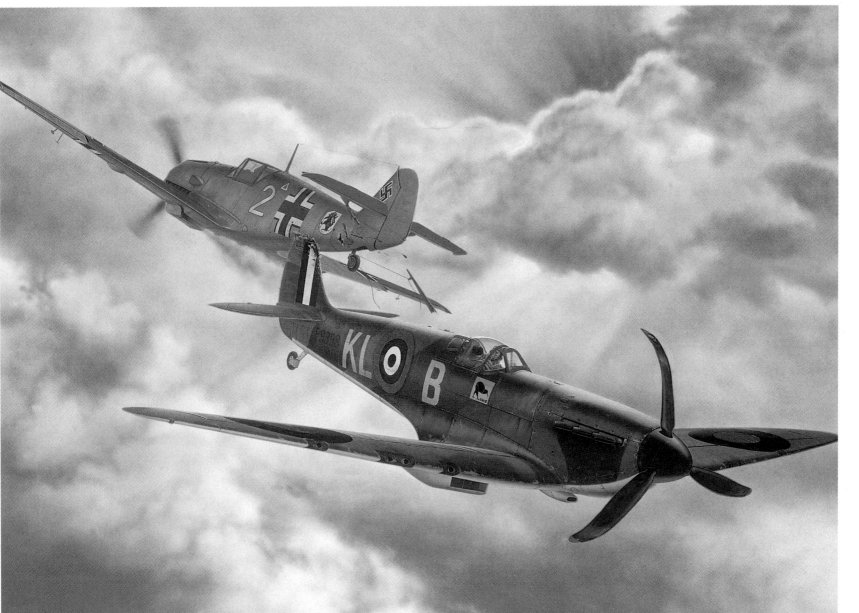

Al Deere Kiwi II — Spitfire Mk. IA
Jerry Crandall

Alan Deere was one of nearly 11,000 New Zealanders to serve during World War II. Many served with the R.A.F. — as many as seven New Zealand squadrons were formed. Deere was assigned to No. 54 Squadron after completing training, and achieved four kills before being shot down on July 4, 1940, in Spitfire Kiwi I. Five days later he was back in the air, patroling near Dover, when he spotted a Heinkel He59 seaplane with an escort of fifteen Bf109s. Red Flight attacked the Heinkel while Deere's section attacked the fighters. Deere downed one enemy aircraft, before making a head-on attack against another. Neither pilot gave way, and both received hits before colliding. Deere's engine seized and caught fire, but he was unable to release the cockpit canopy. With a cockpit full of smoke, and barely able to see, he crash-landed and managed to free himself from the wreckage.

POSTWAR

Finals at Gatow

Charles J. Thompson

Lights blazing through the dense overcast, an R.A.F. Avro York makes its final approach to Gatow airport in Berlin during the 1948-49 Berlin Airlift. From mid-1947 Soviet authorities began restricting access to American and British administered sectors of West Berlin. By July of the following year, R.A.F. and U.S.A.F. aircraft had begun a massive operation to supply the city by air. The airlift brought vital food, fuel, and other commodities through three ten-mile wide air corridors to the airfields at Gatow, Tempelhof, and Tegel. At the peak of operations, aircraft were landing at Gatow every three minutes, allowing one take-off in between. Some forty Avro Yorks operating from their base at Wuntsdorf were involved in the operation. By February 18, 1949, the York fleet had delivered 1,000,000 tons to Berlin.

Above:
Outbound Skytrain

Troy White

Right:
Trail Blazer

Charles J. Thompson

The Douglas C-47 Skytrain was the military version of the DC-3, better known in many parts of the world as the Dakota. There were many variations — from the straight C-47A of the U.S. air forces of World War II, to the AC-47D "Spooky" gunships that operated so effectively in Vietnam. Other Skytrains were designated C-117, and in Canadian service CC-129: they were all rugged and thrived in difficult conditions.

Lockheed Constellation of Qantas Airlines on its inaugural flight in December, 1947, from Sydney, Australia, to London. Having first flown during wartime in 1943, initially all Constellations were used by the U.S. military and designated C-69. The first true civil version (some C-69s were refurbished for civil use) was the L-049 which started service in 1946 with T.W.A.

Above:
Looking for Casey Jones

Troy White

"Casey Jones" was the nickname given to one of the expert Soviet-trained North Korean pilots operating during the Korean war. American pilots came to recognize him by the five diagonal black stripes painted on his aircraft. The aircraft pictured is the F-86 of Lt-Col. Glenn Eagleston of the 334th Fighter Squadron, 4th Fighter Interceptor Wing, who nearly became one of his victims. In November 1950 United Nations' pilots, who had enjoyed almost total air superiority since the opening of hostilities in June, were shocked by the appearance of a new swept wing jet in the service of the North Koreans. The sleek, MiG-15 was faster and more maneuverable than the F-80s. The North American F-86 Sabre was hurriedly rushed into service, and proved a better match for the Soviet aircraft. Most of the aerial combat in Korea took place over the Yalu

River, which was at the very edge of the operational limits of Sabre units from Kimpo and Taegu. This meant that the Sabres had about twenty minutes patroling time over the river, but this did not prevent them from destroying nearly 800 MiGs during the war. As losses mounted the North Koreans found themselves unable to train pilots quickly enough, and few of them were of the caliber of Casey Jones.

Above:
Jabby's Big Day

Troy White

May 20, 1961. Despite the added drag from a hung drop tank, Captain James Jabarra of the 334th Fighter Squadron, 4th Fighter Interceptor Wing, shoots down his second MiG of the day to become America's first jet ace. Jabarra ended the war with fifteen confirmed kills.

F-86A Sabre and MiG-15

Hugh Polder

The North American F-86 Sabre was, unquestionably, one of the greatest combat aircraft of all time. Born from the XFJ-1 Fury, a straight-winged, carrier-borne jet fighter project of 1944, the F-86 benefited from captured German aerodynamic research material and adopted a swept wing. It flew first on October 1, 1947, and deliveries to the U.S. Air Force started on May 28, 1948, the first operational unit being 94th Squadron, 1st Fighter Wing. When production ceased — it was license-built in Australia, Canada, Italy, and Japan — over 9,000 had been built and the Sabre would see front-line service with lesser air forces until well into the 1980s.

The first of a staggering 18,000 Mikoyan-Gurevitch MiG-15s flew for the first time three months after the Sabre, on December 30, 1947, powered by the Soviet copy of the Rolls-Royce Nene turbojet, and benefiting too from captured German scientific research.

The Korean War gave both countries a chance to evaluate their latest hardware in combat conditions, and the MiG-15 made its combat debut on November 1, 1950, when a flight of six aircraft attacked U.S. Air Force P-51 Mustangs south of the Yalu River. During the same month, F-86As of 4th Fighter Interceptor Group, U.S. Air Force, started to operate from Kimpo in South Korea as part of the U.N. forces.

The 4th FIG made its first kill on December 17, when Lt. Col. Bruce Hinton of 336th Fighter Interceptor Squadron shot down a MiG-15 over Sinuiju. It was the start of a two and a half year turkey shoot as U.N. Sabres accounted for over 800 enemy aircraft, 792 of them MiG-15s, for the loss of seventy-eight of their own. These statistics are slightly skewed by the quality of the average MiG-15 pilot, but the Sabre was the better aircraft: while the MiG had better acceleration, rate of climb, and ceiling, the Sabre was better armed, was a better gun-platform at high speed and could out-turn the MiG.

This dramatic painting shows the first encounter of the Korean War.

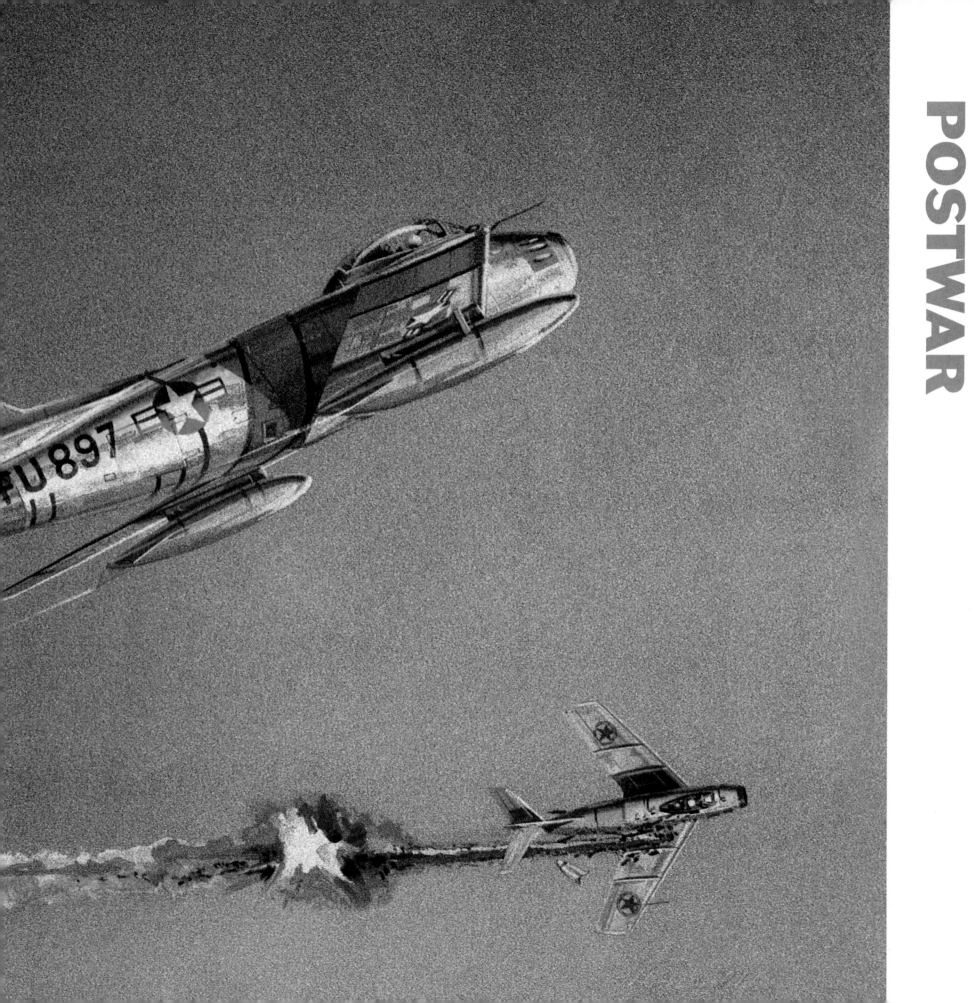

A Real Honey

Charles J. Thompson

The Lockheed C-121 was the military transport version of the Model 1049F Super Constellation, a stretched version of the Constellation that had an increased gross weight and payload, and an 18 ft. 4.75 in. increase in fuselage length. Pictured is a VC-121A of Military Air Transport Service, U.S.A.F., a painting commissioned from Charles Thompson, President of the British Guild of Aviation Artists. Other military transport versions included a single VC-121E for President Eisenhower's use.

Heartland Express

John Young

In a homage to Douglas's inimitable, ubiquitous DC-3, John Young's painting shows a United Airlines' aircraft lifting off from a runway in the heart of America. There's only one replacement for a DC-3, the saying went, and that's another DC-3. Certainly all those companies that tried to supply the burgeoning air transport business of the postwar years with a DC-3 substitute were unable to do so until well into the 1950s. Indeed, even today, over sixty years after the type first flew (December 17, 1935) over 400 DC-3s are still in service worldwide.

Spy in the Sky

Charles J. Thompson

Charles Thompson served out his National Service with the Royal Air Force as a senior aircraftsman at R.A.F. Feltwell, Norfolk. He is seen here refueling one of the Percival Provost training aircraft of No. 3 Flight Training School in 1955. The Provost first entered service as the R.A.F.'s primary trainer in 1953, replacing the Prentice aircraft built by the same company. Overhead flies the first Lockheed U-2 to arrive in England. For years its true role as a spyplane was concealed; reports referred to the aircraft as a "high altitude cosmic research aircraft." Four years later, when Francis Gary Powers was shot down while overflying the Soviet Union, its true purpose was revealed.

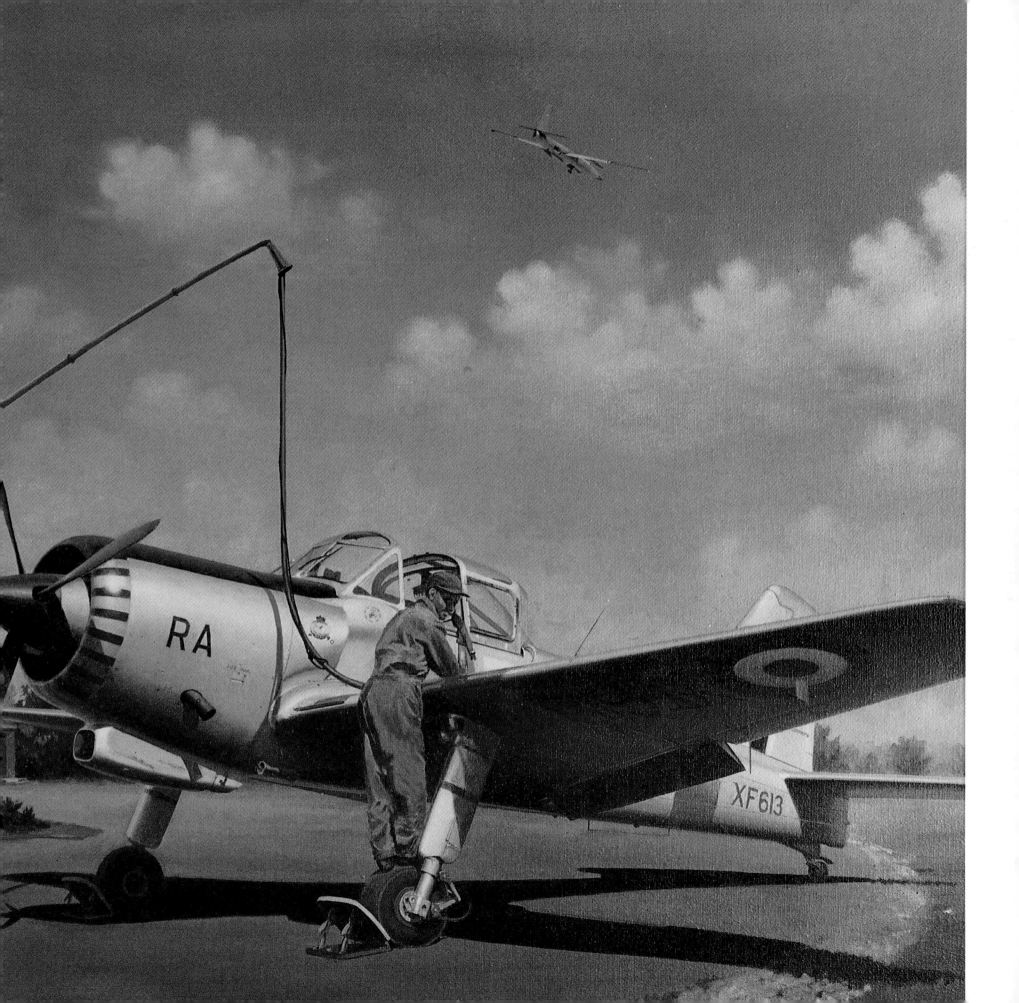

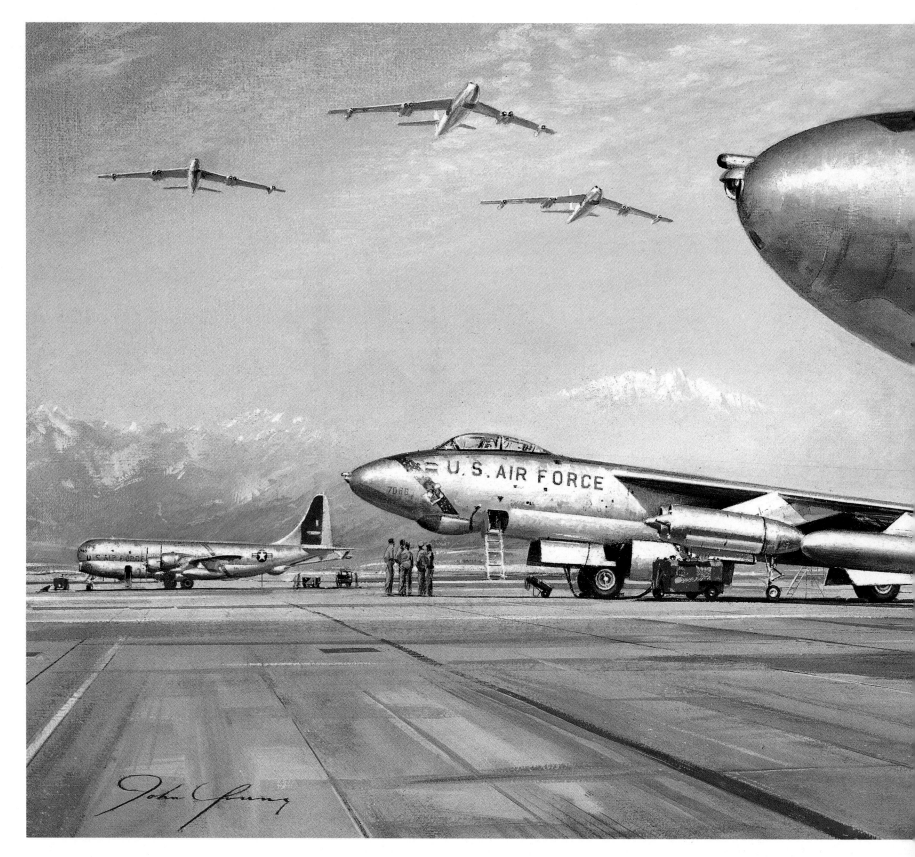

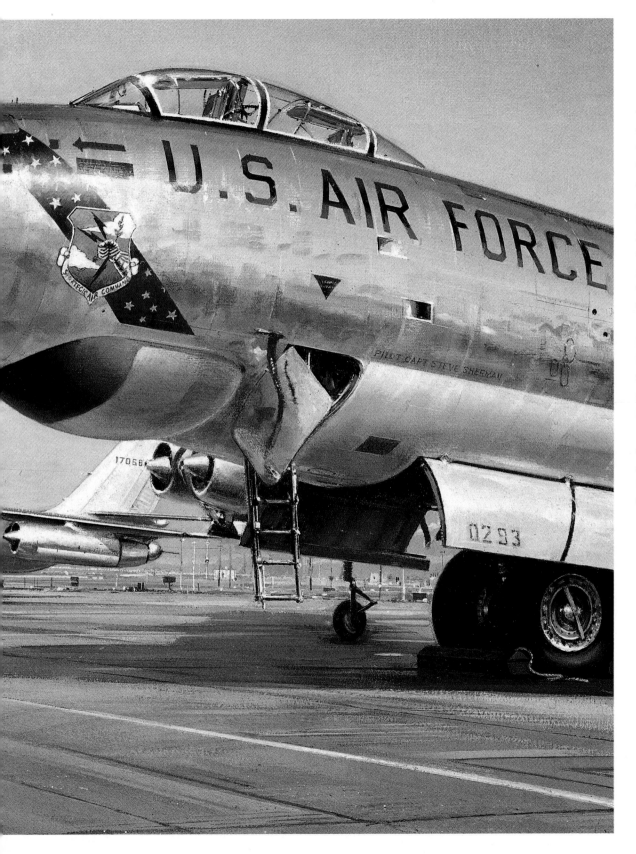

Cold War Warriors

John Young

During the long years of the Cold War the United States' arsenal of nuclear weapons acted as a deterrent to all those who thought about invading the free world. These weapons needed delivery systems and the B-47 provided an excellent platform, the first jet bomber to fill the ranks of the new Strategic Air Command, commanded by General Curtis Lemay. First flying in December 1947, over 2,000 B-47s were built by the time production finished in 1957. Quickly outdated by 1960s fighter technology, these beautiful machines did not have a long lifespan, and few can be seen today, but the time that they were the cutting edge of aviation technology is well remembered here.

John Young was a founding member and past chairman of Britain's Guild of Aviation Artists. He has won the Flight International Trophy as the best professional aviation artist on three occasions.

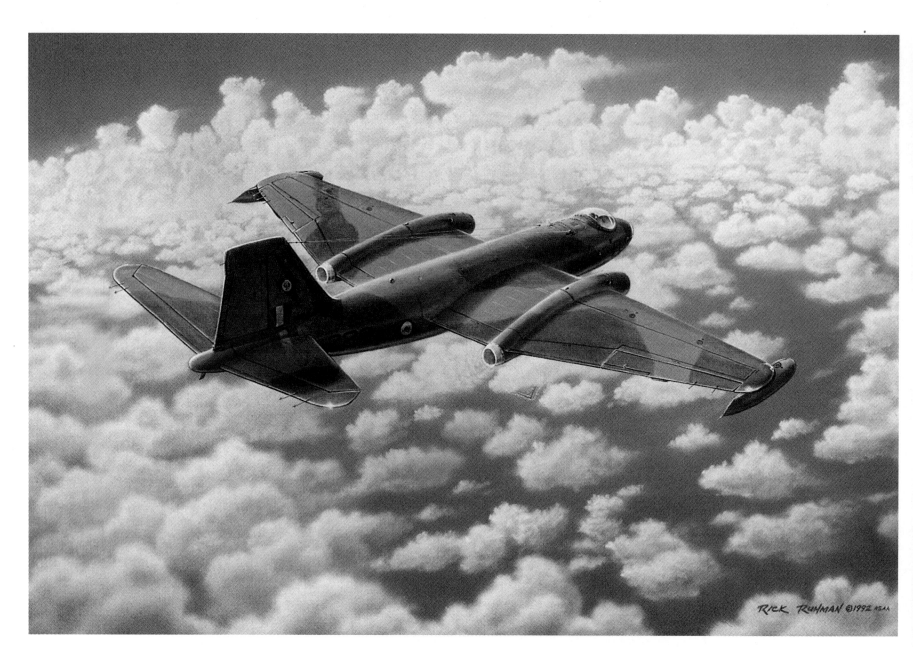

Above:
Coming into Wake

Rick Ruhman

When Steve Picatti acquired the world's only civilian-owned Canberra Mk. 20 bomber from the R.A.A.F. he had to fly his "new" jet back home. He did so on a cloudy day that suddenly cleared. Looking down and to his left he spied the tip of Wake Island (just visible under the right engine in the painting). That moment was chosen for this commissioned piece in 1992.

Right:
Bateleur Eagle

Charles J. Thompson

The Cessna 337 Super Skymaster was adopted by the U.S.A.F. and many air forces as a forward air control aircraft. It had two 210 h.p. engines, one a pusher and the other a puller. Rheims Aviation produced a number of military versions under license, including this F337 Lynx of the Rhodesian Air Force.

Sunrise

William Yenne

The mighty Boeing B-52 was first flown in 1949 and was to become an integral part of American nuclear program as a heavy bomber. This painting shows the B-52G, the main production model, of which 193 were built from 1959 to late 1960. The incredible wing span of 185 ft. and the eight Pratt & Whitney J57-P-43W turbojet engines which gave the B-52 a speed of up to 665 m.p.h. can be clearly seen in the picture. The B-52G could carry two North American Hound Dog missiles and two remotely controlled machine 20 mm. cannon in the tail position. In addition to this it was loaded with various conventional or nuclear weapons. During the Vietnam war, B-52s supported land missions by unloading up to 35,000 lb. of high explosives onto the jungle at a time. In all 704 B-52s of different classes were completed and some will continue to serve on into the twenty-first century.

William Yenne presented this picture to the U.S.A.F. Art Collection in 1980.

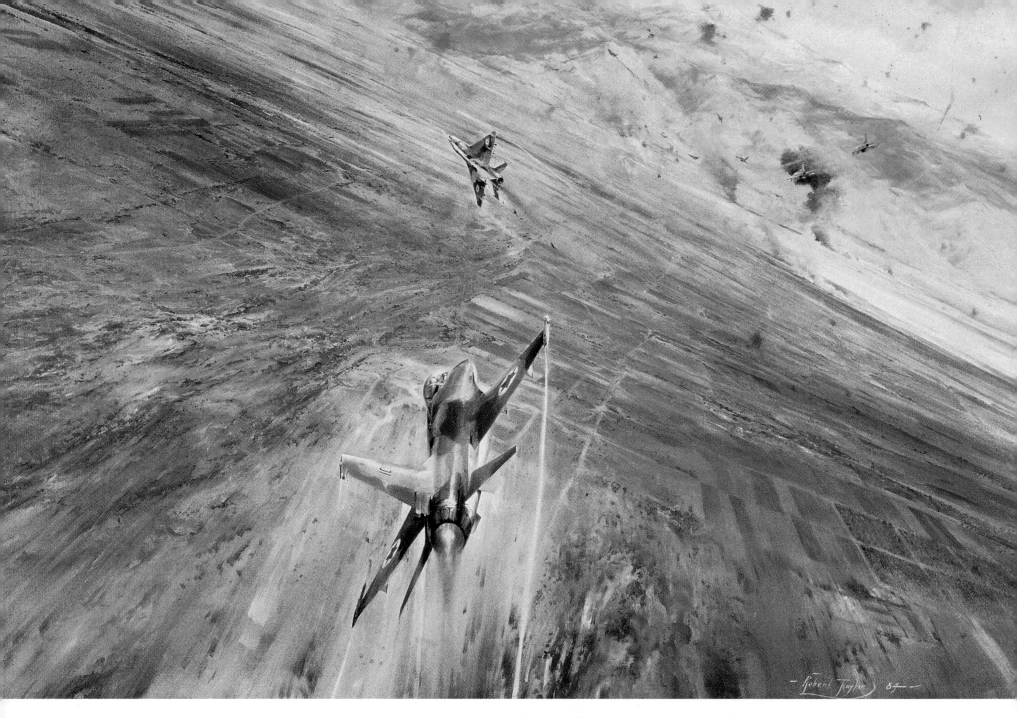

Bekaa Valley Gunfight

Robert Taylor

Probably the best known and best regarded of British aviation artists today, Robert Taylor marries technical talent with an eye for composition and subject that makes his paintings — in both canvas and print form — collected all over the world. This painting shows a dogfight between an Israeli Air Force F-16 Fighting Falcon and a Syrian MiG-21 (NATO codename "Fishbed") just as the Israeli aircraft's 20 mm. cannon score hits on the Syrian. The engagement was unequal: the General Dynamics F-16 is probably the best dogfighting aircraft available today; the MiG-21 was first seen in prototype form in 1956. In two days fighting in the Bekaa Valley, Israeli Air Force aircraft shot down over eighty Syrian aircraft and destroyed numerous anti-aircraft launch sites at no loss to themselves.

Aerial Refueling II

William Yenne

This picture shows a Boeing KC-135 Stratotanker lowering its refueling gear. The KC-135 first took to the skies on August 31, 1956, and fuel deliveries started in June 1957. By 1980, in the region of 600 had been built and equipped eight Air National Guard wings and groups as well as two reserve squadrons. Capable of holding up to 31,200 gallons of fuel, the aircraft can also be used to carry cargo or personnel. During production, a further 220 KC-135s were modified for special duties including eight EC-135s which serve as advanced range instrumentation aircraft for space mission support. Other roles fulfilled by this versatile aircraft include weather and electronic reconnaissance. This painting was given as a gift by the artist to the U.S. Air Force Art Collection in 1980.

Left:
Sabre in the Sun

Charles J. Thompson

Its flying days long gone, a North American F-100 Super Sabre casts its shadow over the tarmac at Bagington Museum in Coventry, England. In 1949, North American initiated a private venture development of the superb F-86, with the aim of producing an aircraft that was capable of achieving Mach 1 in level flight. On October 29, 1953, the first prototype set a new world speed record of 754.99 m.p.h., and the Super Sabre went on to see extensive service in Vietnam. The most numerous variant was the F-100D, of which 1,274 were built.

Above:
Phantom jet refuelling at Akrotiri

John Devane

John Devane's simple crayon sketch of a Royal Air Force Phantom at the R.A.F. base at Akrotiri, Cyprus, in 1978. The British Royal Navy was one of the first foreign clients for what is generally regarded as the greatest fighter of the postwar era. Largely for political reasons, the aircraft, an Anglicized version of the F-4K, were equipped with Rolls-Royce Spey turbofans. Of the forty-eight FG.1s supplied to Britain, the Royal Air Force received twenty. A further order for 120 FGR.2 aircraft was fulfilled, and the aircraft remained in service until 1992.

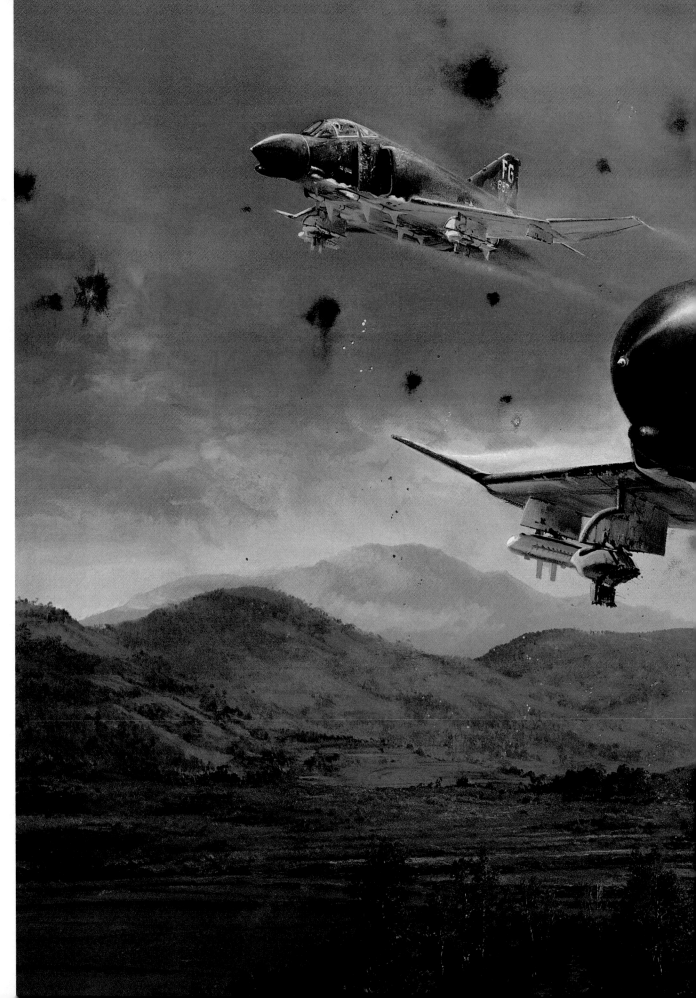

Phantom Strike

Robert Taylor

This dramatic painting records in remarkable detail the F-4 Phantom attack on the steel mills at Thai Nguyen, North Vietnam, on March 30, 1967. The painting shows Brigadier-General Robin Olds' aircraft, accompanied by his two wingmen, seconds after the strike, at ground level, in full afterburner, the flak exploding all around them. "It was the most dangerous mission of all that I flew in both wars," the general said later — and he should know! Robin Olds joined the 434th Fighter Squadron, 479th Fighter Group, flying P-38 Lightnings in June 1943. By early 1945 he commanded the squadron, and by war's end he had twenty-four victories, thirteen in the air. He would go on to add four more victories in Vietnam before retirement in 1973.

AVIATION ART

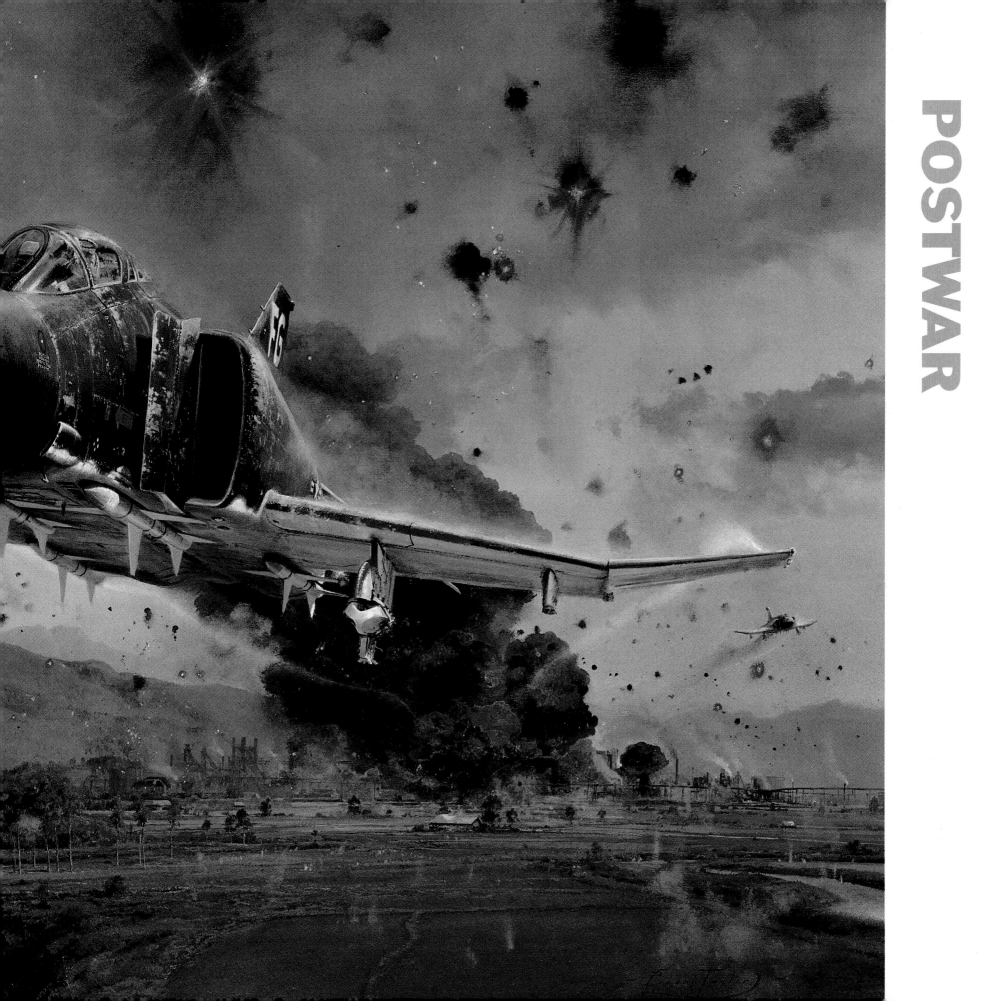

Dago Red

Charles Thompson

Air racing has long been a popular and exciting sport in America, and has provided many World War II vintage aircraft with a new lease of life. Entrants are divided into a number of different categories depending on the extent of modifications carried out to airframe or engine. For obvious reasons the North American P-51 Mustang is a popular choice for racers. *Dago Red* was an entry in the "Unlimited" class at the famous annual Reno air races where it was painted by Charles Thompson.

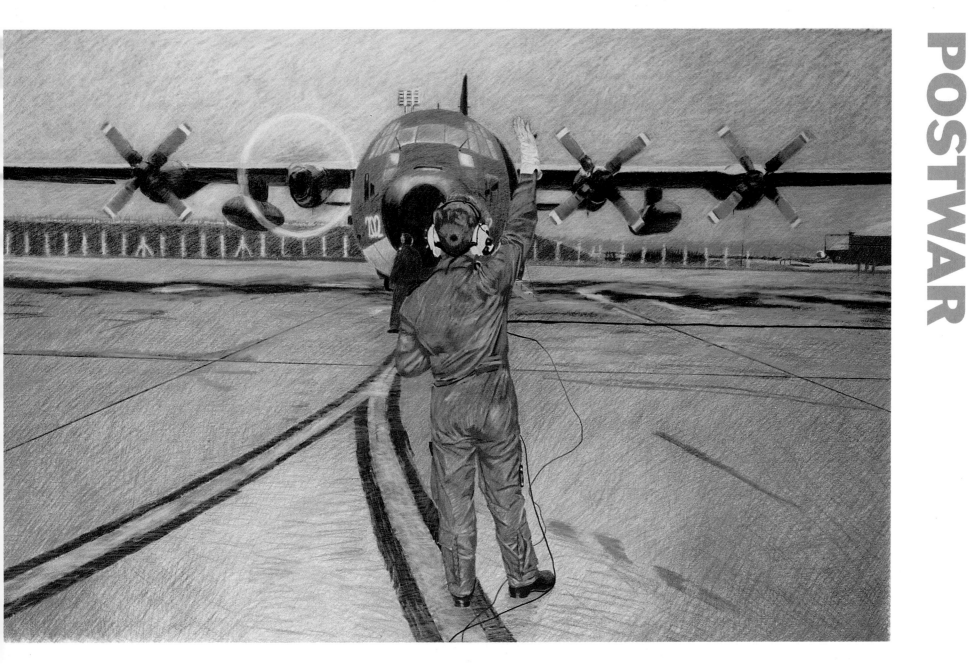

Air Loadmaster checking engines, RAF Lyneham, 1985

Lesley Fionnula Evans

As part of the Hercules crew, the air loadmaster is responsible for cargo, and in this instance for checking engine serviceability. R.A.F. Lyneham is the home of the R.A.F. Hercules fleet. Four squadrons currently operate the Hercules, including No. 47 Squadron's Special Forces Flight. Sixty-six of the aircraft were ordered from 1965, with the R.A.F. designation C. Mk 1. Thirty were subsequently converted to C. Mk. 3 standard, with a stretched fuselage to accommodate up to ninety-two paratroopers. The R.A.F. Hercules have been widely used for a variety of roles, from tanker refueling in the Falklands to airdrops in famine-stricken Africa. In British service the aircraft is nicknamed "Fat Albert." Few other aircraft have provided such sterling service.

AVIATION ART

Security check on the pan, R.A.F. Lyneham, 1985

Lesley Fionnula Evans

In the second of Lesley Evans's paintings of Hercules aircraft, he shows two female members of the Royal Air Force stationed at Lyneham in Hampshire. Women have served in the R.A.F. since the 1930s, and are now accepted in almost every branch of the service. In the picture a member of the R.A.F. (W) police force carries out a routine security check on a member of the engineering wing.

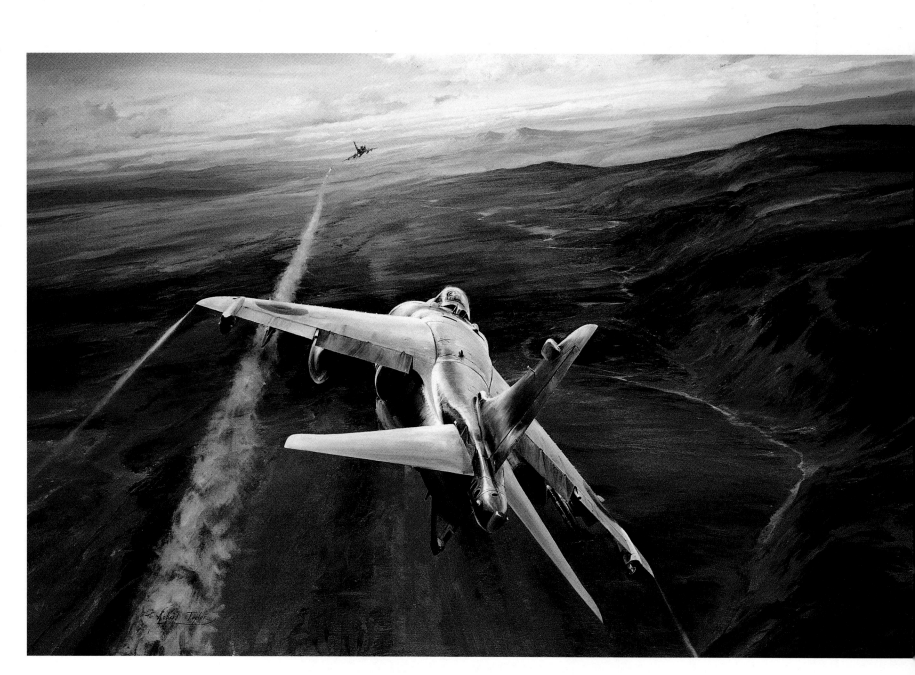

Air Strike Over West Falkland

Robert Taylor

Over the almost featureless terrain of West Falklands, Commander "Sharkey" Ward, D.S.C., A.F.C., R.N., engages an Argentine Dagger with his port Sidewinder missile. The resulting "kill" would be one of nineteen Argentine jets shot down on May 21, 1982. "Sharkey" Ward had been flying Sea Harriers from the start — he commanded the first Sea Harrier squadron — and commanded 801 Squadron, R.N., in the South Atlantic in 1982. His previous flying in Buccaneers and Phantoms make his views on the Harrier all the more pertinent: "at no time when involved in a combat situation, would I have swapped my Sea Harrier for another jet."

Checking between flights; Wessex Helicopter, R.A.F. Shawbury, 1985

Leslie Fionnula Evans

Ground crew carry out preflight checks on a Westland Wessex. Shawbury was originally the training center for the Royal Air Force's Air Traffic Control branch, but subsequently became responsible for rotary wing flying training within the service. In the future, the R.A.F. unit will become the basic flying training center for both the Army and Royal Navy. The Wessex is a license-built version of the Sikorsky S-58, with Napier Gazelle engines, and has been operated by the Royal Air Force since 1961. The Wessex was widely used in S.A.R. and Army co-operation duties, and was utilized for many years by The Queen's Flight at R.A.F. Benson.

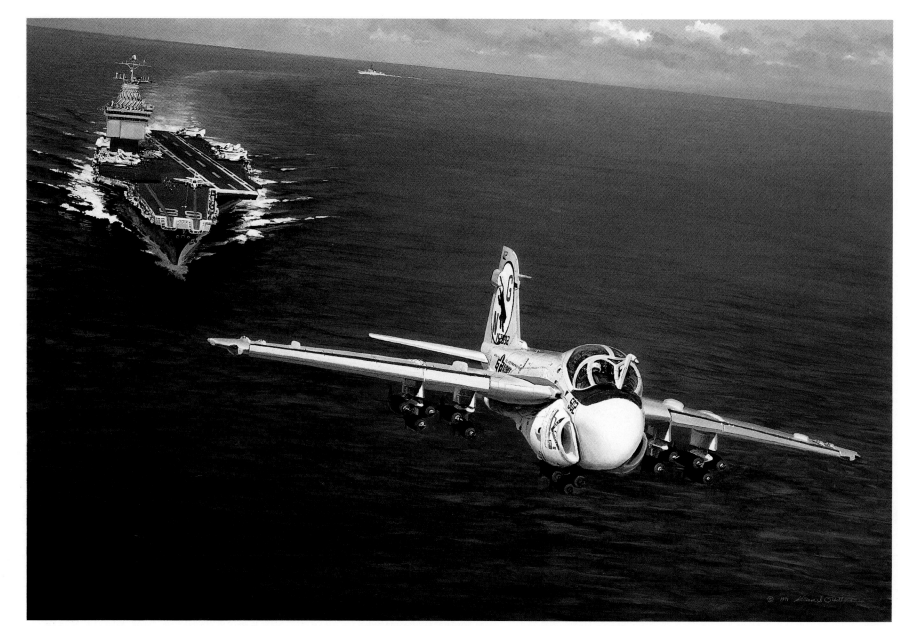

Intruder Outbound

William S. Phillips

The Grumman A-6 Intruder first flew in 1960 and became the standard all-weather attack aircraft for the U.S. Navy and Marine Corps. Soon there were tanker versions, reconnaissance versions and the EA-6B Prowler, a four-seat electronic countermeasures aircraft. Here an A-6A takes off from U.S.S. Enterprise on May 19, 1967, piloted by Navy Captain Eugene McDaniel. It was on this, his eighty-first combat mission that McDaniel was shot down after his aircraft was hit by a Vietnamese surface-to-air missile. He would endure six years of deprivation and torture in a Viet Cong prison camp before release. The accuracy and detail of the painting is in part due to Bill Phillips's time in Vietnam while serving in the air force.

194

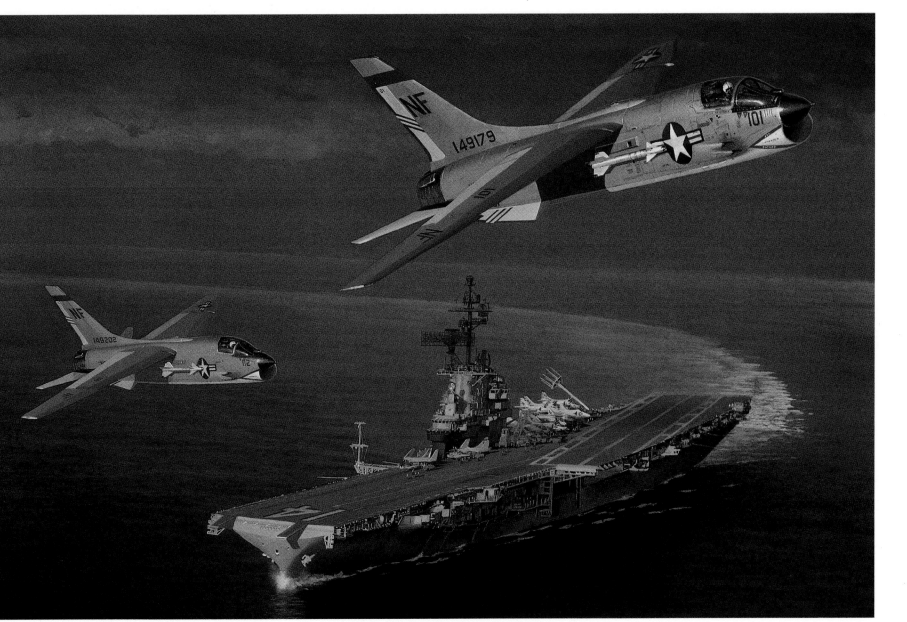

Caping the "Tico"

William S. Phillips

In August, 1964, Commander James B. Stockdale led the first American air attacks against North Vietnam flying F-8 Crusaders from U.S.S. Ticonderoga. He would later be shot down near Thanh Hoa; taken into captivity by the Viet Cong he was the senior naval officer in the camps. He was captured in September 1965 and released in February 1973, nearly seven and a half years later, and for "conspicuous gallantry and intrepidity at the risk of his own life above and beyond the call of duty" he was awarded the United States' highest combat decoration, the Medal of Honor.

C-5A Galaxy transporter

Paul Hogarth

This watercolor, pencil, and ink drawing shows the yawning mouth of a Lockheed C-5A Galaxy, cabable of lifting 798,200 lb. (at the time of building, a world record) across long distances. Lockheed won the C-5 contract from the Military Air Transport Service against their competitors, Boeing and Douglas, in 1964 — but Boeing was able to make use of their proposal in the subsequent 747 program. The maiden flight of the C-5A took place on June 30, 1968 and a total of eighty-one were built. This heavy transporter was important in the resupply of U.S. forces in Europe and missions such as lifting up to three CH-47 Chinook helicopters across the ocean were not uncommon.

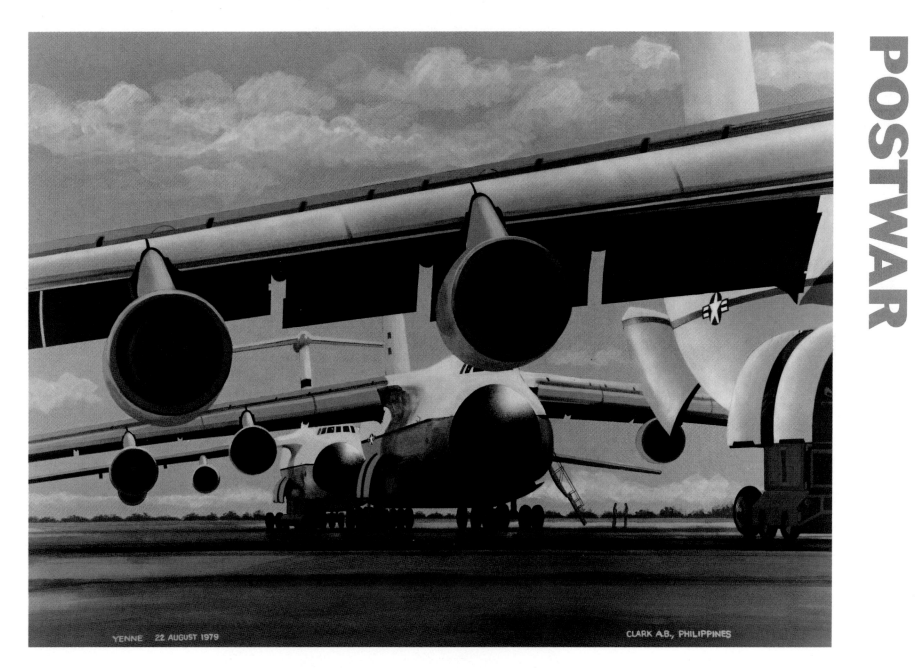

C-5As on the Ground, Clark A.F.B., Phillipines — August 22, 1979

William Yenne

This painting of the Lockheed C-5A is another of Yenne's gifts to the U.S.A.F Art Collection. Executed in acrylic on board it captures the thundering weight of the aircraft on the runway. The aircraft's dimensions are as impressive as they appear in the picture: the C-5A has a wingspan of 222 ft. 8.5 in., a length of 247 ft. 10 in., a gross weight of 769,000 lb. and a range of 6,529 miles. The top speed was 571 m.p.h., not bad for such an apparently bulky aircraft.

Up, Up, and Away

Charles J. Thompson

It may not have sold in quantity, but the Anglo-French Concorde is still the world's only successful supersonic transport aircraft. Designed in the 1960s and taking to the air for the first time on March 2, 1969, Concorde entered service with Air France and British Airways on January 21, 1976. Only twenty were ever manufactured, including two prototypes and two pre-production models. In 1994, both airlines celebrated the 25th anniversary of possibly the most beautiful civil aircraft in the world, and definitely the fastest — cruising at over 1,336 m.p.h. (Mach 2) and 51,000 ft. This is Charles Thompson's celebration of that event.

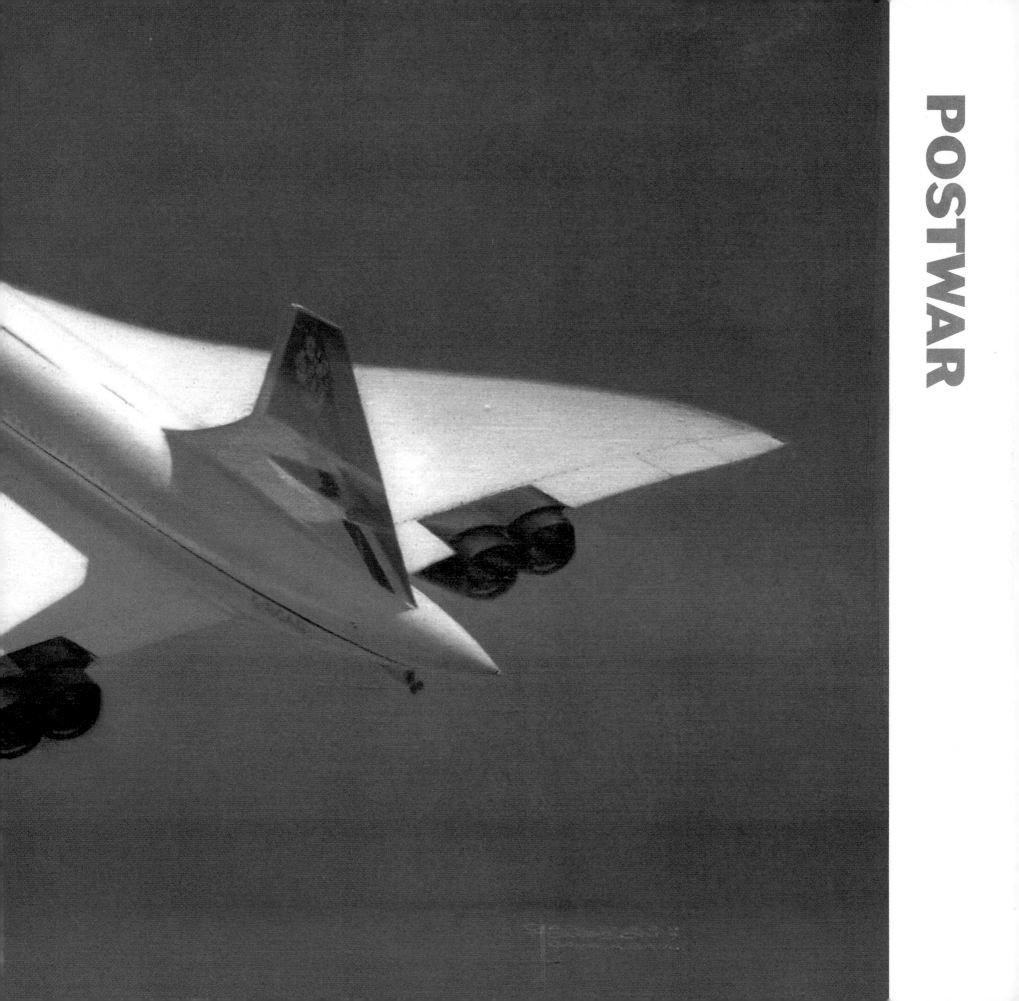

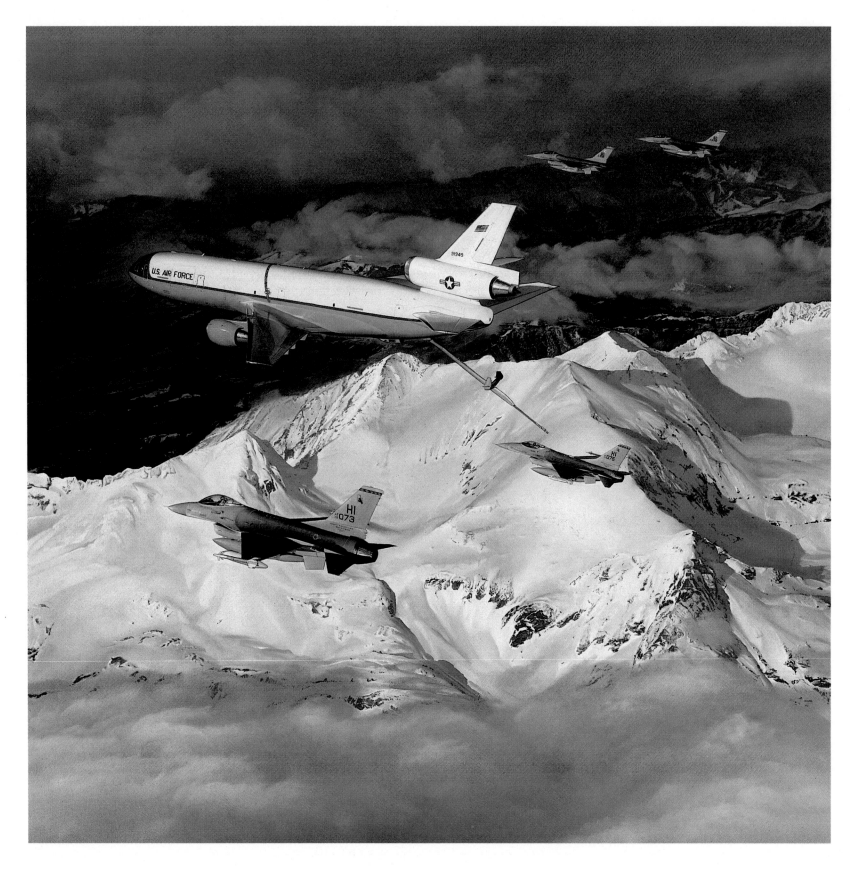

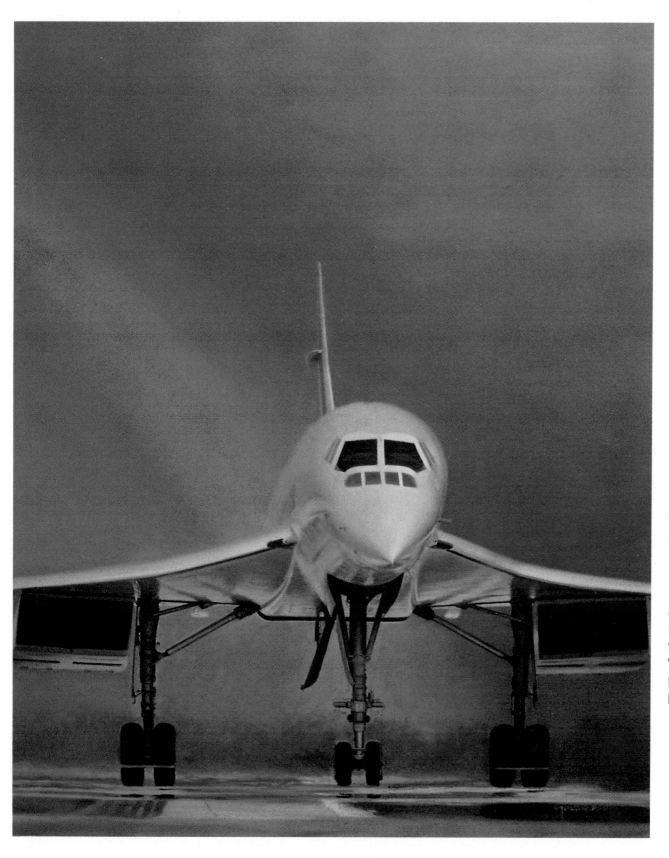

Left:
Way Ahead

Charles J. Thompson

Another view of Concorde. This beautiful aircraft remains a technological acievement over twenty years after its first commercial flight. With four Rolls-Royce/SNECMA Olympus turbofan engines, each with a static thrust of 138 kN (31,000 lb.) it is capable of speeds well over Mach 2, crossing the Atlantic in an astounding three hours and fifty minutes.

Far Left:
The A-Team

Craig Kodera

This is a self portrait of the artist — aircraft commander of this KC-10 Extender of the 79th Air Refueling Squadron, about to refuel an A.N.G. F-16 from McEntire A.F.B., S.C. Who said the Air Force's Reserve Units only got hand-me-downs?

AVIATION ART

The Right Stuff, On Final

William S. Phillips

Officially known as the Space Transportation System, the space shuttle has proved — despite one dramatic mishap — a remarkably efficient means of leaving the bounds of earth. Along with the Apollo program which eventually landed man on the moon, the shuttle is the major achievement of the U.S. National Aeronautics and Space Administration, N.A.S.A., established in 1958 after the Soviets had gained a lead in space in the form of Sputnik.

Built by Rockwell at Palmdale, California, the first of the orbiters — nicknamed *Enterprise* after the *Star Trek* starship — began testing in February 1977, achieving its first flight unpowered, after being piggy-backed to 22,800 ft. by a Boeing 747 specially converted for the job.

The first spaceflight-rated orbiter was OV-102 *Columbia,* and the first flight into space took place in April 1981. After a perfect launch (see painting page 37) and a flight of two days, crewmen Robert Crippen and John Young became the first Americans in space to touch down on land as they returned to Dryden Flight Research Center, California on April 14. Seven months later, on November 12, Joe Engle and Richard Truly would prove the reusable Space Transportation System really did work when they took *Columbia* into space again.

This dramatic N.A.S.A. Art Program oil painting depicts *Columbia* and Chase 1 during the final moments prior to the first touchdown.

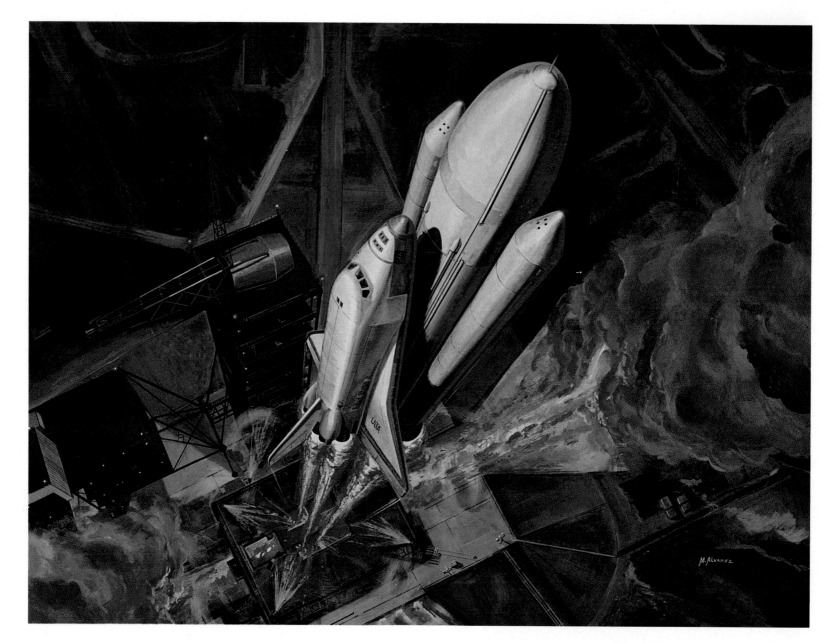

Above:
Space Shuttle Launch

Unknown

Right:
Launch of the Columbia—STS-1

Chet Jezierski

Artist's impressions of what a shuttle launch would look like. The two solid rocket boosters are attached in a skewed fashion to the larger liquid propellant tank and are jettisoned at an altitude of 10,000 ft., recovered, refurbished, and used again.

The real thing — mixed media painting from the N.A.S.A. Art Program portraying a much more realistic view of space shuttle *Columbia* as it is launched into space for its first historic flight on April 12, 1981.

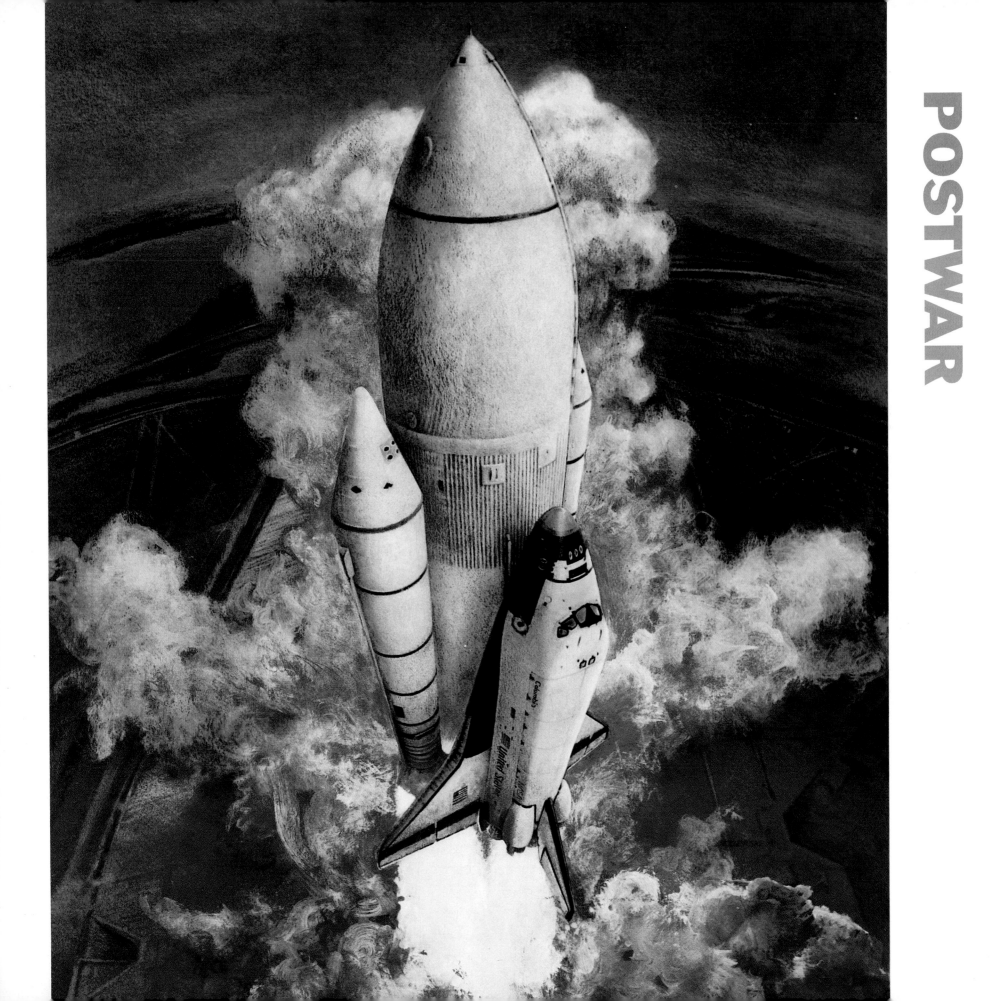

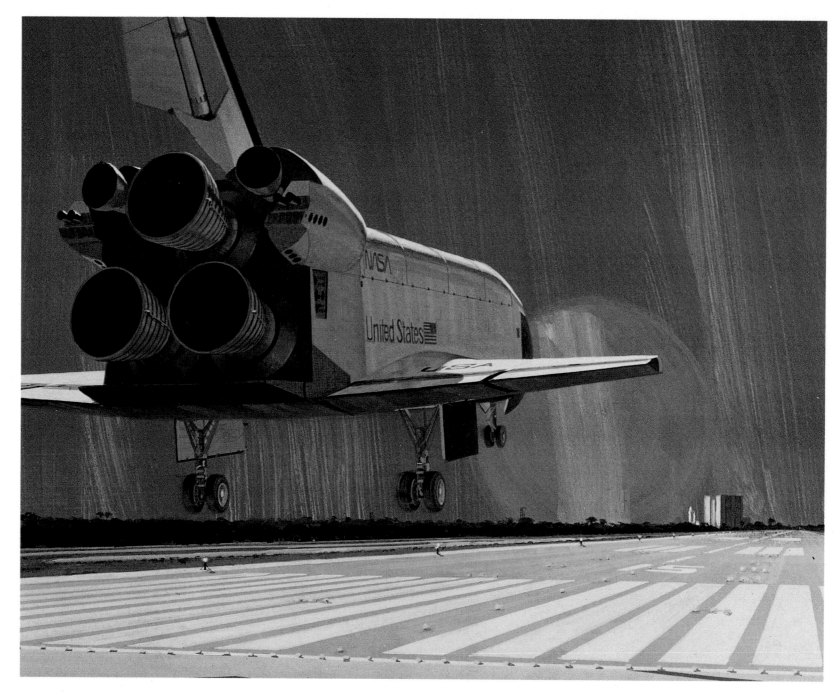

Columbia

N.A.S.A. Art Program

Columbia's name derives from a tradition of American ships. A *Columbia* was the first American ship to circumnavigate the globe and it was also the title of the Apollo command module that made the first lunar landing. The spaceship *Columbia* continues these pioneering exploits and was the first Space Shuttle to achieve orbit in 1981.

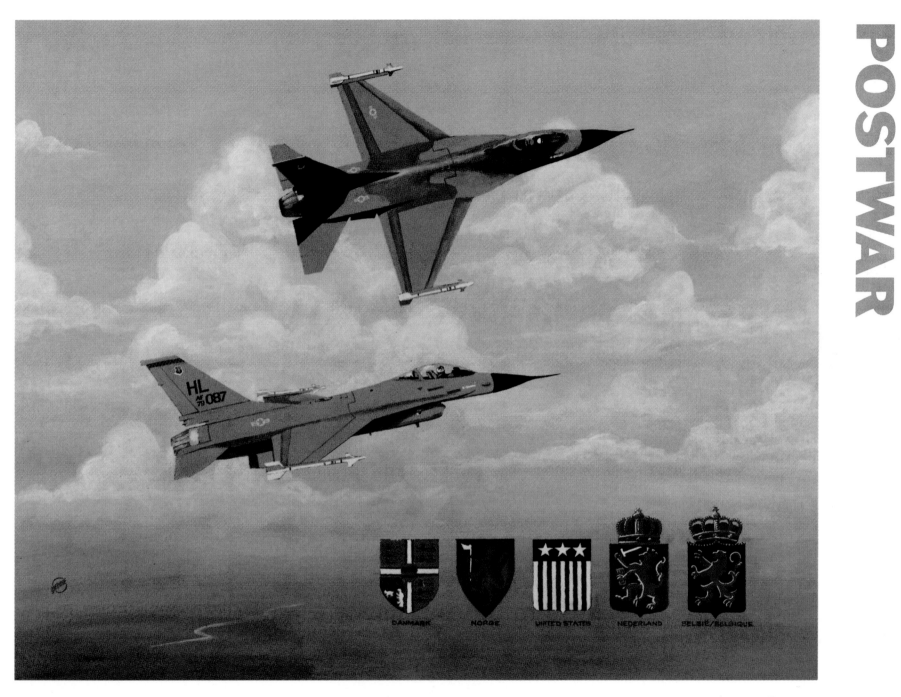

A Multinational Concern

William Yenne

Another of Yenne's gifts to the U.S.A.F. Art Collection, the title of this acrylic on board painting refers to the adoption of General Dynamics F-16 Fighting Falcon by the air forces of five nations as a replacement for the F-104. With a maximum speed of over Mach 2, this deadly aircraft carries an internally mounted M61A-1 20 mm. multi-barrel gun as well as a Sidewinder air-to-air missile on each wingtip. In addition to this there is the capability for extra underwing attatchments.

Acknowledgements

The publishers gratefully acknowledge the following organizations for their kind permission to reproduce artwork on the pages mentioned.

Dare to Move.., Inc, 1132 South 274th Place, Des Moines, WA 98198
Page: 68, 132-133, 150, 173, 176-177

Eagle Editions Ltd., P.O. Box 1830; Sedona, AZ86336
Page: 8, 11, 15, 78, 79, 83, 96, 97, 105, 115, 127, 128, 147, 158, 159, 162, 163

Godines, Henry
Page: 87, 100, 110, 111

The Greenwich Workshop, One Greenwich Place, P.O. Box 875, Shelton, Conneticut 06484-0875
Page: 95, 114, 130, 136, 139, 194, 195, 200, 202-203

Troy White, Stardust Studios, 612N. Salisbury Ave., DeLand, FL 32720 U.S.A. phone/fax 904 738 3142
Page: 52, 75, 77, 90, 101, 109, 123, 126, 129, 131, 134, 138, 153, 166, 168, 169

Hugh's Aviation Prints, 3540 W. Beach Avenue, Chicago, Illinois 60651.
Page: 53, 76, 98, 99, 119, 121, 170-171

Humbrol Ltd., via Jerry Scutts
Page: 12, 16-17

Imperial War Museum, London, England, SE1 6HZ
Page: 7 (top and bottom), 9, 10 (top and bottom), 14, 22, 24, 25, 26, 27, 28, 29, 30, 31, 32, 33, 34, 35, 36, 37, 38, 39, 42, 43, 44, 45, 46,47, 48, 49, 50, 51, 72-73, 80, 86, 92-93, 94, 112, 113, 120, 135, 137, 142, 143, 146, 149, 152, 156, 185, 196

Military Gallery, Bath, England
Page: 82, 91, 157, 182, 186-187, 192

N.A.S.A Art Program
Page: 204, 206

Osbourn, Mike
Page: 40, 41, 54, 55, 56, 57, 59, 60, 71, 89

Ruhman, Rick
Page: 70, 104, 107, 108, 178

Thompson, Charles J.
Page: 58, 61, 62-63, 64, 65, 66, 67, 69, 74, 81, 84, 85, 88, 102, 103, 116, 117, 118, 124, 125, 140-141, 144-145, 148, 151, 154-155, 160, 161, 164-165, 167, 172, 174-175, 179, 184, 188, 189, 190-191, 193, 198-199, 201

U.S Air Force Art Collection, via Bill Yenne
Page: 180-181, 183, 197, 205, 207

U.S Navy, via Jerry Scutts
Page: 18